THE GOTHIC CHOIRSTALLS
OF SPAIN

THE GOTHIC CHOIRSTALLS OF SPAIN

DOROTHY and HENRY KRAUS

Routledge & Kegan Paul
London and New York

First published in 1986
by Routledge & Kegan Paul plc

11 New Fetter Lane, London EC4P 4EE

Published in the USA by
Routledge & Kegan Paul Inc.
in association with Methuen Inc.
29 West 35th Street, New York, NY 10001

Filmset in Garamond
and printed in Great Britain
by BAS Printers Limited,
Over Wallop, Hampshire

Library of Congress Cataloging in Publication Data

Kraus, Dorothy.

The Gothic choirstalls of Spain.
Bibliography: p.
Includes index.
1. Choir-stalls, Gothic—Spain—Oviedo. 2. Wood-carving,
Gothic—Spain—Oviedo. 3. Wood-carving—Spain—
Oviedo. 4. Catedral (Oviedo, Spain) 5. Choir-stalls, Gothic—
Spain. 6. Wood-carving, Gothic—Spain. 7. Wood-carving—
Spain. I. Kraus, Henry, 1905– .
II. Title.
NK9762.09K7 1985 730′.946 85-2228
British Library CIP data also available
ISBN 0-7102-0294-6

Contents

Illustrations

Preface

Writers have often alluded to the part played by accident in the development of their books. This is especially said about works of fiction, plots being described as taking sudden radical departures, characters assuming totally unintended twists that stubbornly resist accommodation. A kind of mystical provocation is sometimes hinted at, or, as in more recent times, the play of the subconscious, which, it is often suggested, adds depth and richness to the work.

The role of accident in the present book is freely acknowledged by the authors, though its cryptic nature is disavowed. Rather, it was the appearance of new and unforeseen data that completely altered the kind of book that they had originally planned. The major innovators were the discovery of the abandoned choirstalls of Oviedo Cathedral, followed by the supervision of their restoration, a task that was foreign to any previous experience but which proved to be unavoidable.

Their unanticipated responsibilities did not stop there however. The developing work prompted an extensive research into the historical background of Oviedo's stalls and its influence on their art, from which it was a natural step to follow through with similar studies of the other figured Gothic assemblies of Spain. The authors had never before experienced so insistent an urge of this kind, not even in France, to whose choirstalls they had devoted several years of investigation.

A pertinent cause of this strong incentive in Spain was undoubtedly the close relationship existing among its twelve figured Gothic sets. This was a direct consequence of the taut time factor underlying their creation, all but two of the twelve having been completed within a range of fifty years. The result, inevitably, was to closely assimilate topical trends in their iconography

and to reduce variant architectonic forms.

But the unity of time would probably not have produced the striking concordances that are found in these sets were it not for the compelling historical circumstances that were operative in Spain during this period. Basic among them was the unification of the country which was marked notably by the political linking of Castile and Aragon, by the final reconquest of its territory from the Moors and by the forced establishment of a religious identity.

These major developments were accompanied by conflict and turmoil and were often imbued with such social passion as to make themselves felt in all the cultural manifestations of the time. This was certainly true of the creation of those rich and complex monuments, the figured Gothic stalls, which are illustrated by as many as a thousand individual carvings in a single assembly.

In these stupendous collections of sculpture, which are studied in detail in this book, will be found a number that reflect the 'reconquest' (as in Toledo and Sevilla), the new social order established in the repopulated lands of Spain's pioneering 'Far West,' the Extremadura (Plasencia, Ciudad Rodrigo), or evidences of the early exploratory period (Leon, Zamora), as well as other more general aspects of the socio-historic setting, such as expressions of antiracial feelings against Moors and Jews, or, in a positive sense, the absorption of elements of their culture by the Christians.

All this historical material has been analyzed by authors of many countries and has excited universal interest in contemporary times. Not often, however, has it been sought out in its artistic manifestations, as the present writers have undertaken to do among the nearly five thousand carvings possessed by Spain's Gothic choirstalls.

Dorothy and Henry Kraus

Acknowledgements

Acknowledgements are meant to record an author's recognition of important assistance in the accomplishment of his work. The restoration of Oviedo's choirstalls, the central feature of this book, hardly fits into that pattern, since it was concerned with a project of much broader participation.

We therefore feel that it would be improper for us to apportion personal thanks as though our responsibility for the restoration were preponderant. Though we may have taken the lead in it and then written this book, there were a number of others who were highly motivated and whose contribution was important.

We ask those who were helpful to our particular effort to excuse our not naming them. Those who may have been cited in the text by chance of the narrative do not by any means exhaust the number of those who were generous to us.

It seems appropriate, on the other hand, to mention the non-personal agencies that provided significant assistance. There were three groups especially without whose aid this task would not have been accomplished.

The support of the authorities and staff of the Cathedral of San Salvador, as exemplified by the dean, Demetrio Cabo, and the *magistral-fabriquero*, Emilio Olavarri, was marked by unfailing care and sensitivity.

Among the lay groups, the outstanding contribution was undoubtedly that of the International Fund for Monuments, of Washington and New York, which was not only the principal financial donor but which in the person of its executive director, Colonel James A. Gray, demonstrated an alert interest in every phase of the work itself.

Very important too was the part played by the Joint Spanish-American Committee for Educational and Cultural Affairs, directed by its co-presidents,

Amaro Gonzales de Mesa, Director-General of Cultural Relations of the Spanish Ministry of Foreign Affairs, and Serban Vallimarescu, American Embassy Counsellor for Public Affairs, which has furnished a remarkable example of co-operation between two countries in the accomplishment of an esthetic goal.

 Other groups or individuals that lent financial assistance were Spanish, of local or regional origin. They included the Association of Friends of the Cathedral of Oviedo; the Chapter of the Cathedral of Oviedo; the Caja de Ahorros (Savings Bank) of Asturias; the College of Architects of Oviedo; Dona Maria Dolore Mesaveu; and the Señores Viudas de Selgas.

 We also wish to add here the Samuel H. Kress Foundation, of New York, which through the initiative of its past and present executive vice-presidents, Mary M. Davis and Dr Marilyn Perry, provided the funds for the photography connected with this book.

PART ONE

Creation, Ruin, and Recreation of Oviedo's Choirstalls

Nothing to Start With

The disappearance of much of Spain's medieval art in the contemporary period has had a handy absolving excuse that was not always justified. Neglect and institutional vandalism have been as much at fault as the civil war of 1936–8, frequent victims of such wilful ruin having been the Gothic choirstalls. The stalls of Oviedo Cathedral suffered from both types of desolation, but it was always the miners' dynamite that was remembered. In the end it little mattered how they had gone, for they were rapidly forgotten.

Anyone who in recent years might have become curious about these stalls, about how they could have looked, how splendid they might have been, would have needed the imagination of an archeologist. Our own considerable efforts to discover some illustration of them proved fruitless. We found no engravings, drawings or paintings, nor even any photographs of the stalls in the nave-centered choir where they had been until 1902; not so much as a description in the literature of the iconographic content of the sculpture or its arrangement.

In fact, the information we got about Oviedo's stalls from the preliminary reading that we did before making our first tour of Spain, in October 1976, was misleading. At the turn of the century, according to the contemporary author, Pelayo Quintero Atauri,[1] these stalls had been withdrawn from the central choir and relegated to an unnamed chapel. Actually they had been divided between two chapels, the Santa Barbara Chapel and the *Sala Capitular* (the assembly room of the cathedral chapter), a detail that was critically important to this account. Thirty years later, during the Revolution of October 1934, the *Sala Capitular* became involved in the cathedral's invasion and dynamiting by the Asturian miners, who in the process 'set fire to the old Gothic choirstalls that were stationed there,' as another historian, Manual Gomez Moreno,[2]

reported, after seeing their 'cinders' a few days later.

In the succeeding period total oblivion seemed to take over what remained of Oviedo's stalls, to the point that Joaquin Manzanares Rodriguez, when writing about them in 1974, adverted to their 'mysterious and lamentable disappearance.'[3] He could last remember seeing them, he said, in the Santa Barbara Chapel, 'around 1960,' which was in any case a surprising lapse of time before their departure was noticed. We had not read this book before our visit in 1976 or we would never have gone to Oviedo, and the events that are described in the following pages would not have occurred. However, the articles of Pelayo Quintero and Gomez Moreno, which we did read, left a good deal of ambiguity regarding the fate of Oviedo's stalls. Accordingly we decided to include that set among those (about forty of them) that we ought to check.

Our train from Leon arrived late, leaving us hardly more than two hours to carry out our investigation. It was cold and raining heavily but we were fortunate to have the offer of a train companion to share his taxi with us, though he had to go considerably out of his way to deposit us at the cathedral. We entered hurriedly, having learnt from often frustrating experience about the confusing opening hours of Spanish churches. The dark vessel was sparsely lighted and the high altar itself was somber.

We could hardly believe our good fortune when we saw, far down the dim north nave-aisle, a priest's figure, fully garbed in cassock and round hat and carrying an umbrella and a briefcase. He was headed our way and we fairly raced toward him while fingering the letter explaining our mission, which the Spanish cultural attaché at Paris had given us. The tall, elderly cleric stopped short and taking the note from our hands searched for his glasses and then for a fitful beam of light from above. He read the letter slowly, folded it carefully and returned it to us.

'But, dear people,' he said, in Spanish, 'those stalls no longer exist. They were destroyed in the Revolution of October 1934.'

'No,' we replied impatiently, in French, 'only the half that were in the *Sala Capitular* were destroyed. What happened to the other half that were in the Santa Barbara Chapel?'

He stood rigid, as though overwhelmed by our assurance, his deeply black eyes crowned by their equally black crescents searching our faces alternately. We became intimidated by our own presumption. But the priest seemed more surprised than affronted. He motioned to us suddenly with his umbrella-hand as if in resignation and started walking back in the direction he had come from.

The sacristy, reached by a large, bare rectangular anteroom, was a neoclassical chamber in form of a Greek cross, its walls entirely lined with chests of

modern-Gothic facture. The cleric deposited his case and umbrella, procured a heavy set of keys from a cabinet and, still silent, led the way through a narrow passage out into a rain-spattered, twilit enclosure. It was the millenary 'pilgrim's cemetery,' we would later learn, and the tiny, blind, two-storeyed, on-first-sight hardly noticeable cubicle in one corner was the illustrious ninth-century *Camara Santa*, chief victim of the 1934 dynamiting, which was by now fully restored.[4]

The rest was even more a blur to us as we followed in silence: past one heavily locked door, up some stairs with a leaky roof, more doors, more keys, more labyrinthine passageways and finally into a maze of linked storerooms, unlighted and frigid, their filthy floors covered by a vast jumble of dismembered wooden fragments, often piled in chaotic mounds. We looked at the priest in amazement. So these were the 'lost,' the strangely dematerialized, lower stalls from the Santa Barbara Chapel!

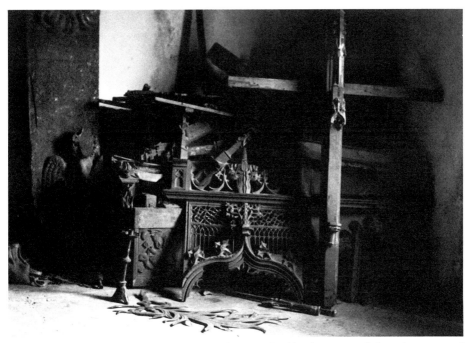

1. Oviedo Cathedral. The *Claustro Alto*. A mound of broken-up and decaying parts of the stalls as originally seen in November 1976. The above and a few more photos will give a certain idea, though only a feeble one, of the appalling condition of the stalls before their restoration. Unfortunately no photos were taken by us when we first saw the stalls, but only a year and more later when the great disorder had been partly corrected. In any case the attempt was never made to establish a kind of photographic corpus of disaster.

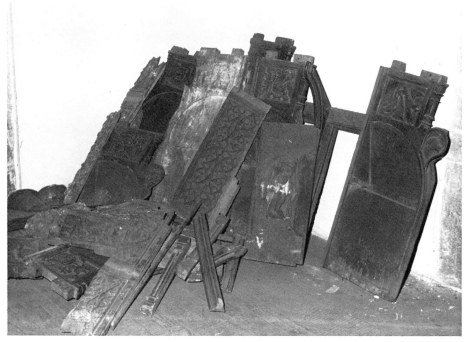

2. Oviedo Cathedral. The *Claustro Alto*. A mass of jetsam from the choirstalls. Parts of it were eventually reclaimed for the restored assembly.

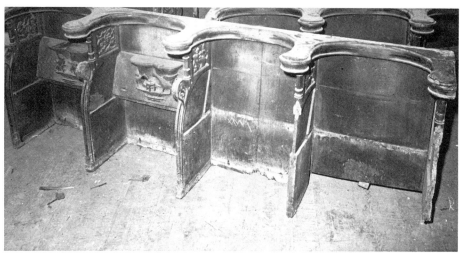

3. Oviedo Cathedral. The *Claustro Alto*. A group of stall seats, ripped apart from their original assemblies and stacked together. All had lost their above-seat busts; almost all had been deprived of some of their carvings.

Yes, the old cleric's uncertain but gracious smile told us, he *had* known about them. Then why had he lied to us? we wondered. If we had believed him we would never have known that they still existed! It was only later that he gave us his reason. He had been ashamed to let 'those Americans' see the stalls in their pathetic state.

Were they truly as bad as they looked? We began to pull at a few of the looser pieces, got several of them free, crying out in delight to find one or another, beyond their grime and bruises, possessed of an amazing charm. There was one small relief of an angel leaning on his harp; a jongleur with fools-cap and bauble; a treeful of twittering birds; we bared the surface of one misericord to reveal a wondrous thick-maned lion. Much of it was consumed by termites and dry rot and the gnawing thought even then began to surface: What was still whole and healthy must be separated from this deadly contagion, quickly, for there was little time to lose.

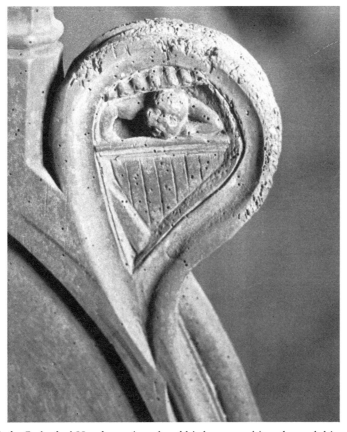

4. Oviedo Cathedral Handrest. Angel and his harp; peeking through his wounds.

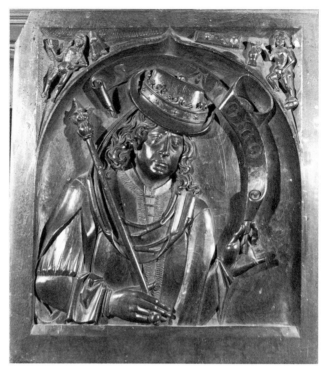

5. Oviedo Cathedral. Above-seat Bust: King Solomon as medieval dandy. Showing the excellent condition of the relief even before restoration.

Nor was the corruption limited to sculpture. In another room with a dripping ceiling, there were hundreds of old books scattered around on the wet floor, among them great volumes of musical manuscripts with heavy parchment covers.[5] The gentle cleric became disconcerted by the shocking disarray and was suddenly eager to end our visit. He took us down by another route, wanting to reward our enthusiasm, he assured us, with a view of the church treasure in the *Camara Santa*. But we were too excited to pay much attention, too disturbed.

As we were washing the grime from our hands and faces, down below, and brushing the dust from our clothes, we could not repress what might have been considered an impertinent challenge. The priest himself recognized the unique quality of the old stalls, we said. How then could he and his colleagues allow this magnificent art to go to pieces, as it was plainly doing? Why didn't they have it restored and brought back into the cathedral where it belonged?

'Because we have no money,' he said, simply.

'Though we are Americans, we have no money either,' we retorted, ironically, but, immediately ashamed, we added quickly: 'We'll try to contact some people in our country who may be able to help.'

We put little stock ourselves in this glib commitment and the elderly priest no more than we, no doubt, but it was the excuse anyway for a warm leavetaking and an exchange of names and addresses. He wrote his own into our notebook.

His script was very plain and irregular: 'Demetrio Cabo, Deán,' we read and were suddenly flushing with confusion. Was it the 'Dean of the Cathedral' whom we had been treating so cavalierly? We shook hands again and hurried up the aisle toward the exit.

Reversing the process of decay in art, if at all possible, is a complex operation which can vary greatly in detail and degree. We had no intention of getting entangled in this work beyond the effort of finding some agency to finance the restoration of the stalls. Yet the dean's delicate smile haunted our thoughts. Even so we would hardly have succeeded in making a proper contact were it not for the help of Mary M. Davis, the responsible officer of the Samuel H. Kress Foundation, who gave us a name that somehow sounded prestigious to us: 'Colonel James A. Gray.'

Since this head of the International Fund for Monuments (IFM)[6] expressed a tentative interest in the project, we decided once again to include Oviedo in the follow-up tour of Spain that we made with our photographer a year later, in November 1977, taking pictures of the stalls we had 'discovered' the year before that would go into a book on Spanish stall art that we planned doing. A few photos of Oviedo, so we thought, might help to convince Colonel Gray to undertake the restoration of these stalls and we hoped in this way to accomplish a worthwhile deed while at the same time getting rid of our troubled conscience.

However, our reception at the cathedral was so gracious that our resolution to avoid involvement was rapidly dispelled. There were as many as a dozen individuals present, a number of them church canons, we imagined, who made the rounds with us as we took our pictures. The dean had arranged to have a cleaning woman up-stairs who dusted vigorously to right and left, a diligence that was to cover the photographs that were taken with a misty cloud. But there were other steps that had been taken that were much more practical. The leaks in the roof had been mended and in one of the great rooms, steel-braced shelves had been erected along the walls upon which the books were stacked in seemly order.

As for the choirstalls, some of the best-preserved sections had been isolated and brought into the open. There was one *ad hoc* ensemble that had been put

together from four separate stalls including their above-seat framed reliefs and overhanging canopies. They were complete except for the gaping holes in two of the carved above-seat panels whereas in a third the entire oval space meant for some saint or prophet was void. This hole at least was quickly filled since one of us recalled having seen the excised bust in the last of the store-rooms. It was none other than St Peter, who was provided with charming whorls of beard and sideburns and two enormous keys that he held uncomfortably in his right hand.

One of the basic requirements in art restoration work, we were to learn, is patience. For the wheels of private routine turn almost as slowly as those of public bureaucracy. We sent Colonel James Gray a set of the Oviedo photographs shortly after our visit, but it was not until six months later that he was able to take a trip there with us to see the stalls themselves. His decision to undertake the project followed, though there remained a number of urgent concrete questions regarding the procedure: Where to begin? How to lay down a plan? Who would do the work?

After Colonel James Gray and his wife left, we decided to stay over for a week and do a preliminary inventory of the stall remnants. Their chaotic condition seemed to require this as a very first step and, more than that, it was clearly necessary for security reasons. The 'rediscovered' stalls in the loft had attracted a lot of attention at the time of our previous visit with our photographer, Pascal Corbierre, and we had become worried about the way they were left lying around. We suggested to the dean that heavy locks be put on several of the doors.

This had not been done and the first check that we made was of the above-seat busts, their apostles and prophets, patriarchs and saints. Some were so badly eaten they could not be moved without falling apart, but we were heartened to find about half of them in surprisingly good condition. It was then that we noticed the absence of the St Peter. He was not in the front, the open room, where we had placed him for the photo the previous November, so we assumed that he must have been put back where we had originally found him. But he was not there either. In fact he was nowhere in the upper loft.

Hoping that he had been moved downstairs, we ran below immediately to reassure ourselves. But neither the dean nor the sacristan knew anything about him. They came up with us to the *Claustro Alto*[7] and all four of us did a thorough search. In vain. This loss would have to be reported to the authorities,[8] we told the dean solemnly, little realizing at the time what a sore spot we had touched. Heartsick, we continued our recordings. What else had disappeared, we wondered, that we would never know about? These old stalls were in so many ways fragile. The importance of restoring them rapidly and putting them back together seemed suddenly extremely urgent.

Since our role in this work was becoming willy-nilly more and more involved we came to realize that we ought to learn something about restoration procedures. We did some reading at the *Bibliothèque Nationale* in Paris and, more important, discussed basic problems of wood-sculpture restoration with the head of this department at the *Louvre*, Daniel Alcouffe, and were introduced by Director Pierre-Marie Auzas to several of his people that were conducting similar projects for the *Monuments Historiques*, the French department of the Ministry of Culture that was concerned with such matters. They showed us photographic dossiers of their activities, some of which shocked us by their radical methods. In the end we prepared a conservative memorandum for the Oviedo restoration, which eventually served as the technical basis for the work.

After several false starts, suitable artisans who would undertake the task were also found, in the shadow of the cathedral's great tower, as it turned out. They were unearthed by Emilio Olavarri, the cathedral *magistral* (meaning literally, 'the preacher'), who doubled as *fabriquero* (that is, the canon in charge of the cathedral's art), and Crisanto Perez-Abad del Valle, president of the lay *Amigos de la Catedral*.[9] The two restorers, Manuel Mariño and Luis Espino, had come up with a reasonable estimate that would permit the completion of ten stalls under the IFM's grant of $10,000. Our own supervisory role, which seemed to be taken for granted by everybody and which we ourselves accepted as a kind of fatality, was financed by the award of a modest six-month (later increased to nine) fellowship from the Joint Spanish-USA Committee for Educational and Cultural Affairs.[10]

Thus, step by step, we had been caught up in the mesh of this obscure and unwanted task. From an accidental accessory to our planned book it had become an independent and overriding feature that seemed to be trying to push what was our major project into the background. We made up our minds not to allow this to happen and without realizing what the physical and mental requirements of the double task would entail, we told ourselves that we would do them both together. We recalled with satisfaction that reports of the 1934 blaze had mentioned that the cathedral archives had been spared.[11] This gave no assurance, however, that they would contain any pertinent information about the choirstalls. Our experience with French stalls had taught us that such records are rarely found among a cathedral's papers. But so many 'happy' accidents had occurred in this Oviedo affair, that we had come to accept anything as possible, or even likely.

CHAPTER I

Certificate of Birth

Practical tasks have a commanding way of taking precedence over all others but we did manage, while working on our first inventory of the stalls, in June 1978, to mention to Dean Demetrio Cabo our desire to look into the cathedral's archives if and when we got the chance to spend some time in Oviedo. The following day he brought a youngish middle-aged man up to the *Claustro Alto* to meet us. He was Raul Arias del Valle, the *archivero*.

We had hopes of being able to separate out and get photocopies made of the few pertinent papers that would, if we were lucky, be available. Hence we were ready with our reply when the archivist asked what documents we were interested in. 'Two sets,' we explained, 'those dealing with the *making* and those dealing with the *unmaking* of the stalls.' We were talking French and actually said '*construites*' and '*détruites*.' The first should cover the period around 1480 to 1500, we added, the second the early years of the present century.

Don Raul, as we soon came to call him as did everyone else, nodded as though intimating that he knew exactly where to put his hands on the desired papers. We felt encouraged but were hardly prepared for what would be awaiting us at our subsequent trip, in February 1979, taken once again at James Gray's appeal, to try and settle the still-pending chore of finding adequate restorers. The archivist presented us on this occasion with a double memorandum, neatly typed and bound, directed at our two requests.[1] The first was titled 'Construction, Documentation, Description and Discussion' and was signed 'Francisco de Caso Fernandez,' who was identified as an instructor ('*catedratico*') of history. The second was by Don Raul himself and was headed: 'Demolition, Removal, Partial Destruction, Documentation.'

We turned eagerly to the first paper though feeling a bit apprehensive at

so ambitious a title. These doubts were swept away when we noticed that four archival entries were actually listed, three from the year 1492 and one from 1497. We were further encouraged by the scholar's observation that these documents had never been published before.

When, at our previous meeting with him, we had offered Don Raul the time lapse of 1480–1500, it was a snap guess based on our abbreviated study of the style of the stalls and their comparison with other sets that we had seen on our two trips through Spain. From our readings, still very fragmentary, we had seen no firm date offered for Oviedo's stalls. It would be safer, therefore, we felt, to examine a rather broad time span in the documents, a task we expected to have to do ourselves to be sure. We were swept with self-reproach as well as pleasure, accordingly, when we learned that someone else had done this work for us. What a frustrating quest it must have been for the young scholar to plod through a dozen years of fruitless seeking before coming to the meaningful one of 1492.

But it was not so, Francisco de Caso assured us, explaining that he had already done all that work before while occupied with his doctoral thesis on the building history of the cathedral in the Gothic period.[2] When therefore Don Raul had approached him with our request, he had 'merely' gone down the chronological lists of his multitudinous entries and picked out those that concerned the stalls.

In his memorandum, however, the young scholar had taken advantage of the occasion to do a reasoned examination of the data. He considered at some length the claim of the well-known scholar, Manuel Gomez Moreno, that the famous Flemish artist, Juan de Malinas, had 'surely' (*seguramente*') done the stalls of Oviedo, basing his conclusion on their 'similarity' (hardly demonstrated) to those of Leon. Malinas's responsibility for the latter assembly was itself based on the flimsiest of evidence that had been brought forward by Gomez Moreno,[3] but by a kind of sliding logic leading from possibility to probability to certainty, he ended by asserting Malinas's authorship of both sets.

Starting off with a token salute to the old scholar (whose essay we shall later be studying on the dynamiting of the cathedral by the Asturian miners) as an 'incomparable connoisseur of Spanish art,' Francisco de Caso then proceeded unabashedly to tear his reasoning regarding the authorship of Oviedo's stalls apart. It was all very handsome but actually unnecessary. For there was one irrefutable fact that he pointed to that Gomez Moreno had neglected which contradicted his entire argument. Juan de Malinas had died in 1476 and could hardly therefore have been creating Oviedo's stalls in 1492, the date when Francisco de Caso had established beyond question they were being done.

There was another matter, though, about which the young scholar's conclusions were less certain: the length of time that the stalls must have taken to

produce. The documents he had found corroborated the general assumption that they were done during Juan Arias de Villar's episcopacy (1487–1498).[4] 'No doubt,' he observed, 'twelve years are an excessively lengthy period to accomplish such a work,' and, since the significant documents he had unearthed all fell in the one year of 1492, he concluded that it was 'obligatory to deduce that that year was the crucial one in the realization of this work.'

Did he mean that Oviedo's stalls might have been done in a single year? He did not say that, though his words inferred something like it. To create eighty great stalls[5] with hundreds of figures and reliefs and infinitely detailed decoration in one year – we had never met up with anything that distantly approached such an accomplishment. Francisco de Caso had apparently figured that if work had been done in other years besides 1492 there would have been archival references to them. However, a wider acquaintance with the stalls of other churches could have told him that their documentation was often far from complete.

From our own studies, we informed him, choirstalls took much more time to do than he had assumed. The comparative experience in various countries (and even in Spain, as we would eventually learn) was quite definite about this. The full discussion of this subject for the Spanish Gothic stalls with figured carving that have survived will be taken up in the second part of this work. But we should perhaps at this point refer briefly to the production record of Barcelona's stalls, whose documentation is almost complete.[6]

For the assembly there of sixty-five lower stalls, a large group of sculptors required five years' work (1394–1399). Four of twelve named men went the full stretch, in addition to the master-of-works, Pere Sanglada. Several others put in one to two years each. Equivalent construction periods could be listed for many English, German, Belgian and French stalls. Dating of the last group, to whose study we have devoted a considerable amount of time, includes such famous sets as St-Claude (1449–1465); Rouen (1458–1469); Rodez (1478–1489); Amiens (1508–1519); and numerous others.

In attempting to bracket the production dates of Oviedo's stalls, the fourth entry from the archives furnished by Francisco de Caso, which is dated 1497, does not at first reading seem to supply anything to the point, telling merely of a fire in which one of the stalls had been burnt 'a little.'[7] Yet the information is significant after all, for it testifies that the stalls were already in place at the time – and hence completed. This could have happened in any year starting from 1492, the date when the three most important entries occur. Work during that year was indeed going along at a lively clip, judging from the data supplied. But this did not necessarily mean that the stalls were on the way to being completed. Otherwise, why would the canons be complaining just then (as they did) about the extravagant expenditures on these stalls if this expense

was coming to an end?

Since we feel that it may have taken as long as ten years to create Oviedo's eighty stalls (forty-five upper ones and thirty-five of the lower register), it is almost certain that they were started a number of years before 1492. This could hardly have been much later than the outset of Juan Arias's prelacy, 1487, or even one or two years earlier, under his predecessor, as has been suggested by some authors.[8] The fact that Alonso de Palenzuela's term (1470–1485) was abruptly terminated by his assassination left the task for Juan Arias to finish. Nor is it a contradiction that the latter's tombal monument, which can be seen in the cathedral's chancel ('*capilla mayor*'), bears an inscription crediting this prelate alone for the construction of the '*Chorum cum Sculptis*', since the lion's share was almost certainly done in his time.

Juan Arias de Villar's name is cited in all three entries of the Actas Capitulares of 1492 that speak of the stalls.[9] At two of the chapter meetings that are reported (dated February 17 and March 30) he is merely mentioned as being represented by his '*provisor,*' Don Gregorio de Herrera, Archdeacon of Grado, who seems to have been an extraordinary building churchman, having as nephew of Palenzuela already taken charge of fabric affairs for that prelate, a care that he continued under Juan Arias.[10] It was not customary for a bishop to attend chapter sessions unless he felt that the occasion warranted it. This was evidently the case of the third meeting in our 1492 archives, where Juan Arias is specifically named as being present. There can be no doubt of the subject he was concerned with, for it is explicitly said that it was 'the making of the capitular stalls of the choir.'

The bishop's attendance at this meeting emphasizes the urgency that was lent to the subject of the stalls by all concerned and strongly indicates that a plan was laid down on this date to energize the campaign for their completion. Such, clearly, is the meaning of the order given by the chapter to Don Lope de Tineo, canon, and no doubt a member of the fabric committee, to arrange for the 'transfer' of some additional men 'to the masters of the stalls.'[11]

It is curiously *a propos* that the last in date of the three archival entries of 1492, that of March 30, should contain a detailed complaint that the fabric fund was 'in great need of money as a result of the many diverse works – besides the stonework – that were and are being done.' Named among the auxiliary undertakings are the organs and especially the stalls, 'on which were (working) many foreigners.'[12] These few phrases are all pregnant with significance for us, not the least of which is the fact that they contain the corroboration of a datum that their artistic style has made presumptive: that some non-Spanish (and possibly Flemish) influence was involved in the making of Oviedo's choirstalls.

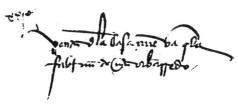

6. Actas Capitulares. Copy of folio xxix, 1492 (otherwise undated). Report of important session of the Cathedral Chapter, in which the great amount of production going on is cited. The Chapter complains of shortage of funds, bringing into cause the stalls, 'on which were (working) many foreigners.' (Section at bottom underlined by authors)

Reference to the 'stonework' in the above quotation is a reminder also that Juan Arias's term was likewise rich in accomplishment on the cathedral's monumental side.[13] He is credited with doing a large part of the nave in both his burial memorial and in a famous inscription at the top of the inner façade which links this 'most magnificent' prelate with the 'finishing and closing off' of the cathedral fabric (structure) at the west front in February 1498.[14] Actually most of the last half of the fifteenth century saw a great spurt in the church's construction after a slow start that dragged through the previous century and a half, much of which was torn by civil strife.[15] The unification of Castile and Aragon in the latter part of the fifteenth century and the general pacification of the country may thus be seen as having favored the acceleration of San Salvador's construction, including that of its stalls.

Leading up to Juan Arias's contributions to the church's building were those – perhaps as great as his – of Alonso de Palenzuela.[16] Ferdinand and Isabel's confessor and leading crown diplomat was responsible for the completion of the transept and also of the first two of the nave's five bays. Those first two sections of the central nave were destined to house the stalls, which may have already been under construction, as we have said. In any case it was very likely that the stone and ironwork enclosure of the stalls, which was functionally indispensable to them, was prepared under Palenzuela.

It is most interesting to learn that not only was San Salvador Cathedral entirely reconstructed in the Gothic style but that its choirstalls likewise underwent a similar recreation. We have no idea what the original set looked like, but we are advised that such an assembly definitely existed and indeed it is explicity referred to in a pair of documents, both of 1234, that are cited in the archives of Oviedo and Toledo Cathedrals. They tell of a brotherhood having been formed by the two chapters providing for mutual visiting privileges that assured the guest food, shelter and a stall-seat ('*stallum in choro habeat*').[17] If these early stalls were still in use in the 1480s they would surely have become totally inadequate for the 'magnificent' Juan Arias de Villar, royal counsellor and favorite, who would want new ones made to match the many splendid features of the great new edifice.[18]

Unhappily the beautiful choir ensemble that he left to Oviedo as his most impressive artistic bequest can only be imagined today, with any illustration of the interior lacking, its many elements now either dispersed or destroyed. The only aids available to us are the descriptive words of a few authors who saw the choir interior before it was demolished. The most meticulous of such reporters was Ciriaco Miguel Vigil, who in 1887 published a two-volume edition of the cathedral's monumental and artistic possessions and especially of its memorial inscriptions.[19]

From Vigil's unadorned details, and other sources, we can reproduce men-

tally the two levels of the choirstalls, which were arranged in oblong form with the fourth side open. This was turned toward the chancel (east) where it was shut off by an elegant Gothic iron grill. At the opposite end, two full bays away, was the stone roodscreen against whose flat inner surface the rear central section of the upper stalls abutted. There were thirteen seats along this section with the pinnacled bishop's throne prominently occupying the medial position.

On each side of the upper stalls, Vigil went on, were sixteen 'canonical' seats that ran the full length of the choir, with a door of entry on either side that divided the stalls and led to the stairs descending to the floor level. The lower stalls were also arranged in oblong but were fewer in number: seven at the center-rear and fourteen on each side, totalling thirty-five[20] as against the forty-five in the upper seats. Vigil detailed their major features rather summarily but typically complete were his listings of the 'legends in white boxwood' on the upperstall panels, quoting apostles and prophets, whose citations would not have been known in their entirety were it not for Vigil's inscriptions.

Descriptions of the choir's other furnishings, like the pulpits and the organs, can only be fragmentarily gathered from remnants or illustrations. Not from any views of the inside choir, however, for those do not exist, as far as we have been able to determine. There are two engravings in a book published in 1855[21] that show the choir, but they were both 'sighted' from the outside, at the eastern grill and the western roodscreen, and give only vague views of the stalls. In the print of the grill, one side of the double organs can be seen with its curious horizontal 'trumpets' resembling a battery of armworks. Each organ rests on a kind of platform, beneath which an upper stall or two can be tantalizingly glimpsed.

One other engraving,[22] quite blurred in part, was actually sighted from inside the choir though it shows only the bishop's throne and merely a part of that, the upper part. Deposited on the seat-top is a kind of cylindrical niche set off by decorated side pillars, in which sits a squat, solemn, overdressed little man with heavy mitre and cross, blessing demurely with two fingers. At the crest of the lofty seat is visible only the lower part of a pointed ornate pinnacle, at both sides of which are ranged the traceried overhangs of the companion stalls. All of it is of handsome, unmistakeable late-Gothic make.

It is cold comfort to have only verbal or even illustrated descriptions of great artistic treasures when the originals are gone. Nevertheless the information that these abstract reminders furnish does often serve an historic purpose or may contain some item of topical interest. Of this nature is the knowledge that we gain from the three engravings that Oviedo's stalls were established from the beginning in the nave's center as an integral part of the Gothic

7. Oviedo Cathedral. Nineteenth-century engraving, sighting the old grill at eastern end of former choir, with one of the organs above and the stalls below.

church's structure.[23] For it will help us to judge the arguments brought forward by Bishop Ramon Martinez Vigil when, in 1894, he announced his project for the demolition of San Salvador's central choir.

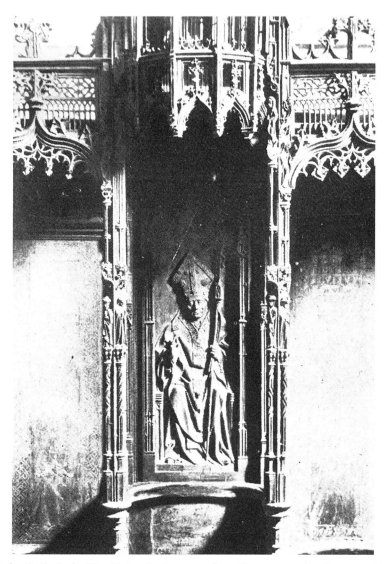

8. Oviedo Cathedral. The bishop's throne, taken from an early photograph of the upperstalls when they were still in the central choir. The seated statue and all the other decoration, including the high pinnacle, have disappeared. The only recognizable parts here are the two crest segments from the neighboring stalls, which can now be seen in the restored choirstalls.

Iconoclasm by Subterfuge

The first thing that happened as we began reading the plump volume of the chapter's minutes for 1894–1905 in the cathedral archives was for us to correct a grave injustice. For we had had in mind what Pelayo Quintero Atauri wrote in 1907:

'These stalls were until quite recently in the center of the nave. But for reasons unknown to us they were removed from there and put away into a chapel *by order of the cathedral chapter*. . . .' (our emphasis)[1]

There are actually two serious errors in this statement, one of which has already been mentioned: that the stalls were shifted to two chapels and not one, as is said. The other error was early exposed in the Actas Capitulares, at folio 7,[2] where we learned that it was not the chapter but the bishop who had initiated the transfer. His letter of February 10, 1894, to the canons began with a verve of good will as he told of the great benefits that would accrue to the church, to the clergy and to 'the faithful' by the change. Not a word did he say about the esthetic losses that would result.

After four hundred years the church had become too small for the diocese's doubled population, Ramon Martinez Vigil explained.[3] The space in the presbytery around the high altar was, in particular, so cramped that important pontifical ceremonies, 'especially those of the prelate's predications,' could not be held in it. And in funerals of any 'ostentation, the catafalque had to be put in an inappropriate place.' Hardly two hundred people could see the altar at present, he went on, while the others had to stand 'on the cold marble exposed to the currents of all the winds.' This in itself explained the emptiness that 'has surrounded our sacred functions,' after which the people left in a hurry, if they had not already departed before the ceremony was ended.

Bishop Martinez Vigil added a phrase at this point reminding the canons

of the dire need to fight for souls these days when 'the enemies of God' sought to draw them from the paths of faith. This struck us as a routine verbalism that would be common among churchmen. Later, however, when we came to read some of the prelate's voluminous writings, we learned that the words actually reflected deeply felt misgivings in this bishop, as in many other conservative churchmen of his time that were linked with such developments as the strong surge of socialism on the political scene as well as the 'liberal' current within the church itself.

To correct all the shortcomings in the arrangement of the choir, Martinez Vigil went on to explain in his letter, he had conferred with various 'illustrious' people and had obtained the services of an architect of 'recognized competence' to prepare two projects, one of which by general consent was soon eliminated. For both, in any case, the preliminary act which was hardly mentioned except to be presented as a *fait accompli*, on a (non-existent) drawing, was the obliteration of the nave-centered choir. In this manner, it was said, there would be offered to the eye of the spectator 'a grandiose and imposing aspect.'

It was for the planned arrangement of the new choir in the presbytery that the prelate called up a precise and exultant vision:

> The episcopal throne occupies the center and at its sides, on two levels, are placed the stalls for twenty-four canons above and twenty-two prebendaries below, with sufficient space left over for the lectern, the benches for the supernumeraries, the seats for the choir. The two small entries are provided with double screens and the choir can be shut off at the front *ad libitum* with beautiful curtains of damask, which being slid behind the altar will improve greatly the shelter and acoustics that exist in the present choir.

The altar itself would evidently be brought far forward into the transept crossing, in the full unobstructed view of the entire church.

This vision, with some supplementary details, the prelate turned over to the cathedral chapter, 'to accept, reject or modify.' One had the feeling that he did not expect much opposition, especially since he or some unknown agent had already arranged to leak his project to the 'public,' thus assuring him, he must have thought, of a welling support for his reform.

As a matter of fact the way the article was written up in the local newspaper, *El Carbayon*, of January 25, 1894,[4] the whole matter could have seemed to be completely disposed of already. It spoke without equivocation about the bishop's project having been 'approved by the "*excelentisimo*" chapter' and while repeating the list of all the advantages that would accrue to the church and the cult from it, it did not show the slightest concern about any adverse

eventualities that might likewise result. Most interesting was the fact that the disposition of the old stalls was spelled out more explicitly in the article than would ever occur in the Actas Capitulares correspondence. The stalls, it was said, would be moved into the chancel and set right up against the base of the great reredos, 'without obscuring any part of it.' How this conjurer's trick would be accomplished was not explained, however.

It was all the more surprising, accordingly, to find the chapter less than euphoric about the proposals. Operating through a committee called the *Consulta*, which were to play an extraordinary role in this entire matter, the canons informed the prelate that three major points required clarification.[5] The first concerned 'conditions of health.' They reminded him that 'early and late in every weather' the chapter had to perform their divine offices. Once before, they said, in 1878 (six years before Martinez Vigil had taken office), the experiment was tried of moving the altar out of the chancel, with disastrous consequences. That winter many canons and prebendaries who officiated at the altar fell ill, 'no doubt from the cold winds that constantly blow around it.'

This seems like an insignificant point to raise over so great an undertaking. But the canons evidently did not feel that way about it for they were to repeat it over and over. They had reason to put it first since the bishop had not thought of mentioning it while exposing his grandiose plans. Would not (they continued) the architectonic unity of the church be impaired by the changes? Would not serious flaws appear in its fabric through the elimination of the double organs and the central choir with its stalls? The latter, they reminded the prelate, were 'a notable work of ogival style, whether seen as a whole or in its details, as all people of culture agree.' Would these stalls and the handsome ironwork grill that shut off the old choir at its eastern end be preserved when these great changes were undertaken?

And finally, the chapter made it plain that they were hardly reassured about the bishop's promises regarding the financing of the proposed works. It was not enough to have funds to start them; provision must be on hand to finish them as well. For, they said, bluntly, the bishop could be advanced to another see or he could even die before terminating his 'ardent plans.' It would be 'sad' if the chapter had to celebrate their functions for years to come in some small chapel before the new choir could be provided. 'Today we already possess a church that answers all our needs and in which the services of the cult are celebrated with dignity.' And with modest pride they informed the prelate, who clearly had visions of attracting great masses to the cathedral, that such as it was, 'there are 40,000 communions given annually at the basilica.'

It was almost a year (January 25, 1895) before the chapter heard from the bishop again on the matter.[6] Had he been waiting patiently for the canons to complete the 'thorough study' of the project that they had promised to

make? It seemed hardly consistent with the impulsive character he was to display on various occasions. But the canons' disquietude was profound and the Actas Capitulares reveal a persistent effort on their part to match the expert advice that the bishop had obtained. For this they went to Miguel Laguardia, the city architect, whom they saw a number of times in the interval.

Apparently Señor Laguardia was reluctant to become engaged in what might well turn into a conflictive situation. He pleaded with the chapter *Consulta* that he was overwhelmed with work, above all with a project involving the city's water supply system, but promised that he would take up the bishop's project as soon as the waterworks job was ended. The chapter reported this promise to the prelate, explaining that without the architect's report they could not possibly have 'the full knowledge of the facts' permitting them to reach the decision demanded of them.[7]

It was still another eight months (October 5, 1895), and once more after repeated appeals to him, until Miguel Laguardia managed to visit the cathedral and observe what was involved in the bishop's project. He then prepared the blandest of possible reports.[8] From the esthetic point of view, he said, the organs would have to be shifted to another place (after the choir's demolition). As for the choirstalls, their dismounting and transfer would result in the destruction of a large part of them while other elements would require much delicate recarving. This would raise the cost of the reinstallment, he concluded. And that was all.

Small wonder that the chapter delayed again in sending their reply to the bishop. What could they do with such a flimsy statement? They must have realized that a professional judgement would be of critical importance in so delicate a situation. Lacking this, they still did nothing except to continue to urge Señor Laguardia to prepare a more complete analysis. On January 31, 1896, the thing that they must have feared occurred. Righteously indignant, Martinez Vigil wrote them that 'a proper amount of time – with increase – had elapsed' since he had first written them about the project. And he fixed the space of forty days for the chapter to make up their minds.[9]

The Actas do not inform us as to what may have taken place in the weeks that followed this ultimatum. All we know is that the chapter had decided that 'with or without the architect's report' their reply to the bishop would be given in the time set forth. After thirty-six of the forty days had elapsed, on March 7, 1896, Miguel Laguardia's analysis was finally received and duly entered into the Actas.[10] Declaring it 'luminous' and associating themselves with it 'in all its parts,' the canons quickly shipped the architect's commentary to Martinez Vigil. Actually they were too hasty and should have added some qualifying remarks of their own, doubts which they later revealed and that Laguardia's comments did not clarify.

Martinez Vigil's proposal, Miguel Laguardia had written, did not constitute an actual project, which should have been supplied with full details of the works to be accomplished, the methods of execution, the materials that would be required, including drawings, and a full estimate of the cost. On the other hand, he agreed that the proposed shift of the choir to the presbytery and other suggested changes were practicable. But before they were carried out several important questions must be considered and disadvantages foreseen, such as the cold currents that might result from the change due to the bad orientation of the church's main doors, as well as regarding certain esthetical matters which he merely listed without going into any detail about them.

On the crucial question of the stalls, Miguel Laguardia merely qualified his previous disturbing approval of their being shifted (though he mentioned the presbytery as the place that would receive them), with a warning that the change would be expensive. But it is amazing that he did not say a word against the demolition of the central choir itself, which in the sequel would prove the key move in the devastation that followed. Was Laguardia reluctant to get into a technical discussion of this admittedly complex matter? His repeated self-abnegating assertions about his lack of competence would indicate that this may well have been the case. Curiously the matter then went into abeyance again – for fifteenth months, until June 10, 1898.

It was an affair of *force majeure* that was to blame for the delay this time, an historic event of great moment, whose warning shadow had already begun two years earlier to darken the pages of the Actas. This was Spain's war with the United States over Cuba. Bishop Martinez Vigil's early church career had brought him into close contact with the Spanish colonies, in particular the Philippines where he had spent eleven years, teaching at Manila. The Cubans' uprising was to agitate him greatly, as is illustrated by his letter of March 4, 1896,[11] in which the bishop invited the chapter to attend a meeting at the episcopal palace where 'efficacious means' would be discussed of 'coming to the aid of our country in the difficult circumstances through which it is now passing.' Soon after, the prelate directed the organization and equipment of a battalion of volunteers, which eventually embarked at the Port of Gijon.

The war no sooner ended, Martinez Vigil returned to the project of the new choir, now over four years old. From his letter to the chapter of June 10, 1898,[12] one might have thought that all the entangled problems had by now vanished. He intimated in it that important progress had been made in the interval by the two-man committee that he had designated twenty-seven months ago. 'With care and calmness . . . and keeping in mind Señor Laguardia's observations,' he wrote, the diocesan architect and the head of the

cathedral fabric had gone to work 'and the result could not be more satisfactory.'

'That the temple will gain very much artistically,' the prelate added, 'that all its original (*primitiva*) beauty will be restored, is a subject now beyond all controversy, whether for art experts or the profane.' We read his letter over numerous times and could find no substantiation cited for this boasting. There was nothing positive that had been added, nothing in reply to the objections that had been raised. The bishop's assurance that there were sufficient funds in the till to cover all costs was still only a blank statement, hardly the careful detailed estimate of costs that had been asked for.

Only one fresh element was cited and it was hardly of a nature to generate much enthusiasm. Architect Laguardia had prepared the way for it by over-playing the problems of transferring the old stalls to the presbytery. The bishop had seized on the dilemma to decide that a new set would be made, which he confidently announced would be 'of equal merit to the old.' This insensitive remark could only have revolted the genuine admirers of the beautiful Gothic stalls among the canons. It also gave the full measure of the prelate's cultural obtuseness which explained his willingness to sacrifice various other works of exceptional esthetic value: the organs, the pulpits, the iron grill, the tribunes, the balustrades. These few 'small details could only be properly resolved on the job,' he declared, and would all be objects of special study once the important task (that is, the demolition of the choir) was consummated.

The canons were angry; they were insulted. In the reply prepared by the *Consulta*,[13] they once more read out to the bishop the A-B-C of their views. They had expected a detailed answer to all points raised, 'practical solutions to the difficulties' cited by Miguel Laguardia. Above all they had expected drawings of the nine elements of the project so that they could be seen graphically and eventually examined by 'a technical body competent in these matters, that is, the San Fernando Royal Academy of Fine Arts.' And the chapter asked that the bishop's spoken pledge be spelled out in writing, 'that no blow of a pick-axe would be struck!'

About Martinez Vigil's decision to have new stalls made, which evidently came as a bitter surprise to the canons, they were particularly sharp. They commented ironically about his being so prompt

> to discard the artistic stalls that are in our choir and construct new 'simple' ones at 6,500 pesetas a-piece. The chapter cannot expect an art treasure at such a bargain! It will be impossible to create stalls at that price to match the architectonic beauty of our great reredos to which those stalls will be a kind of pedestal.

The chapter ended their reply to Martinez Vigil with the suggestion that his

architect should start all over again. Their stern, almost ironical suggestion did not meet with the unanimous approval of the canons, however. For the first time in this conflict we become aware of a division in the chapter, and in the vote on the letter proposed by the *Consulta*, the dean and one other canon split away from the group. This break and the inevitable sense of weakness that it brought might, we feel, explain the chapter's request that the bishop's project be turned over for arbitration to the authoritative San Fernando Academy,[14] in the hope of winning a powerful ally in what must have appeared to them a very unequal contest.

However, Bishop Martinez Vigil had the most pertinent reasons for keeping the San Fernando Academy out of the Oviedo dispute, since that illustrious body had recently intervened in other similar cases, one of which was at Leon Cathedral, where it had successfully opposed the breaking up of the central choir! Martinez Vigil could not have failed to know about this intervention and it may have been his fear that the Academy might now be precipitated into the Oviedo conflict that hastened the bishop's decision to cut the contention short with a coldly authoritative act.

Accusing the chapter of 'chicanery' and cowardice in having concealed for so long their true views about his project, the bishop declared that his long and 'magnanimous' patience was now at an end. 'Cathedrals have been built and rebuilt and embellished by the bishops, who when funds of the fabric (which were controlled by the chapter) are not involved . . . do not have to get the consent or counsel of the chapter.' Those funds, he announced for the first time, had been made available by a pious donation, enough to cover twice the cost of the proposed works. 'They are in the till, gratuitous and without charges, and destined for the restoration of the cathedral, so crudely deformed, to its original beauty.'

And the bishop then proceeded to call on the highest authority of the Church in such matters in support of his edict – the decisions of the Council of Trent on the cult of images, taken over three hundred years ago. These decrees, he insisted, as paraphrased by Lambertini, later Pope Benedict XIV, held that

> the construction of the choir of a cathedral, of the high altar and the decoration of its walls, when paid for by a donation, were the exclusive concern of the bishop. The chapter . . . could not intrude in the administration, nor in the direction of the work, nor in the contracts, nor in the choice of the artisans; in fact, in nothing.

This applied to the decoration and placement of the choirstalls as well, the prelate added, though admitting that that right came later, by 'interpretation.'[15]

Martinez Vigil concluded,

In virtue of these and other documents, of which the Holy See is aware since they emanate from it, I notify the Cathedral Chapter that I am resolved to carry forward the projected works . . . and as representative of the apostolic throne, I grant them the space of ten days in which to communicate to me their consent, failing which I shall have recourse to the Sacred Congregation of the Council [the Court of Rome].

In face of this awesome threat, there seemed nothing that the chapter could do but submit and this they did with dignity and courage.[16] They had been aware, they replied, that their observations would not please the bishop. But they could not, must not approve what to them was a disastrous proposal. They were moreover aware of their own legal rights in this matter but they did not wish to bring discord into the church while attempting to avert the most grave prejudice that the proposed alteration would cause. Like a somber prophecy from the Old Testament, the chapter's words then tolled heavily their prediction of doom:

Time, dispassionate judge and inexorable censor, will decide and pass judgment. Contemplating the artistic riches condemned to disappear beneath the rude blows of the demolishing pick-axe, the foreboding assails us of a repetition of the disasters that followed the inauguration of the Second Temple. . . .

The date was July 15, 1898. It was not until April 3, 1900,[17] that Bishop Martinez Vigil chaired an extraordinary meeting of the chapter, called *ante diem*, and read a 'paper,' which was humbly approved by the canons. Why the further delay?[18] Had he been clearing the legal paths in Rome, Madrid, and elsewhere? It was still another year, on June 18, 1901,[19] before the works were started. By May 2, 1902, the canons could take their seats in the new choir, 'rigorously assigned according to seniority.'
 And the rest was bathos:
March 18, 1902: The bishop asked the chapter if they felt that the organs should be left in place or be moved. His opinion was that they should be moved 'so as to leave the nave free and unobstructed.'[20]
October 9, 1903: The organs' 'cases' were sold to a small church at Natalhoyo to be used to make frames for pious pictures, which indicates that the organs had been cleared away by this date.[21] Not mentioned in the minutes were the organs' charming rococo angels which were thrown on one of the several heaps of dying treasures in the *Claustro Alto*, and which we still saw there three-quarters of a century later.
August 20, 1906: The new organ was consecrated after a delay caused by

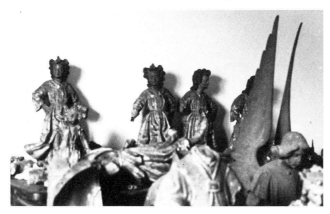

9. Oviedo Cathedral. *Claustro Alto*. Lovely cast-off rococo angels from the organs of the suppressed central choir. (Photo taken by authors for documentation)

the falling of part of the transept vault: a delayed consequence of the earlier demolitions perhaps? The dean had come running breathlessly into the *Sala Capitular* to announce the calamity (August 1).[22]

August 31, 1906: The chapter ruled that a suitable place should be found for 'the artistic ironwork grill' that had probably been thrown out into the open cloister. They also announced that the four old iron pulpits had been removed to make way for new ones.[23]

November 9, 1908: A gift was announced from a new bishop of a 'perpetual rent' to make possible the 'conservation of the [old] organ.'[24] Which meant that it should be stored away some place!

March 11, 1909: The chapter repeated their injunction about the grill. It was not until many years later that, rusted and dismembered, it was deposited in the corridor leading to the cathedral archives.[25]

September 20, 1909: Decision by the chapter that the loose stones from the old choir enclosure (which was never to be touched by a pick-axe, as promised Martinez Vigil) should be used – somewhere.[26]

Ramon Martinez Vigil did not live to witness all these minor consequences of his great project, his death being announced in the Actas on August 16, 1904, without ostentation.[27] But references continued to be made for many years to his radical transformation of the church, even some that were favorable at first. However, the long-term judgment of experts and amateurs was negative, the well-known architect Luis Menendez Pidal, for example, citing it in dismay over a half-century later.[28] By this unfortunate change, he said, '"*à la française*," as the bishop called it,' Oviedo Cathedral lost 'a large part of its riches, leaving it naked and cold as we see it today.' And the architect

expressed his amazement at this destruction 'by one of our most illustrious prelates.'

Scholar and author, Martinez Vigil was wilfully ignorant, twisting words and facts to suit his purpose. By quoting French monuments as his models of the 'open church,' he failed to mention the fact that they owed this description to the destruction of their marvelous Gothic roodscreens in the seventeenth century. And in the eighteenth, the French canons had torn out their refulgent stained-glass windows to 'bring light' into those same churches, while often plastering their walls over or painting them a hideous white for mysterious hygienico-esthetic reasons.

Equally disingenuous was Martinez Vigil's claim that he was bringing Oviedo Cathedral back to its 'original form' in demolishing its central choir. For there is evidence in his own writings that he knew perfectly well that San Salvador was totally rebuilt in the Gothic style,[29] starting at the chancel at the end of the fourteenth century and going on, in the fifteenth, to transept and nave, and finally in the sixteenth, to façade, porch and the stupendous tower. Choir, stalls, pulpits, grill, roodscreen, organs (later redone) were all products of this great sweep that had created the church that Martinez Vigil inherited. Most of these beautiful accessories were destroyed by his initiative. Only the choirstalls remained where he had deposited them – in the *Sala Capitular* and in the Santa Barbara Chapel – where for some decades yet they awaited their hapless fate.

Spain's 'October': Destruction of the Upper Stalls

There is no published visual account of the destruction of San Salvador's upper stalls in October 1934. That there *were* witnesses is self-evident since someone set the fire that burnt them. But they would hardly have been inclined to tell their story to the court martial that was held a few months after the tumult and which found some thirty insurrectionists guilty of capital crime. Even after all but two of this number were graced, this would have been no invitation for the incendiaries to come forward with their revelations.

Before realizing this element of simple logic we spent quite a bit of time trying to find a participant still living who was on the 'other side.' It is an age-old doctrine that the history of war is written by the victors and there are indeed several reports of this particular event from that point of view. But none of them claims to be a direct witness nor even to be quoting one as his source, such as some 'defender' of the cathedral who might have later told how he had seen the 'revolutionaries' set the fire. But even without such an attribution, a number of writers have purported to inform us about how it happened, including so prominent an historian as Manuel Gomez Moreno.[1]

The rebels broke into the cathedral through a window of the *Sala Capitular*, he begins, and the first thing they thought of was to rob the canons' cashbox. They then went on into the cloister and at the south door of the transept one of them, disguised as a riot guard, broke into the church and shot and killed one of the 'loyal' ('*verdaderos*') defenders. Other guards then came running and forced the invaders to flee, who took the same route as they had used to enter. But before leaving, 'they set fire to the old stalls which burnt to cinders.' We must assume that the cathedral's defenders had not followed the escaping intruders, who were thus able to go unhindered about their mischief.

There are several things that are unclear about this account which Manuel Gomez Moreno delivered to the Academia de la Historia at Madrid on November 9, 1934, shortly after having visited Oviedo Cathedral and inspected the damage. He must have interviewed a number of people there, including some who had been in the church on that day of the burning of the stalls, which he said was 'probably' October 10. That he had not verified this date is understandable since the obliteration of the stalls was only a minor incident compared to the truly overwhelming disaster that occurred on another occasion during that violent week. This was the dynamiting of the celebrated *Camara Santa*, the tiny ninth-century church enclosed within the cathedral compound, which had completely gutted it and left its precious treasures buried in the wreckage. Gomez Moreno had been called in after the suppression of the uprising to take charge of the restoration.

While the art historian devoted but a single phrase to the snuffing out of the cathedral's upper stalls, their destruction brought a nostalgic outcry from Arturo de Sandoval, the chapter secretary, several years later when he reviewed the church's losses in a lengthy memorandum in the Actas Capitulares.[2] 'Those stalls,' he wrote, 'so exquisite, so pure, so complete, we shall never see them again.' And he recalled how an English antique dealer, shortly before the revolt, had offered to purchase them from the cathedral, 'for God knows how great a sum!' But this belated appreciation of the stalls in the *Sala Capitular* by an important church dignitary would not serve to protect their counterparts in the Santa Barbara Chapel from obliteration by the canons themselves a few years later.

Sandoval reported that the *Sala Capitular* was already being repaired at the time of his writing (1941). But its irreparable losses had been enormous:[3] its art (the stalls especially), its furnishings, the archives in the secretary's desk, the ancient sepulchers containing the remains of several early prelates – all had been fuel for the flames. The stones themselves had been splintered by the heat and the ogival vault was badly damaged. The splendid high-arched chamber, which dated from the late thirteenth and early fourteenth centuries, when its construction had launched San Salvador's Gothic rebuilding, had played a scintillating role in Oviedo's history. It had long served as the site for sessions of the Asturian Principality and here, too, on May 25, 1808, the war of the Asturian people against Napoleon had been declared.

Sandoval's memorandum reviewed the happenings in which the church was engaged during the 1934 rising and in the civil war that followed two years later. He told how, after the victory over the insurgents in October, when the image of the Virgin of Covadonga was paraded throughout Asturias, the miners at Pola de Siero had gathered 4,000 strong with their 'lamps aglow' to greet her. During the revolt these same miners had been reported to have

blown up the parish church, burnt archives and sacred images and been preparing to set up a kind of Soviet.[4]

The Asturian miners may have changed by the time of the ceremony at Pola de Siero but all sources agree that in October 1934 they had been the backbone of the revolt.[5] The Spanish republic which was proclaimed in April 1931, after giving early signs of a democratic development, made a sharp turn to the right in the November 1933 elections for the *Cortes*, the parties of the left winning only slightly more than a fifth of the seats. This defeat must be seen against the backdrop of concurrent events in other European countries, particularly in Germany where the Nazis took power early in 1933 and proceeded to crush the trade unions and the parties of the working class, and in Austria, where in February 1934 the democracy was violently replaced by a military dictatorship.

In Spain fears centered on the extreme rightwing CEDA (*Confederacion Española de Derechas Autonomas*), led by Gil Robles, whose steady growth in strength during 1934 crested in its assumption on October 1 of three ministries in the government. This set the cap to the insurrectionary sentiments that erupted a few days later. A general strike was declared throughout Spain, on October 5, but the attempt to turn it into a revolt had scant success except in a few centers of the North, most particularly in Asturias, where the great majority of the 27,000 miners supported the uprising. Six thousand of them or more were under arms, equipped with rifles, machine guns, a few armored cars, cannons – and dynamite, their chief weapon. Close to two thousand of them started off from the coalfields early on the morning of October 6 and a few hours later began to occupy Oviedo, quickly dominating a much smaller force of government infantry, riot guards and police, who retreated into a few previously prepared strong points.

One of these was supposed to be the cathedral but it is curious that San Salvador was not taken over by the government force until October 7, though the order to do so had been given two days earlier. These facts are verified by the most trustworthy of all chroniclers of the Asturian rising, Aurelio de Llano Roza de Ampudia, who left a memorable day-by-day and even hour-by-hour account of the October events as seen by himself or other direct witnesses and added to it in the months following the suppression by a series of 'oral histories.'

Armed with a pair of strong binoculars, he stood day and night at the top of his high apartment building in the heart of the city, recording his unique observations. But it was not only what he saw that counted but how he looked. Pure of heart, devotee of the truth: 'I belong to no party,' he wrote, 'for I keep my pen free so as to write impartially.' Though a professional writer and member of the well-off middle class, he was respected by the revolution-

aries who went out of their way to help him avoid distressing eventualities for himself or his family. The entering government troops almost shot him but the people in the street warned them off. Lieutenant-Colonel Yagüe had him brought down and asked him what he was doing 'up there.' And this modern Thucydides replied: 'Taking notes.'

One of these 'notes,' of primary significance to our story, was the taking over of the cathedral by government guards on October 7. This happened, as was said, two days after the order had been given by the local command. It is almost in comic-opera style, surely unintentional, that Aurelio de Llano tells of the belated seizure of what he characterized as 'one of the most strategic points for the defense of the city: the cathedral tower.'[6] It certainly proved to be so as things developed.

A squad of guards started out at nine that morning to get the cathedral's keys from the sacristan, who lived in the *Calle San Vicente*, right behind the chevet. En route, one of the men was killed and the squad chief called for a retreat, reporting to his superiors that there was a mass of revolutionaries gathered at this point. Next a squad of the security corps went around to the cathedral front and tried to enter by smashing the porch grill. One gets the impression that they did not have the proper tools for this chore, though the squad leader again announced that they had been outnumbered. Finally, an imposing force of two commandants (majors), a captain, a lieutenant, a sergeant, thirteen guards and two chiefs of the security corps managed to smash the lock of one of the cathedral's iron doors, then with a hatchet made a breach in the wooden portal behind it, and entered the church.

In neither of the last two operations was the slightest opposition reported. The reason for this seems to be that, contrary to what was later said by different reporters, the rebels evidently had had no intention at that time of occupying the cathedral. That they could have taken it at will appears to be beyond question. Yet they somehow regarded it as a kind of open precinct, which both sides would respect. The churchmen themselves seem likewise to have had that opinion for they had simply locked up the church and left it standing unprotected.[7] The insurgents were very soon to regret their failure to take it over, however, after rifle and machine-gun fire began to hit them from the two towers, causing many dead and wounded during the next five days.

The relatively small number of soldiers (plus two unidentified 'civilians') who held the cathedral during this period did a stout job of it. With little food, no sleep, and the water main cut so that they had to ration out holy water from the sacristy,[8] they came out of their ordeal looking more like captives in the last throes of survival than the heroes they were acclaimed to be.[9] This entire episode is described at length in his report by Arturo de Sandoval, the chapter secretary, and what is inescapably clear from his account is that

the occupation of the cathedral was not, nor ever meant to be, a simple 'defense.'

A handful of armed guards were placed as lookouts in vulnerable spots to give warning of any incursion while the larger number took up positions in the two towers, the great 'Gothic tower' at the façade and the much smaller 'old tower' which was located just outside the south transept. The best marksmen were picked for these positions, who lay on the stairs in permanent alert. One of them, a sergeant, was a crack shot whose exploits were sung by Sandoval. He told how the lieutenant in charge, Luis Plaza, kept screening the area roundabout with his binoculars.

Suddenly he shouted : 'Here, Lopez! Here, Lopez!'[10] and the sergeant would quickly prop up his gun and take careful aim. 'In this manner [the reds] lost eighty men,' the churchman reported, 'three in a single burst of shots.' The rebels, taken unawares, 'went crazy, not knowing from where the shooting came.' It is hardly surprising that they began to reply in kind but despite all their efforts they could not, Sandoval exulted, 'shoot down the big tower of the cathedral nor the seven armed men who were enclosed within it.'

That the revolutionaries were able to penetrate into the church ground on at least the two occasions when great destruction ensued was due to the manner in which it was held. Since a majority of the men were used for sniper duty, the number available for defense in the expansive church was seriously reduced. They sought to strengthen their position by jamming the doors and other likely entrances. But total impenetrability was not attainable and such areas as the cloister, which was entirely separate from the church, were left comparatively free.[11] The rebels took advantage of this arrangement in their two attacks, the one on the *Sala Capitular* on October 10 and the other, a day and a half later : the dynamiting of the *Camara Santa*.

We are very much in the dark about the second action, more so even than for the burning of the stalls. What is especially obscure about it is its motivation since it took place when the uprising was already receding, the revolutionary forces breaking up, the relieving government troops at the outskirts of the city. It is pertinent to know that on October 9, when the insurrectionary situation was at its zenith, the demand had come up out of the ranks to blow up the cathedral. It was partly a furious reaction to the first bombings in Asturias by government planes,[12] which caused hundreds of civilian casualties, especially at Gijon, but even more a cumulative response to the great number of victims that continued to be claimed by the snipers hidden in the cathedral towers. Demands for retaliation suddenly became so clamorous that the Oviedo Revolutionary Committee, headed by a leading Socialist miner, Ramon Gonzales Peña, decided to call an emergency session.

The meeting is described by Manuel Grossi Mier,[13] representative of the

Alianza Obrera, the joint organization of all groups engaged in the insurrection, in his book published a few months following these events. Gonzalez Peña, he narrates (and Aurelio de Llano corroborates), made a strong plea against dynamiting the cathedral. The debate, to say the least, was passionate but in the end the demand of the rank and file fighters was turned down unanimously, the minority group of Communists included. 'The cathedral will not be blown up by means of dynamite,' Manuel Grossi recorded his relief in his journal. 'The cathedral will be respected.' It seems significant however that the Committee considered it expedient to send couriers out immediately to the ranks to explain this decision to them.

By the next day, however, the relationship of forces had greatly altered. The revolutionaries considered their situation perilous and decided to abandon the city,[14] though a considerable number of men evidently opted to stay on.[15] It was probably some of these irregulars who decided to dynamite the *Camara Santa*, albeit the direct responsibility for this act remains uncertain. It took place the morning after the main body of revolutionaries had left the city.[16]

Manuel Gomez Moreno cites a 'technical expert' who estimated that 400 kilograms of dynamite must have been used to cause the enormous damage that took place.[17] Whatever the technicalities, there can be no doubt about the hugeness of the devastation, as can be seen from Gomez Moreno's photographs. These show the *Camara Santa* and the *Antecamara*, which lay right above the Santa Leocadia crypt where the explosives were set, as being completed gutted. So too were the contiguous chapels of Covadonga and Ildefonso. Adjoining sections of the cloister and even of the transept were also greatly damaged.[18] Nevertheless a number of other nearby elements were strangely spared. The old tower at the south transept for example was 'absolutely unhurt,' Gomez Moreno related, and his exhaustive listing of destruction contains no single instance of serious ravage inside the church itself except for the sixteenth-century stained-glass windows which were 'in large part' shattered.[19]

The only other major damage to the cathedral during the 1934 uprising was at the Gothic tower, which, as a death-dealing battlement of the government force, was the target of preference for the revolutionaries. Their eagerness to smother the effectiveness of firing from this vantage point brought several attacks on it from the rebels' confiscated cannons, whose power was almost nullified, however, since their shells lacked detonators![20] Nevertheless one hit on the spire broke off one of the four elegant little corner turrets, 'which fell with a great racket,' Aurelio de Llano recalled. 'If they had continued,' he added, 'they would have brought down the spire itself.'

It seems callous to have given priority here to an index of esthetic losses in a revolutionary episode which was as sanguinary as was this Asturian upris-

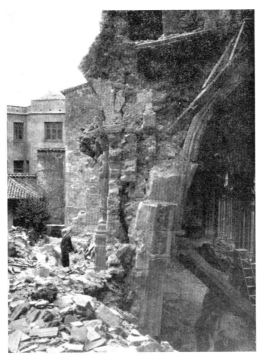

10. View near ruined *Camara Santa*, after the dynamiting on October 11, 1934. This was the second invasion of the cathedral by the revolutionaries. The upper choirstalls in the *Sala Capitular* had been burnt two days earlier.

ing of October 1934. Specialists have pointed out that the sacrifice of life here was far greater than in the Russian 'October' or in the Austrian revolt of February 1934.[21] There were at least 2,500 civilian casualties in the Asturian revolution, three-fourths of them in Oviedo, which suffered almost a thousand dead.[22] Aurelio de Llano reports that 631 bodies were buried in one single day after the fighting: 'It was horrible to see the vans loaded with cadavers passing through the streets.'[23] While a certain number of the victims were clerics[24] or other non-participants, the vast majority were civilian fighters. Military losses were close to a thousand, about one-fourth dead. As for the destruction of artistic monuments and art, it was stupendous in Oviedo during the turbulent week of October 5–12, the worst of it falling to San Salvador's lot.

Nevertheless, as we have learnt from its earlier experiences, the tragic story of San Salvador's artistic ruin was not confined to civil strife. Bishop Martinez Vigil's responsibility itself went far beyond the losses due to his destruction of the choir. Indeed iconoclasm marked a good part of his episcopacy, as Luis Menendez Pidal has shown,[25] one of his most grievous acts having been the

stripping of the epistolary side of the transept of its remarkable rose-window, 'in order to bring more light into the interior,' as the architect interprets his intention. This sixteenth-century glass, hc adds, was of 'similar composition and design' to that which was 'destroyed by the detonation of the *Camara Santa*.' Here too, then, the bishop shared roles with the rebels' dynamite.

Martinez Vigil's vandalism was always accompanied by high-sounding esthetic and religious vindications: 'to bring the church back to its pristine beauty;' 'advantages for the cult.' But these arguments were hypocritical and particularly blameworthy in the one who above all others should have dedicated himself to the preservation of the church's art treasures. The assault on the cathedral's choirstalls continued in the following decades. After their tragic losses due to the bishop's pick-axes and the rebels' incendiary torches, the guilty instruments would next be wielded by those who had once been the stalls' most solicitous custodians: the cathedral canons.

CHAPTER IV

The Lower Stalls Get 'Lost' in the Cathedral

From the deplorable condition in which we had found the stalls in the *Claustro Alto* we concluded that they must have been there for many decades. We were all the more surprised to read in Joaquin Manzanares's report of 1974 that he had seen these stalls in the Santa Barbara Chapel 'around 1960.'[1] This would mean that it was hardly more than fifteen years between the time that they had been cast into the loft and that late afternoon in November 1976 when we first saw them there in the company of Dean Demetrio Cabo.

We later decided that it must have been some years earlier than 1960 that Manzanares had actually seen the stalls in the Santa Barbara Chapel since another author had written in 1954 of their already being in the *Claustro Alto* by that date.[2] They could not have been in both places at the same time! Abandoned wood carvings could in any case deteriorate rapidly when exposed to humidity and the action of parasites.

Documentary testimony, whether positive or negative, is nonetheless often misleading. For example we found no entry in the Actas Capitulares, despite a careful search, to the effect that the upper and the lower stalls had been divided after the demolition of the central choir in 1902, the former going into the *Sala Capitular*, the latter into the Santa Barbara Chapel. Pelayo Quintero Atauri was the first writer, as far as we know, to describe this transfer, which he did in the 1907 issue of the *Boletin Español de Excursiones*.[3] Yet he gave a totally erroneous account of it, proving that he had never actually seen the displaced stalls themselves!

What Pelayo Quintero must have 'seen' was only the photograph which he published with his article, showing a double tier of seats which he described as being 'all the same.' This was technically true but the person who had sent him the photograph had neglected to tell him that *all* these seats had come

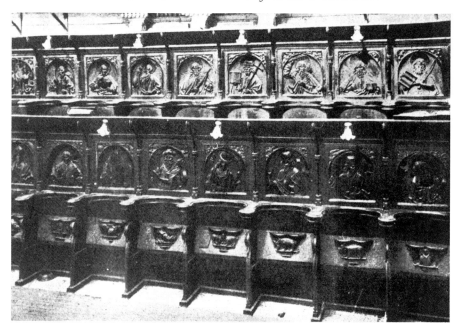

11. Oviedo Cathedral. Santa Barbara Chapel. Two tiers of lower stalls set up in the chapel after their removal from the demolished central choir. Half were elevated by being put on a platform, giving Pelayo Quintero the idea that they were upper and lower stalls from the original assembly.

from the lower register of the original set, that is, the lower stalls. These had been completely rearranged when put into the Santa Barbara Chapel in 1902. Half of them had been deposited on two elevated platforms which had been built on either side of the chamber, the other half being ranged at ground level. Pelayo Quintero decided from their positions alone that they must be the upper and the lower stalls, despite the fact that they were all exactly alike, which was rarely the case in such an assembly, as he himself should have known.

It is our belief that the confusion surrounding Pelayo Quintero's early report was largely responsible for the general impression that had got around to the effect that the October 1934 incendiary had destroyed all of Oviedo's stalls. Pelayo Quintero, we recall, had cited only a single chapel (which he did not name) as having received these stalls and even numbered them as totalling 'seventy-nine,' as though he might have counted them himself. It would have been a mighty chapel that could have housed so monumental a mass. But no one had apparently bothered to correct the author's errors. So, during the tormented days of October 1934, while half of Oviedo's stalls were gaining

a kind of pitiable notoriety in destruction, the other half by seeming to undergo the same fate fell into oblivion while remaining quietly in the Santa Barbara Chapel.

As far as we know, the Santa Barbara Chapel, which has an impressive mass when seen from the outside, was not damaged by gun or cannon fire during the October uprising. This is surprising since it lies right behind the great Gothic tower, which was several times a rebel target. It is true that firing at the Santa Barbara Chapel by rifle or machine gun would have been next to impossible with the deadly marksmen mounting guard in the adjacent towers. But cannon shot could have easily reached it, even if lacking the proper detonators!

What then had caused the chapel to be spared? When we remembered that Santa Barbara was the patron saint of miners we wondered if this could have been the reason. The men working in the pits, who practice one of the most hazardous of trades, have long had a strong devotion for their protectress. One could read recently how the devout miners of Polish Silesia had added to their demands for the five-day work-week, retirement at fifty and other major economic and social improvements the request that a statue of Santa Barbara be put into every mine.[4] As for the revolutionary Asturian miners, who in one of their songs directed a global curse at 'superintendents,' 'scabs,' 'stock-holders,' and 'fascists,' they did not evidently consider it amiss to ask their patron saint also to 'Accept this shirt, red with the blood of a comrade!'[5]

Though untouched in the October revolt, the Santa Barbara Chapel suffered heavy damage during the civil war of 1936–1938. To explain this change of fortune it will help to note that the relationship of forces was entirely altered in the latter period, with the national government now held by a left-wing coalition which was challenged by a right-wing uprising supported by a major part of the armed forces, backed by German and Italian power. Steadily increasing areas of Spain fell into the hands of the 'insurgents,' as did Oviedo very early, thus subjecting it to attack on several occasions by those now designated as 'loyalists.'

San Salvador Cathedral again played a dramatic role in these hostilities, in which the great tower, its wounds of 1934 not yet repaired, was once more a pivot of alert. Chapter Secretary Arturo de Sandoval gives an animated account of the tower's importance for

> our men, as it had been in October, an impregnable bulwark of defense.[6] On its highest platform, was established the observation post where a sergeant and two soldiers communicated telephonically with headquarters, giving reports of the movements of the enemy. The great bell, the Wamba, warned of the coming of red planes by giving an accelerated beat. . . . Such

services lent to Oviedo by the cathedral bell and tower caused the reds to let loose against her all their furies. . . .

These attacks took the form of artillery fire, and the shells, it should be said, were not lacking in fuses as they had been in 1934. No part of the cathedral, and in particular its tower, was spared. There were three major periods of shellfire experienced by the latter. One, on October 13, 1936, brought 'grave damage' to the 'stairway of access, the archivolt, the face of the big clock and a section of the spire and pyramid.' On February 13, 1937, the south facet of the tower was badly mauled and a week later over thirty cannon shots produced 'basic ravages to the physiognomy of the spire,' including the bells. Through much of May of that same year the cathedral was often hit. On October 21, 1937, the siege of Oviedo was lifted.[7]

It could have been on any of these occasions that Santa Barbara Chapel was struck. This happened most likely on February 13, 1937, however, when the concentration of fire seemed to have been on the tower's south face. Right beside it was the triple compartmentalized bulk of the chapel with its dome rising prominently at its crest. It is easy to imagine that in all the fire that had been directed at the adjacent tower, a shot or two could have gone astray and hit the chapel even if it was nominally being spared. In effect it was the dome that was struck, judging from the reports of different writers who described it as being 'demolished' or having 'collapsed.'[8] Photographs of the tower itself taken at the time show it to have been ripped and torn over its entire height and looking like a distressed giant in tattered clothing though still erect.

A photograph[9] of the interior of Santa Barbara Chapel after the shelling is of most particular interest since it shows the choirstalls very clearly. One is in fact astonished to find that the evil fortune that tracked these furnishings for three-fourths of a century had seemed to spare them any major harm on this occasion. The worst of the cupola collapse is concentrated in the chapel center. A layer of stone-dust covers everything. The sloped canopies at the top of the stalls had definitely played a protective function and seem almost to have been meant for such an emergency, justifying in this way their Spanish name of '*guardapolvo*' ('dust-protector').

This is the only photograph we have seen showing how the lower stalls had been arranged inside the chapel after their transfer in 1902.[10] They are presented end-on, appearing through a narrow door that reveals only part of the room. In the foreground are several steps leading up to the platform on which the upper row of seats had been deposited. Both levels of the stalls are of the very same make and without any doubt all stemmed from the lower section of the old choir.

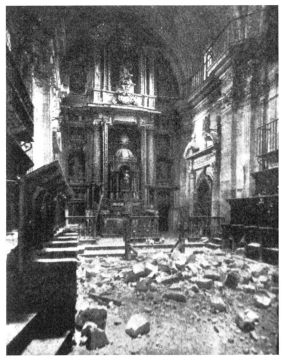

12. Oviedo Cathedral. Santa Barbara Chapel. View of debris after cave-in of cupola following bombing of 1937. Note arrangement of two tiers on both lengths of chapel. Eight seats can be counted in lower tier at left, which corresponds to the number in the Pelayo Quintero Atauri photo, Fig. 11.

All these details were of interest to us, due to the persistent mystery that continued to cover the story of these stalls. We just could not believe that these beautiful objects were willfully done away with – no one could have been that insensitive to their esthetic charm. Somehow we felt, besides, that if we could discover and record all there was to know about their unhappy fate it might serve to avoid a repetition at some future date.

Thus we were eager to learn exactly when and with what motivation that last component of the stalls was moved out of the Santa Barbara Chapel into the *Claustro Alto*. We tried the Actas Capitulares first and, failing to find the volume of these minutes covering the years of 1950 to 1960 in the archival reading room, we asked Don Raul where it might be. He made a search but without success, telling us finally that the volume must have been borrowed by an aged canon for use in his quarters and was never reclaimed at his death. It sounded strange to us that so important a document would be let out of the archives, and we could not help wondering whether its disappearance

might not have some other explanation.

A possible motive for the removal of the stalls from the Santa Barbara was supplied by a former cathedral archivist, Vicente Jose Gonzalez Garcia, who conjectured that it was to permit the repair of the chapel's damaged cupola. This idea seemed to be substantiated by another piece of information that evidently identified the place where the stalls were temporarily stored during the restoration. This was brought to our attention by a reference in the prologue (dated 1955) to the catalogue of the cathedral's parchments[11] in which the author, Santos Garcia Larraguete, described the large corridor leading to the archives as a 'depository of bits of furniture and the temporary storage-place of the beautiful grill and the *stalls that belonged to the choir....*' (our emphasis).

A letter to Professor Larraguete, now at Pamplona University, asking for a description of the stalls he had seen (Were they upper or lower stalls? Approximately how many were there?) failed, understandably, to elicit a complete recall. 'Memory fails me,' he wrote. 'All I do remember is that there was a large number of them. I would say that almost all the stalls were there.' This seeming verification of a stopover point in the stalls' tragic odyssey to the *Claustro Alto* was somewhat in conflict with the report of Luis Menendez Pidal, who in his work published in 1954[12] had already identified them as being there. However, we do not consider the minor discrepancy in dates as necessarily contradictory. Professor Larraguete might have been writing from memory of an earlier observation that was slightly inexact, the difference thus being covered by the permitted 'margin of error.'

The only question that remains unanswered is why the stalls would not have been taken directly to the *Claustro Alto* from the Santa Barbara Chapel. The most likely reason seems to have been that the original plan was indeed to bring the stalls back to the Santa Barbara, but that it was changed during the long delay in the restoration. Crammed into the corridor, they must have presented an unsightly spectacle. And so, by an impatient decision, they were transferred to the cathedral's upper purgatory of discarded furnishings and art.

Thus the lapse of time that the stalls were in the loft until November 1976 when we saw them for the first time was only slightly over twenty years. This may seem far too short a span for them to have passed into a state bordering on decay. However the corruption that can be caused by a harsh and inhospitable milieu is incalculable. The stalls of Sevilla were stored away after an accident in 1888 for a period only half as long as the one Oviedo's set experienced, yet their deterioration was probably just as serious.[13] The perennity of art is a fable that stems from the fraction that has survived. The rest, without care, is as vulnerable, as mortal, as any living objects.

CHAPTER V

Problems of the Restoration

When we arrived at Oviedo early in September 1979 the restorers had already been at work for two weeks and the experience of seeing an energetic and skilled effort being put forth on the basis of our personal directions provoked in us a strange and pleasant emotion. We had left with them our memorandum on restoration procedures as well as the choice of parts for three stalls drawn from our preliminary inventory of June 1978, on which they were working.

Their admirable handicraft seemed to define the proper limits to our contribution. What we had used for our memorandum, we realized, was derivative, whereas what Manuel Mariño and Luis Espino brought to the task were years of personal experience. And yet people who spend much time visiting repositories of art, especially churches, occasionally see restoration work being done and can learn quite a bit about it if they are inclined to watch. We ourselves had recently had this opportunity while visiting the church of Sainte Trinité at Vendôme, where a group of young sculptors were restoring the façade. They were actually pounding away with chisel and hammer on new reliefs based on the badly worn originals.

We were both fascinated and amazed by the verisimilitude of their effort. But after leaving them we were troubled by doubting thoughts. Was it proper, was it right? We recalled having seen other recarved sculpture in Europe, like the Genesis story from the lower façade of the Cathedral of Orvieto, in Italian Umbria, which we had come to love many years earlier. On our return there after a long absence, we were shocked to find much of it redone and looking cold and lifeless. Twenty-five years ago we had already been dismayed by the condition of this sculpture and could see the cause in the incessant winter downpour that had been going on for six hundred years. What was urgently needed, so we thought – and we told one of the canons as much

– was a protective glass guard to avoid total dilapidation and which would have cost a pittance. Well, they had put the glass front in, we were to discover, but when it was too late, and after the original had died they substituted a soulless replica for it.

More relevant to our present preoccupations was the recent investigation we had made about the restoration of wood carving at the *Monuments Historiques* in Paris. There we spoke at length with one of the leading technicians, who had worked specifically with choirstalls and other church furniture. He seemed to be a convinced advocate of total repair, even to the extent of filling termite holes and painting over them. We studied the dossiers of jobs on choirstalls that had been done by *Monuments* artisans at Saulieu, Charité-sur-Loire and several other churches. Most of the work consisted of the renewal of totally ruined structural elements, with which we had no quarrel.

But the case was different at the church of Moyenmoutier in the Vosges, where a fire had destroyed six of the old stalls, a fourth of the total number, whose handsome large statues had been charred beyond recognition. It had been decided to have these pieces recarved, evidently from photos, and in general to fill in what was called the 'hole' that had been left in the church's ornamental pattern. The financial accounts were included among the papers, indicating that the new sculpture had consumed at least two-thirds of the cost of the restoration, which came to about $60,000. Since most of this important sum was covered by insurance, we were told, there was no reason not to do the recarving. None but the most important reason of all, we thought.

What came out of this examination was the decision (which also had many authoritative defenders, we had learnt from our readings at the *Bibliothèque Nationale*) to bar all new sculpture in the Oviedo restoration. This, we felt, would not present a serious problem in the first phase of the work in which we expected to recover ten stalls. We had no idea of what would happen after that: whether there would be any money to continue or how many additional restorable stalls would be found. Only the complete inventory could inform us about the latter. Meanwhile what seemed to be clearly indicated was to choose ten stalls that would be easily repaired and which might turn out so striking that the problem of continuing would be simplified: that is, everybody would be enormously impressed and new funds would pour in.

Our reading of the dossiers at the *Monuments Historiques*, and especially our study of the many photographs that were supplied had taught us to make a fundamental differentiation in the stall elements. They were broadly of two kinds: esthetic and functional. It was not difficult to sort out the features that characterized each and these we entered into our memorandum.

Esthetic Elements: These include carved figures (humans, animals, mon-

sters), body members, clothes, drapery, decorative details such as foliage, floral design, scroll patterns (rinceaux), pilasters, etc. It is our firm opinion that these elements should not be touched, that no attempt be made to recarve missing parts. Nor should cracks be filled though if possible separated sections of a carving should be brought together. If any of these carved elements have been badly eaten by insects or damaged by dry rot, the scarred portions should be consolidated by a binding agent after a preliminary cleansing process.

Functional Elements: These include plain uncarved sections such as framing, back or side panels, vertical struts, horizontal planks, and the like. These sections have often been badly damaged in the Oviedo stalls by rough handling or neglect and should be thoroughly repaired or replaced if repair is too difficult. Fortunately in our stalls we have a considerable amount of good extra parts that can be substituted for mutilated sections. However when such parts are not available, new wood of similar texture and color can be used. Also larger holes should be filled with mastic and colored over.

Though this paper was prepared six months prior to our participation in the Oviedo restoration (it is dated March 10, 1979), our acquaintance with the condition of the stalls as well as the limited funds that could be anticipated for the work had already served to evolve the sole method that might cover these special circumstances. It expressed itself in the word 'substitution,' which likewise found its place in the memorandum.

Substitution of Esthetic Elements: A number of the stalls that are in fairly good condition may have a sculptured unit (misericord, handrest, side-relief), which is in very poor condition. We feel that it is entirely permissible to substitute for the mutilated carving . . . a similar one taken from another stall that is in too bad a state to be used. This can be done by simple carpentry. . . . These substitutions are allowable in the stalls since in the vast majority of cases (including Oviedo), there is no programmatic relationship between the major religious figures (at Oviedo, the above-seat reliefs of saints and prophets) and the secular carvings of the misericords, etc.

Unknown to us, this method of substitution of parts, which we were almost prepared to consider a clever device of our own invention, actually had a very wide usage. But not necessarily in art restoration! It was Colonel James A. Gray who disillusioned us about our originality when we sent our memorandum to him. The method, he told us, was often used in the Army, especially during warfare. When tanks or trucks or even guns had certain parts that were shattered, it was sometimes possible to repair them by lifting those

elements from other outfits. 'Only we didn't give it any fancy name,' Jim said. 'We called it *cannibalism*.'

What has been said about the lack of a unified program in the iconography of choirstalls had been verified by us from the study of literally thousands of individual stalls in half a dozen countries. We shall examine this question more fully when comparing the Oviedo stalls with the other Gothic sets in Part Two of this book. It is sufficient for the moment to observe that the basic reason for this absence of ideational pattern was the disinclination or even inability of the original churchmen-iconographers to establish a tie between the vast number of profane themes in the misericords, handrests and side-reliefs with the major religious sculptures with which the clerics were basically concerned. The result was therefore for them to abandon almost completely the secular subjects to the artists.

We have explained in a previous book on the misericords of France[1] how these secular carvings had come to assume an almost independent creativity in the hands of the sculptors. This did not preclude the occasional introduction of some religious subjects into the mass of worldly themes. In modern times the seeming incongruity of so preponderant a secular art in the very heart of the church has led some authors to deny such attributions and to seek out moralistic interpretations for these works. But in the Oviedo restoration we have assumed the correctness of what has been taken for granted by most contemporary authors, that the separate carvings of a stall have no thematic inter-relationship except in isolated and usually easily recognizable cases.

Nevertheless, wherever we knew what the initial arrangement of a particular stall might have been, we kept it, the condition of the parts permitting. A fortunate opportunity of this kind was obtained through studying the photograph in Pelayo Quintero's early article (See Fig. 11), which afforded the recognition in eight stalls of their large above-seat reliefs and the misericords that went with them. In the restoration, all of these pairings were maintained. Unfortunately the misericords of the nine other stalls that can be seen behind and above the eight front seats are blocked off by their canopies in the photograph and must therefore remain forever unknown, by this method at least.

As for the restorers, the substitution method served them well and actually facilitated their task. Clearly, if the use of replacement components had not been allowed, it would very much have complicated and prolonged their work. In the same way the ban on new sculpture was also welcome to them though it did eventually raise a few questions that affronted their professional pride and brought on big discussions between us. They were, however, artisans and not sculptors and must have known from their preliminary examination of the remnants in the upper loft and their talks with us that they would not be faced by tasks that were beyond their competence. They had, accordingly,

simply separated off the parts that we had designated for the first three stalls
and had proceeded to disinfect, clean and repair them in anticipation of their
final reassemblage.[2]

It was exciting to watch them work. They were very competent and full
of eagerness and good will. Yet we had been forewarned by our perusal of
the *Monuments Historiques* documents and our talks with the restorers there
that high proficiency might not rule out what we considered an incorrect
approach. Our responsibility for the Oviedo stalls weighed upon us insistently,
the more so because of our newness in this work, which exposed us, we knew,
to error. The result was a kind of stubbornness on our parts that must have
at times proved very trying to these amiable men.

One of the things that disquieted us was the vigorous way they scrubbed
the wood surface after it had been submerged in the ammoniac fluid. It worried
us particularly that the sculpture came out totally colorless. Did that not mean
that the patina was destroyed in the process? They replied that the colouring
we saw on the stalls was no longer patina. That had been completely obliterated
during the nineteenth century by the constant use of a paint called Nogalina
which was derived from walnut leaves. They had seen it all the time on antique
furniture. There was nothing you could do about it now, they argued, but
once this ugly smear had been removed and the wood was covered with
beeswax, its true beauty would emerge. We had no reply to this seemingly
reasonable explanation.

Yet in certain respects the restorers' association with 'commercial' restor-
ation was a handicap from our point of view. When we told them that we
were opposed to filling in termite holes unless it was necessary to consolidate
parts that had become soft and porous, they admitted that most clients of
antique dealers insisted on eliminating these holes. On the other hand, they
said, others who felt that a piece of 'antique' furniture looked too new would
ask to have some holes drilled into the surface to give the impression of age!
Inevitably they had acquired a tendency to prettify things. They kept coming
back to the question of whether they should not finish off missing finger-joints,
repair chipped noses, smooth over eaten beards.

We were assailed by self-reproach now and then as time went on and we
could see the result of their talent and hard work which brought life and beauty
back to the decrepit stalls. Our attitude began to soften. Our consent to the
repair of a two or three-inch cavity in the flat 'uncarved' surface of an above-
seat bust was readily given but it was much more difficult to decide what
to do about the void at shoulder height in St Blase's bust, $2\frac{1}{2}$ inches wide
and $5\frac{1}{2}$ high. Actually it did not take in any major feature, only a small section
of his halo and of the decorative trim of the saint's stole.

Luis Espino, who had a flare for carving, made a drawing of the section,

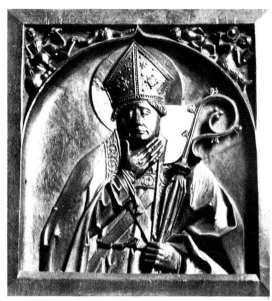

13. Oviedo. *Problems of Restoration*: To repair or not repair? Involved was the rather large gap at right of St Blase's head. Restoration required recarving part of the decorated collar.

filling in the missing part by extending the pretty design from the still existing portion beneath the gap. We hesitated for several days before making up our minds while thinking that the preferable course might be to provide a plain flat insertion that would indicate the missing area. But in the end we concluded that the disguise was really too minor to constitute a breach of trust, whereas the correction would really improve the appearance of the relief. Thus does transgression grow by feeding on itself.

No matter how elegant the work of the restorers was, there remained one blemish that ruined the overall impression. This was the bottom of the stalls which presented a continuous worn and jagged edge (See Introduction, Fig. 3). They suggested a footing that would cover the ruined part. We considered at first a flat thin lath which would seem the least objectionable. But its very plainness somehow rendered it more obtrusive than the quite simple molding that the restorers drew for us. It was only the toe that jutted out from the front of the strut that we objected to: it seemed so alien to the rest. Finally we suggested that they copy the socle of the small pilaster that framed each side-relief at the front. Whether it was more or less handsome than their drawings was beside the point to us. Its authentic source rendered it more acceptable.

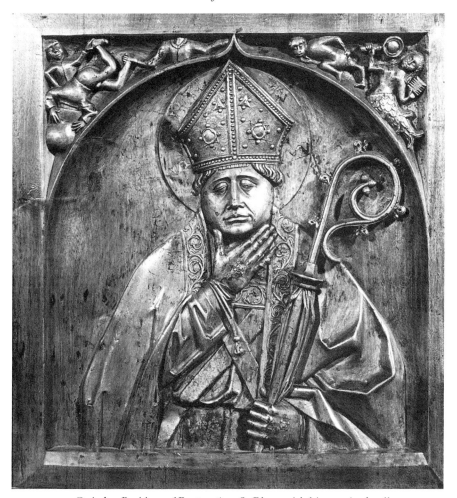

14. Oviedo. *Problems of Restoration:* St Blase with his repaired collar.

These seemingly insignificant details were taken very seriously by all concerned and by the two of us primarily. We never thought of ourselves as having a special authority, though the restorers must have done so, we realized, particularly whenever we found a clear reluctance in them to concede some point on which we insisted. When they gave in, their amiability would seem excessive since we wanted to feel that it was through being convinced by our reasoning. Therefore we made every effort to reduce the number of confrontations, granting them priority in almost all technical matters. Unquestionably the fact that our conversation took place in a language of which we still had a limited command added to the difficulty of our intercourse.

Now and then the problem of language as it concerned them more particularly struck us quite acutely when we realized that the vocabulary they were using, though Spanish, might be new and unfamiliar to them. An amusing but meaningful instance occurred when we were discussing the choice of canopies that fitted onto the top of the stalls. We had earlier emphasized that they should be alternated between those with an abstract pattern and those with a background of mixed foliar, human and animal elements. On this occasion we were laying out with them the first group of five canopies in the loft and pointed out the sequence to be followed.

'But that would be wrong,' Manuel Mariño objected to one pairing. 'You said that we should use one *baldaquino* that is Gothic and then one that is Renaissance. But here you've got two Renaissance pieces together.'

He was right but his use of the words '*gotico*' and '*renacimiento*' to make the distinction seemed to call for a clarification. Did he think, we asked, that there was so fundamental a difference in the styles of the two types of reliefs? Yes, he nodded. But how could that be, we said, since they were all made at the same time and by the same artist or artists? Did that mean that they were all Gothic? he asked. Yes, we replied, late Gothic.

Manuel seemed rather troubled or maybe even unconvinced. Yet when we thought about the matter afterwards we realized that in his apparent confusion he had actually come closer to the truth than we had suspected. For he had seen with his eyes and not by scholarly rote. The 'confusion' consisted partly in the fact that the art of the canopies, as also of much of the rest of the stalls, was *transitional* and bore elements of both of these great historic styles.

Piecing the New Choir Together

In the daily division of our work, one of us and sometimes both arranged to spend an hour or more at the atelier. It was by no means a question of supervisory control: mutual understanding and respect quickly became the token of our relationship with the restorers. The constant emergence of new problems, however, benefited by quick solutions. And as another phase of our work got underway – the complete inventory of every carving in the loft, its condition and possible or eventual assignment – Manuel and Luis would accompany us upstairs from time to time to help decide questions of reparability, necessary substitutions and the like.

There were also other facets of our activity that had to be thought of and which would soon require more time than the rest, such matters as the work in the cathedral archives especially, as well as the systematic search of printed historic sources at the university and municipal libraries, both of which were a few minutes' walk from the cathedral. But the inventory of necessity took precedence, since the work of the restorers depended on it. They needed to know how many stalls would be assigned to the first assemblage (for they were made to fit together and not stand alone) and which ones they would be. Since ten thousand dollars had been made available by the International Fund for Monuments, the number of stalls that could be done according to the restorers' estimate was exactly ten. But they had to be certain ones. The choice was in our hands.

In deference to the unknown fifteenth-century churchmen who had conceived their iconographic pattern, we identified the stalls according to their above-seat busts of apostles and saints, prophets and patriarchs. There were in all thirty-five of these, ten or twelve of which were immediately eliminated as being beyond repair. For the rest it was not simply a question of picking

15. Oviedo Cathedral. Inventorizing the abandoned stall parts in the *Claustro Alto*, recording their condition and possible use. The Above-Seat Canopies.

out the ten carvings that were the best preserved. We were anxious, too, that there should be a rationale of relationship among them, such as had certainly existed in their original arrangement. As near as possible we wanted to approximate this disposition of the seats.

It was the first question that we considered in our readings. We went through all the pertinent works that we could find at both libraries that had been published before the old choir had been destroyed. Since this in the main fell into the period before book-photography, it was illustrative engravings that we sought, in old art histories of the city and the region, histories of the cathedral especially, travel books, early guides, encyclopedias, collections of drawings. The search was limited by the great losses caused during the civil disturbances of the 1930s, particularly at the university library which had been completely gutted in October 1934.[1] Aurelio de Llano reports that as the miners were abandoning Oviedo, they set fuses at a number of important buildings, including the university.[2]

Not one of the authors we consulted had described or offered illustrations of the exact distribution of the lower stalls in the old choir. Not even Ciriaco Miguel Vigil,[3] from whose two-volume work on the cathedral had come much other important information about its vanished art, had thought of naming the figures represented in their above-seat reliefs and of placing them in sequence. One author, Ceruelo de Velasco,[4] alluded to the fact that the 'middle' seat was assigned to the '*presidente*,' the title that even today is given to Spanish deans. But he did not identify that seat in any way or establish its exact position. On the other hand, what was amazing in these early writers, of whom there

were quite a number who had commented on the stalls, was the universal admiration that they expressed for them. This indicated to us how distant Bishop Martinez Vigil had been from the local tradition, which was probably an added element in the bitter conflict that this 'outsider' was to engage in with his chapter.

Among the books we explored was Clarin's great novel, *La Regenta*,[5] which had appeared in 1885 and one of whose leading characters was a cathedral dignitary. We did find a number of descriptions in it of the church interior, but the few references to the choir were disappointing. This included one scene of a sermon where the faithful were described as being grouped around the raised pulpit at the choir grill while the canons were said to have used the opportunity to retire into the privacy afforded by their (upper) stalls to take a little nap. But that was as far as it went.

Closer to the vanished reality were the two engravings already cited, by Parcerisa, in Jose-Maria Quadrado's *Recuerdos y bellezas de España*,[6] first published in 1855, and a painting by a well-known nineteenth-century artist, Uria Uria, which Magistral Emilio Olavarri remembered having seen reproduced somewhere. We were able to trace the painting to the home of the artist's aged son. It was small, and pictured in bright colors some kind of procession that was taking place near the former choir's eastern grill. Though it had actually been painted from the interior of the choir, the view was facing outward and revealed not even a tiny corner of the stalls.

Other inquiries were no more fruitful. Curiously the only solid idea we ever obtained about the original arrangement of the lower stalls was neither from a written description nor an illustration but merely a deduction that was drawn from our inventory. We had continued with this task by priority and the first group that we completed was that of the above-seat reliefs of Old and New Testament figures. There was little trouble in naming them properly since the Gothic letters that spelled them out in archaic orthography on halos or banderoles were for the most part easily legible.

We made up two lists, one of the Christian, the other of the Jewish personages. The former counted eleven apostles, excluding Andrew and including the two Matthews (the second having been chosen to take Judas's place), then Mary and Gabriel of the Annunciation, each in a separate relief, St Catherine, St Barbara, St Blase and St Stephen. The Jewish busts were of Moses, David, Solomon, Samuel, Ruth, Esdras, and the rest of prophets: Isaiah, Daniel, Jeremiah, Ezekiel, Hosea, Micah, Amos, Malachi, Joel, Zechariah and Sophonias. There was, finally, one relief that could be deemed of divided appurtenance, the Church-and-Synagogue.

On counting the two groups we were startled to find seventeen figures in each of them. We knew that this exact partition could only have been planned.

In other sets of the kind that we had seen, including those in Spain, whenever there were such busts in the lower stalls they were almost always exclusively Old Testament figures. The Christian characters were given precedence, as at Leon, Zamora and Astorga, by being put into the higher stalls and carved in full stature. When there were no lower reliefs however, which was often the case, a few important Old Testament personages might be admitted into the upper stalls.

At Oviedo, where there were no upper-stall figures, the opposite arrangement had been made. The Christian luminaries had been brought down into the lower field where they shared places with the Jewish notables and it was a most remarkable feature of this distribution that the apportionment should be exactly equal. Whatever was the original theological or programmatic rationale for this, we could suddenly see it looming out as a shining architectural feature within the darkness of the vanished choir. The Old and New Testament stalls had in all likelihood been divided off uniformly on the two sides, adding up to seventeen at the south and seventeen at the north!

Immediately the way that we ought to arrange the stalls occurred to us: they must follow what had almost certainly been the original distribution. Even if only a partial number of the lower stalls could now be saved, which would of course be the case, they should be so chosen as to make this kind of an arrangement possible. For ten, there should be five figures of the New Testament and five of the Old. And so on, as the number of restored stalls increased.

We could now make our first choices. The restorers would start by doing five stalls presided over by Christian figures. And for the second batch there would be five Old Testament selections. The important thing to decide was exactly which ones among the two groups should be chosen for these first sets of five. Since we were by no means certain that there would be any more than these done, we wanted to make sure that they would include all of the important personalities that were available.

It was a pity, we felt, that because of their poor condition several outstanding carvings could not be used for the first set, which we wanted to be particularly impressive. It was certain, for example, that the two Annunciation reliefs must have had a conspicuous position in the original arrangement where they would have brought a dramatic tension into a rather static assembly. But both were in a woeful condition, the entire middle section of Mary beneath the head having been eaten away while the Archangel Gabriel's state was no better.

Available nonetheless, fortunately, were St Peter and St James, who had every ecclesiastic sanction to be selected, one being the head of the universal church, the other the patron saint of Spain. As sculptured, both were strong, individualized figures. To them we joined St Martin, St Matthew the Evangel-

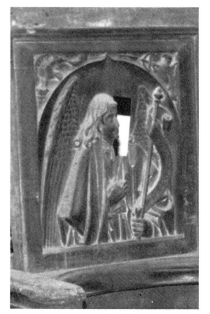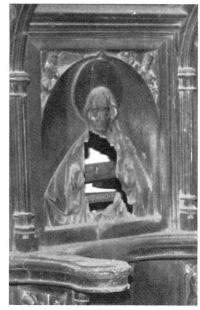

16. Above-seat reliefs of Gabriel and Mary

ist, and St Blase, who was a highly popular figure in Spanish hagiography.

The choice was both easier and more uniformly prestigious among the Old Testament personalities, since their conservation was for some reason or other much better than that of the Christian apostles and saints. The first five were almost automatically determined: Moses, David, Solomon, and two of the major prophets, Isaiah and Jeremiah, all requiring only minor repairs. Our first ten selections were no sooner provided for when all at once the relief of Church-and-Synagogue drew our attention. Where, we wondered, would *its* proper place be?

We thought about this question for some time without finding a satisfactory answer until one day Manuel and Luis told us that this double-relief was very wide, at least four inches wider than any of the others. This would have constituted a problem of fitting it into any sequence by the original arrangers, but it might also have meant that the stall was from the beginning intended for a special use. As that of the *presidente*, perhaps? Recalling that Ceruelo de Velasco had described this dignitary's seat in 1872 as being 'in the middle' of the thirty-five lower stalls,[7] we realized that what this must have meant was that the dean's chair had been established at the deep center of the stalls on ground level, just beneath the bishop's throne! And thus another element was added to our recreated image of the choir.

Discovery of this apparently authentic arrangement translated itself into the

decision to set Church-and-Synagogue off by itself at the center of the two equal restored groups of Old Testament and New Testament figures. Because of its prominent position we felt it must be esthetically outstanding as well. For this purpose our steadily progressing inventory furnished two elements of glowing distinction. While marking off all the section dividers we had come upon a few with one entire face carved in striking Gothic patterns while the obverse side was devoid of any sculpture. They were doubtless terminals that

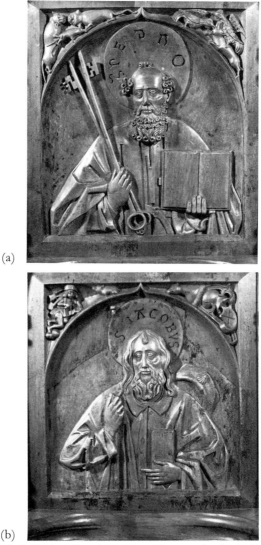

(a)

(b)

17. Oviedo Cathedral Choirstalls: (a) St Peter (Restored). (b) St James, patron saint of Spain. (Restored)

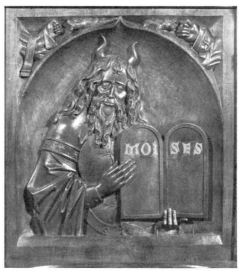

18. Oviedo Cathedral Choirstalls: Above-seat relief of Moses. (Restored)

had been used to set off groups of seats at some stairway or other break. Most were terribly eaten but there were exactly two that were in an almost perfect state, one carved on the left side, the other on the right. They would make an excellent frame for Church-and-Synagogue.

Our inventory had other pleasant surprises, the most important being that there were enough fairly well-preserved parts for at least twenty stalls. Besides the basic seat forms of which we counted twenty-six, there were twenty-four reparable above-seat reliefs, twenty-seven usable canopies and as high as forty between-seat dividers or struts. The last category was rather difficult to count since it contained a sculptured side-relief and a handrest on each face and the poor condition of any of these four carvings might condemn the use of the entire member unless a deft substitution were possible. At any event their supply for the first ten or even twenty stalls was adequate.

The same was true of the misericords. Their inventory, moreover, was particularly rich in revelations. We had expected at best to find thirty-five of them, the same as the above-seat busts, one for each of the lower stalls. We discovered no less than thirty-nine in various areas of the loft. Some were still attached to their seats but since the above-seat figures had all been removed we could make no tie-up between the two categories. Some of the detached misericords were in a deplorable state and unusable. But the large number that we had to start with – thirty-nine – left a sufficiency for our purposes.

Thirty-nine? Where had the four extra misericords come from? From the

61

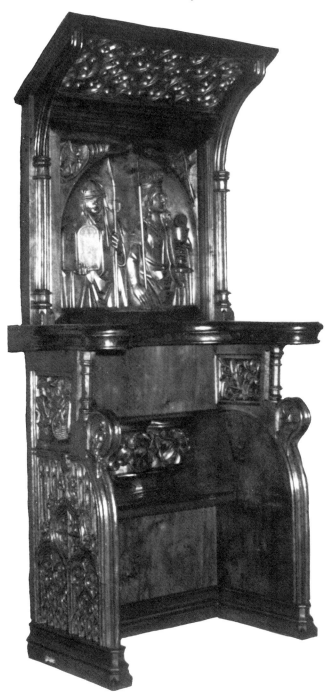

19. Oviedo Cathedral Choirstalls: Restored stall of 'Church and Synagogue'.

20. Oviedo Cathedral Choirstalls. Misericord of two fantastic creatures in attitude of combat. The carving, photographed in 1972, has disappeared.

upper stalls, clearly, three of which Luis Menendez Pidal had seen in the loft as far back as 1954. And we discovered still others. One day, as one of us was checking the conglomerate of abandoned art objects strewn all over the cloister walks, a misericord showed up that must have been there for many years. It was in so crumbling a state that the original subject was uncertain. And a few weeks later, while reading Isabel Mateo Gomez's remarkable recently published work, *Temas profanos en la scultura gotica española*,[8] we were amazed to find reproduced in it a misericord from Oviedo that we had never seen. The reason, as it turned out, was that it had disappeared. The author noted that it had been photographed for her by a colleague from the University of Oviedo, German Ramallo. This had been done around 1972, the young professor told us.

The six extra misericords thus accounted for had, then, come from the upper stalls that had survived the fire of October 10, 1934.[9] They had survived because they had never been in the *Sala Capitular* which had been too crowded to contain them. Besides Menendez Pidal, other authors had mentioned seeing some of these upper stalls, a few here, one or two there. The editor of a book published in 1929 specified that there were in the Santa Barbara Chapel at that time, aside from the lower stalls, three upper stalls,[10] and he had noticed others in the Covadonga Chapel, which had probably disappeared at the dynamiting of the *Camara Santa*. All those that survived eventually found their way to the upper loft.

We had very soon realized that there were remnants of the upper stalls in the loft. Quite early we did a partial inventory of these elements and later a more complete one. In composition the upper stalls were exactly the same

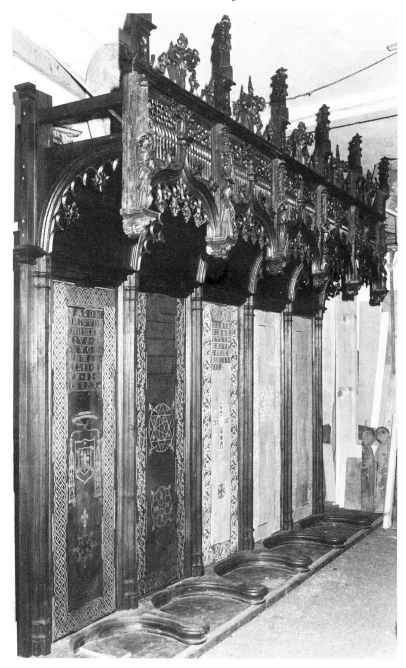

21. Oviedo Cathedral. Five of eleven upper-stall panels found in *Claustro Alto*. Note the panel at the left with the central blazon of a bishop's hat.
(Photograph taken after restoration)

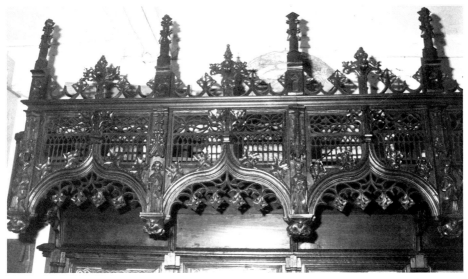

22. Oviedo Cathedral Choirstalls. Detail of Upper-stall Crest. (Restored)

as the lower ones up to the level of the seat arms. Then, instead of the carved above-seat busts and canopies, there were great panels almost two meters high decorated in marquetry. Very surprising was the discovery that there were eleven of these panels in the loft. Could there have been that many upper stalls that had been spared from the flames? It was hard to believe, yet it was clearly important to verify that possibility.

At the top of each panel was a quoted intarsia inscription from Old and New Testament characters and in the field below were emblematic configurations. The remaining inscribed citations[11] were from Judith, Abraham, Zechariah, Jeremiah, Solomon, Isaac, David, Moses and Isaiah, as well as from two apostles, Thadeus and Simon. In the center of five of the eleven panels were coats-of-arms, actually all the same. They showed a bishop's hat with tassels, between which was a shield ranged with a great fleur-de-lis – *veranas* – and stars. Five out of eleven: it was a preponderant proportion that should settle the question of the donorship of the stalls once and for all. For this was known to be the blazon of Bishop Juan Arias de Villar![12]

At the summit of the upper stalls had been an overhanging crest with a lovely facing pattern of slim open-work lancets and lozenges that rested on a flamboyant inverted arc. Typical Gothic finials bordered the upper line of the frontal facets, which were divided off from each other by pillarets with small but identifiable carvings of apostles and prophets who stood on socles, on the lower surfaces of which were music-making angels. Lying on the loft

floor were a couple of still-joined assemblages of these crests, lacking small parts here and there, that had belonged to three and four stalls respectively. And there were in the heaps of remnants additional halves and quarters of the crest. It was beyond doubt that though some small bits and pieces had disappeared from the jigsaw, the *Claustro Alto* might well have once housed eleven complete upper stalls which had by a series of lucky chances escaped the conflagration of October 10, 1934.

From all these disparate elements, the restorers would, when the time came, put together a crown for Oviedo Cathedral's recreated stalls.

CHAPTER VII

A Museum of Four Hundred Carvings

Though Oviedo Cathedral has lost more than half its stalls, those that survive still possess an extraordinarily rich iconography. It is like a vast museum, wonderfully varied in scope, fascinating in conception and often brilliantly adept in execution. There were, we know, a number of artists who participated in making these stalls, which are, consequently, marked by differences in skill as well as style, each category of the sculpture revealing the work of several hands.

Among the outstanding carvings are the sloped canopies that offer a symbolic protection to the religious busts beneath them. The art of these *baldaquinos* is the finest of its kind that we have seen in Spain, characterized by whorled abstract patterns or swarming mysterious universes with mixed human, animal and foliar elements. The ornamental feature is emphasized, but here and there

23. Oviedo Cathedral. Above-seat Canopy: Mortal combat in agitated foliar pattern.

action vignettes are isolated within the larger design that are as alive and sharply sculpted as one will find anywhere in the stalls. One wonders that artists practicing the decorative specialty should possess this high standard of figurative expression.

Yet it is by no means unknown that more than one artist should have worked on a single piece. In painting this is quite common and it is not too rare in sculpture either. It is difficult to assume, for instance, that the same men that did the remarkable, deeply serious bust-reliefs of apostles and patriarchs also carved their frivolous upper-corner spandrels. The proof of duality of effort seems to lie especially in the divergence in technical aptitude: universally superb in the large 'portraits' and often quite primitive in the small triangular diableries. A number of the latter, however, are done with such verve and skill that they could easily have come from a master's hand.

On first view there is a great solemnity in all the busts that masks individuation. It is a trait of unmistakeably Flemish inspiration, which yields personality only to more careful examination. Obvious details of differentiation are avoided. There is not the slightest distinction, for example, between Christian and Jewish characters in the treatment of their hair, beard, headdress, eyes, nose, lips, or raiment, the latter being the anachronous garb of the prosperous Flemish bourgeois class of that period. And why indeed should there be any difference in those portrayed? They were almost all Jews and those of the Old Testament were bound to Christ or Mary by strong exegetic ties.

Little effort is made to link these men and women psychologically to their reverberant roles. There are a few apparent exceptions such as St James, whose deep spirituality is heightened by the emaciated face and pale eyes of the risen dead while the cruel travails of Moses with his stiffnecked people are reflected in his tragic features. The rest are kindly sad or sadly kind in token seemingly of their past (and present) efforts to bring mankind to an elusive salvation. St John's young face is heavy with his memories; the Annunciation to Mary (a plebian woman who reminds one of Caravaggio's moving painting of the Death of the Virgin) whose impending role in the incarnation overwhelms her with a sense of inadequacy and foreboding.

One wonders consequently why the double portrait of Church and Synagogue should have been depicted as so outspoken a contrast. Undoubtedly the artist felt that the theological antinomy demanded such a sharp differentiation. Aside from the well-known attributes that each carries (Synagogue, the tablets of the 'Old Law,' the broken staff and the bound eyes in token of the Jews' refusal of Christian revelation; Church, the eucharistic chalice, the triumphant cross, the crown signifying world hegemony), the two women could hardly be more antithetic in characterization. Synagogue is old and shrunken, pinched in features, thin of body, wearing the hood, cape and loose weeds

of an aged and decrepit woman. Church is young, beautiful, erect, sharp-eyed, strong-featured and full-breasted, her splendid garments tightly fitting her strong youthful body like a coat of mail.

While of unequal quality, the misericords include a number of highly attractive subjects which testify to the participation of one or two first-rate talents. Enchanting is the carving of St Francis who is shown kneeling, his palms joined as though in prayer, addressing a bird. The great lion with commanding presence was, contrary to the boast of Villard de Honnecourt, surely 'done from life.'[1] But there are other pieces that do not come up to these standards. There are monsters that engender humor rather than fright, animals with amorphous bodies, humans ineptly done. The carving of Aristotle and Campaspe (or Phyllis), for example, completely misses the point of the legend by its poor execution. Aristotle's body lies stiffly extended like a log and the beautiful courtesan for whose favors he has agreed to submit to this incredible indignity turns out to be an ugly harridan like those scolding wives often portrayed in misogynous stall carvings shown administering a paddling to their cowed husbands. Portrayals of this subject are usually more believable, making the point that even the greatest of thinkers could fall victim to a lovely woman's wiles.

The numerous small side-reliefs and handrests are the richest of all categories in their diversity of subject matter. But they are also the most poorly made,

24. Oviedo Cathedral Misericord. St Francis, speaking to a bird.

69

indicating that they were done by young artists or apprentices or joiners who had little practice in the sculptor's craft. At times the 'idea' is so original that it seems to have been copied from a drawing or another carving, often with solecisms in the detail. A certain number, however, are carved with perfect skill and charm, regardless of the subject, showing that great art need not be 'great' in content to be remarkable. Such are the angel leaning on his harp; the frolicking pigs; the hamadryad; the fool administering an enema; and a number of others.

The thing that strikes one most forcefully about Oviedo's iconography is its overwhelmingly secular content. But this is the common trait of all Gothic stall art in Spain and in every other European country, and, since most of it was done prior to the Reformation, it must be regarded as having been tolerated by the Catholic Church. It is our opinion that the reason was not because this art, though ostensibly secular, actually pointed homiletic messages that made it palatable to the clerics. Rather, we feel, it was because churchmen of that time were more receptive to the totality of man's experience on earth and more broadminded about it when described in art or literature than they have been in various periods since.

In this respect these carvings are like the mischievous art that one finds in the margins of old religious manuscripts. Thus the spandrel, showing a monkey exposing its anus to a siren, appears just a few inches above St Blase's

25. Oviedo Cathedral. Detail of bust of St Blase, showing a spandrel of a monkey exposing its anus to a siren, just inches above the saint's head.

head. It is hard to imagine from this carved metaphor what sermon the saint might be supposed to be preaching. The secular topics of the choirstalls are far from being uniformly obscene. Moreover, their scope covers a vast expanse of medieval life and fantasy.

It was in the nineteenth century, when the great surge of interest in medieval art took place, that some prominent authors began to propagate the notion of an exclusive moralistic meaning in works done for churches. This interpretation reached a high point in the writings of Emile Mâle and was exemplified in a ludicrous manner in regard to stall sculpture itself by the Belgian scholar, Louis Maeterlinck, who saw 'satires' in all profane subjects. More recent authors have rejected this anachronistic type of thinking. H. W. Janson sums up very well their viewpoint:

> We have come to realize increasingly that medieval painters and sculptors . . . did not simply carry out the commands of the clergy; that they enjoyed in fact considerable freedom in exercising their own imagination, so that their work must be regarded as complementary to the literary sources in expressing the thoughts and emotions of the era. . . .[2]

At Oviedo, of the 408 subjects that were counted in our inventory, 72 were religious and 336 non-religious.[3] The first group embraces mainly Old and New Testament figures and what we call para-religious themes: angels, devils, priests, monks and nuns, Christian symbols and acts. There are in addition a smaller number of subjects that have an undeniably moralistic or religio-symbolic meaning. As for the secular topics, a surprising number, almost half of the total (198), appear in the 'natural animal' group, the ten leading occurrences being: birds (26); dogs (23); foxes (18); lions (17); pigs (12); deer (10); cranes (9); roosters (8); eagles (7); sheep, goats and wolves (5 each).[4]

Contrary to the view of some Spanish authors, particularly clerics, we do not consider these animals as having an unfailing theological meaning, as though they constituted a bestiary of purely symbolic reference, which centuries earlier had been excogitated by cloistered mentalities which interpreted them as representing good or evil, most often the latter and sometimes both! We assume, rather, that they were seen by the artists as familiar beings of everyday life with simple, useful and often lovable traits. A number of them occur in story form as an outflow of the millenial tendency of man to spin fantasies about the creatures that nature presented to him and with which he had long since become intimate, whether at home or in the encroaching forest.

There are a certain number of the animals which do live a double life, however. But the alternative role is not necessarily theological. There are twenty-six lions or eagles or other animals (as well as unicorns) that are heraldic, for

example, reflecting seigniorial attributes of the time. And there are various others that display human foibles (not necessarily sinful ones!) in legends and fables, as they have been doing from far back in pre-Christian epochs. The fable of the fox inviting the crane to dinner and vice versa was already told by Aesop and has long since come to have a proverbial meaning: 'Do unto others as you would have them do unto you.' It occurs six times at Oviedo.

Oddly the fox is shown getting the better of it on four of these occasions. This happens also in the well-known *fabliau* showing a fox, disguised as a monk, preaching to chickens, geese, ducks or other foolish fowl, while one of their number is already trapped inside his cowl. The warning against false doctrine is an obvious interpretation, but the fourteenth-century *fabliau* often played it from a class angle, the fox designating the thieving seignior and his victims the poor peasants or serfs. Reflecting a similar viewpoint, the stall art of Oviedo has two striking scenes where the fox is punished for his crimes, one of which is a side-relief showing him being hanged by birds. It is significant that this same subject can be seen on a fourteenth-century capital in the cathedral cloister.

The other scene, in a canopy, is among the most remarkable of all the secular carvings at San Salvador Cathedral. Against a background of twisting foliage, a great rotisserie has been mounted between the branches of two trees into which the fox is skewered. One rooster turns the spit; a second tends the fire; and a third, straddling the fox's rotating body, pecks at his flesh to see how the barbecue is progressing. Isabel Mateo Gomez refers to this kind of scene of ardently imagined revenge as the 'dream world' (it has also been called

26. Oviedo Cathedral Canopy Relief. Turnabout World: Chickens barbecue a fox.

the 'turnabout' or 'upsidedown world'), which is doubly apposite in this demonstration. For, behind the spit-turning rooster at the left, a second fox has appeared which makes a gnashing snatch at his tail. Startled, the rooster veers around to look: his dream is ended.

While preponderantly profane, the iconography in Oviedo's misericords, handrests and side-reliefs does, as we have said, shift occasionally to subjects with religious connotation. There is a beautiful misericord depicting the Lamb of God bearing a flagellum, a reference both to Christ's scourging and to the then current practice of self-mortification. Two references to Jews have an anti-Semitic accent. In one the blind 'Jewish' owl is attacked by 'Christian' birds[5] (which we have also seen in French and English pieces). And very anomalous is the interpretation in a side-relief of the return from the Holy Land of the two scouts sent out by Moses.

Early Christian glosses have read this scene as a figuration of Christ on the cross, the mystic grape-cluster that the two scouts carry symbolizing the blood of the Holy Grail.[6] The scout in the front was sometimes seen as the Jew, 'who turned his back on Christ,' while the one at the rear was the Gentile who accepted him. On first sight one would think that the artist's rendering in the present piece was erroneous, since he placed the pointed cap (a Jewish symbol) on the man at the back who faced the grape cluster and should therefore represent the Gentile. We suggest however that the 'mistake' was intentional since the cleric-iconographer who had worked out the scene had evidently wanted to identify the Jew with the crow (a Jewish-diabolic symbol), which can be seen swooping down to peck at the 'body' of Christ!

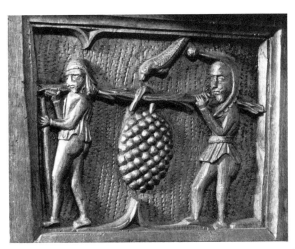

27. Oviedo Cathedral Side Relief. Moses's envoys bring a giant grape-cluster back from the Holy Land. Deliberate misinterpretation with anti-Jewish accent.

Fools appear rather frequently in the carvings, usually in scenes of pure fun, like those describing the Festival of Fools, so popular in the art of the northern countries. At Oviedo one fool can be seen dancing to a monkey's bagpiping and a second offering a clyster (enema) to another man. This hygienic treatment, much-esteemed in medieval times, was commonly performed by an apothecary but is here given a frolicsome note. Even the wily fox assumes a lighter touch on occasion, being shown playing his devious game from a wicker pulpit, where disguised as a priest he performs for ecstatic birds – on a bagpipe![7] But this ever-amazing animal returns to type in another piece, where his entire family engages in a kind of black mass inspired by an heretical text, whose 'dada' litany adds to the scene's bitter ironical commentary.

So the dichotomy of interpretation passes freely from religious to profane meaning and back again in these carvings. There is, on the other hand, no double sense in the work scenes, of which there are seven or eight at Oviedo: two of shepherds with their flocks; peasants trimming a vine; a man with a cow; another with a pig; still another with a donkey; a man pulling a loaded cart. But with three carvings of clerics we are back to 'religious' topics. All, however, are pejorative comments about monks, which is quite the usual thing in the art of secular churches.

One of the friars is seen illustrating the Flemish foolish-act proverb: 'He tries to open his mouth as wide as a furnace.' A second is shown at a table set with food and drink, which might be seen as a reference to the hypocrisy of the mendicants who put on a front of poverty and abstinence while secretly living the life of gluttons. The third carving, in a spandrel, places a monk in a virulent setting, that of a homosexual act. Even so, these scenes do not compare in total malicious impact with the attacks for various types of depravity, chiefly sexual, to which monks are subjected in the stalls of several other Spanish churches, as will be seen in Part Two of this book.

In fact sex plays a relatively minor role altogether in Oviedo's stall art, even in secular pieces where it could have a broad moralistic application. An example of this is the handrest of a naked man who is masturbating, and there are five sirens, to one of which a monkey is exposing its anus, as cited earlier, while the others are quite 'innocent.'[8] A pair of related spandrels are, on the other hand, frankly erotic, presenting a naked woman and man, both posing suggestively and making sexual gestures. In the side-relief of a young man and an older woman playing dice, the latter wears the headdress of a prostitute. And the display of a thumb between two fore-fingers, usually signifying an offer of sex, is seen four times. But in two of them a talismanic sign against the 'evil eye' is probably intended since the thumb is pointed at a pair of little monsters and the sleeve of one of the gesturing hands is laced with a phylactery.

In the bestiaries the pig is described as the most lustful of animals, a symbol of the Vice of *Luxuria*. But such a blanket characterization is not applicable to the stall art of any country[9] and least of all to Spain, where this remarkable creature is shown in a variety of other postures, as we shall see when studying the remaining Gothic assemblies. In Oviedo the pig occurs twelve times, four of them in music-and-dancing scenes, with the mother pig either holding the distaff or playing the bagpipe or teating one of her piglets. In only one carving is this supposedly gluttonous animal shown eating – acorns. In another it is curled up asleep; in still another it is wisely declining a man's beckoning invitation. An obviously 'intelligent' pig in a mutilated misericord sits intently listening to a talking bear, while in a second misericord a powerful razorback with tusks looks fiercely proud of his strength.

Only two carvings show this presumably lustful animal in amorous poses. In one, two razorbacks stand upright – the preferred posture of clever Spanish pigs – and kiss, quite delicately, it must be admitted. But there is no innocenting the activity of the animals in the final carving. They are making love. Yet there is no implication of guilt either. Indeed it is impossible to associate the scene with violent disapproval, or disgust. The work is altogether too charming to be meant to convey such negative meanings. And the fact that the sex act is set to bagpipe music, rather than implying an immoral connotation, could have merely been intended to heighten the jubilant mood.

At the heart of the problem whether stall carvings are sacred or profane is the question of their source. It strikes one as a mammoth undertaking to

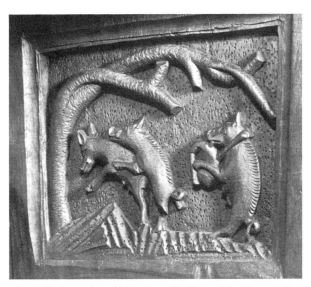

28. Oviedo Cathedral Handrest. Two razorbacks making love to bagpipe music.

disprove that they spring overwhelmingly from life, a task that would have to account for hidden meanings in several hundred animal subjects or scenes of human activity: work, play, domestic chores, eating, drinking, fighting, sex. Some pieces are demonstrably inspired by other art works, either seen in the original or in graphic reproduction. But this derivation has been highly exaggerated by some writers, who produce drawings or engravings as the alleged origins of the most ordinary acts, as though it were possible to trace the first artist who showed a man killing a pig or swilling wine or burying his head in a pot or making pee.

If we were to try to pin-point any convincing models of Oviedo's stall art the most obvious place to look would be at the fourteenth-century capital carvings in the cloister. Here you will find a fox hanged by chickens; two animal bodies with a single head; a centaur aiming an arrow; two men fighting with swords and shields; a lion with a curly mane; a razorback eating acorns; a woman with a tall floppy hat facing a man; a deer-hunting scene; several familiar-looking foliar subjects; and numerous blazons held by lions, birds or angels. And all of these can be matched in side-reliefs, canopies or misericords. But the originality of the stall art is not contradicted by such facile correspondences. Its great charm lies in its frequently offbeat and imaginative interpretations of the most commonplace subjects.

Trying to name the nationality of the artists runs into other problems. There is no question that Flemish, German, French and English influences all impinged on the Gothic stall art of Spain. Yet sorting out these impressions is hazardous, one important reason being that the Spanish 'style' did not remain static but swiftly developed into something that was neither a selection nor a synthesis but a completely new and ever-changing entity. If there were any national impact that one would be inclined to suggest for Oviedo's above-seat busts it would be Flemish. And in the smaller carvings as well there are concordances with the profane art of Diest, Walcourt, Hoogstraten and other Belgian stalls, where you can find a man trying to open his mouth as wide as an oven, two dogs on one bone, a fool with his bauble, an armed merman, a man letting his pants down to evacuate, a man with his head in a pot and various other obvious themes that are matched at Oviedo, to say nothing of more subtle parallels in style.

Most striking for the freedom of their portrayals at San Salvador arc the seventy spandrels in the upper corner triangles of the above-seat busts. One might have expected that their closeness to the important religious figures would have called for greater reserve, if not actually reverence. Yet only five times do we find subjects with a pious echo in these spandrels. In two (related to Ruth and Church-and-Synagogue), the heart pierced by an arrow might be a reference to Christ or Mary, while the pelican piercing its breast to feed

its young is a well-known figure of the Eucharist. Only the Mary of the Annunciation has sacred allusions in both spandrels: an angel with a scepter and Christ carrying the globe. But the corner pieces of the Gabriel relief are purely profane: two birds beak-to-beak and an eagle aiming an arrow at another bird.

There are six other spandrels which are frankly erotic, suggestive or irreverent. One dares not assume that they may be pejorative comments on the lives of the accompanying figures for fully four of these are apostles or saints (St Blase, St Barbara, St Bartholomew, St James-the-Lesser). Several of these spandrels have subjects that are among the most scandalous in all of Oviedo's stall art. But the vast majority of the other profane themes are simply exuberant displays of high spirits or of a wide-eyed interest in the surrounding world.

And so it is that the stall art of Oviedo, despite its ruinous experiences over three-quarters of a century, is still very much alive in the re-created assembly, partly enunciating a transcendent message through its major figures, partly describing the passing world in a great display of secular themes. Freely and frankly these two aspects of man's being, the spiritual and the mundane, were allowed to cohabit in the symbiotic association of choir art, exemplified most strikingly in the above-seat sculpture, where busts of many of the theological giants are seen in startling propinquity to the raucous indecencies of their collateral spandrels.

A Kind of Consecration

In mid-October of 1979, Manuel Mariño and Luis Espino had completed the first set of six stalls (five Christian figures and Church-and-Synagogue) and were prepared to transport them back to the cathedral. It had been decided some time before, on the occasion of our third visit to Oviedo in the company of James Gray and his wife, that they would be assembled in the *Sala Capitular*. Dean Demetrio Cabo had led the party down to the cloister to show us this magnificent Gothic chamber, whose restoration after the October 1934

29. Oviedo Cathedral. The first restored group installed in the *Sala Capitular*.

incendiary had only in recent years been terminated, and the choice was instantly and enthusiastically made.

At the time we still had no idea how many stalls could actually be saved, and had set our modest hopes on ten. Later, when this number was doubled and even that figure surpassed by the expected addition of several upper stalls, other chapels began to be suggested as alternatives. But we opposed them all on one pretext or another since we had set our hearts on the *Sala Capitular*, the oldest and by far the most striking of all the cathedral's chapels. In the end, our argument turned out to be unanswerable: How could we put Gothic stalls into anything but a Gothic room? The Santa Barbara Chapel, which had often been suggested, was in contrast an inappropriate baroque enclosure of the late seventeenth century.

The six stalls, consisting of the one group of five and the separate Church-and-Synagogue, were pushed up the hill from the atelier in dismounted form, in six trips on a wheelbarrow. They were reassembled without the use of nail or screw but only with long cylindrical wooden pegs, many of which had been spared from the original joints. It was done in the late afternoon when few people were about. Forewarned had been only the dean, the archivist, and Crisanto Perez-Abad with one or two of his colleagues from the *Amigos de la Catedral*. Emilio Olavarri, who was an archeologist by avocation, was away on a digging project in Jordania.

A big spotlight on the end of a long cable had been brought into the *Sala Capitular* by Don Raul, and as he played the bright focus on the stalls all eyes followed in awed unison. Demetrio Cabo came in last, accompanied by a canon. We all stopped to watch him as he moved slowly down the stone stairs and then approached the stalls with deliberate steps. Stopping midway and folding his arms on his chest, he stood as though in prayer for some moments, then turned from one to another of us with wet eyes and a great joyful smile. 'This is my day of glory,' he exulted, but then, quickly self-conscious, he added in a chastened tone: 'Wait till the chapter sees them tomorrow morning.'

We were the first ones there, followed soon after by Don Raul, who busied himself adjusting the spotlight cable. It was exactly eleven o'clock, after the canonical mass, when the canons began to arrive. Soon the entire number were there, with several extras from among the very old men who had come over from the *Casa Sacerdotal*. Curiosity had taken the place of the previous evening's solemnity. The churchmen swarmed about the stalls and began examining the carvings. Seemingly bewildered at first with their great variety and feeling inhibited perhaps by a sense of strangeness, they latched on eventually to some recognizable attribute and soon were sputtering with questions.

They turned toward us, as though we might have been responsible for any peculiarity in the iconography or other details. Why was it, one canon asked,

that only San Pedro's name was inscribed in 'Castilian' while all the others were in Latin? *San Blas* was also in Spanish, we pointed out, and there were others of the same designation among those that had not yet been repaired. 'Perhaps it was just the whim of the artist or an idea of the churchman who was in charge of the iconography at that time.' But the canon shook his head and smiled knowingly, implying, we felt, that the reason was that there was a difference of nationality among the artists, which was true enough.

Don Alfredo de la Roza, the choral director, let out a joyous cry of recognition. 'Here is another *gaita!*' he exclaimed, pointing to a razor-backed pig playing the bagpipes. He had already talked to us about this instrument, which he firmly believed was an Asturian invention.[1] He had told us that he had never seen more than two or three examples of this instrument in medieval carvings and this new discovery must have seemed a corroboration of sorts to him. But then he suddenly broke into a gust of laughter as he became aware of the other half of the carving: the mating couple (See Fig. 28 in Chapter VII). 'Look here!' he cried. Other canons quickly joined him and for a few minutes there was a scene of unaffected hilarity.

'The dean has to see this,' someone said and they called him over.

In his vague and absentminded way he came and bent over to look at the little relief. Then, puckering his lips in a small smile, he shook his head slowly several times. But it was not in disapproval, we felt, but just giving the kind of response he thought was expected of him. We had wondered how the canons would react to this piece, out of curiosity rather than trepidation. After all, it was not we who had made this art! As we looked at the almost festive group we suddenly were very pleased with them. They had acted as we might have hoped they would. They had passed the test. And in a way so had we.

Some of the canons were elderly, veterans of the chapter corps. We scrutinized several of them, wondering suddenly if they had been witnesses to the casting-away of the Santa Barbara stalls into the loft in 1954. Was the matter brought up at a chapter meeting and approved, as we had conjectured from the 'loss' of the 1950–1960 volume of the Actas? We had felt the urge several times before to put the question to the older canons, on the abstract principle of discovering the 'whole truth' about the stalls. But the present scene seemed to render the impulse distasteful. The general delight so heartfully shared had wiped out the 'guilty' past, in which even our beloved dean might have been involved.

But it was not so![2] He of all the others was surely blameless: his love of the stalls proved that. We were happy to receive a corroboration of this intuition a bit later, when Don Raul brought us a letter which he presented to us as a kind of curiosity. It was dated September 18, 1969, years before we had come on the scene, and was written by Demetrio Cabo to the director

of architecture of the Spanish Ministry of Finance. In it the dean had asked for help to restore various objects of the cathedral's neglected treasures. 'Among the works that merit repair,' he wrote, 'are a number of choirstalls on the verge of disappearing as victims of the termites.'

The first eleven stalls (ten plus one) were completed by January 1980 and work on the next group was begun soon after. As we had hoped, the impress- iveness of the first restorations facilitated the acquisition of supplementary funds, which became available without delay. This time James Gray's founda- tion shared the vital patron's role with the Joint Spanish-American Commit- tee.[3] Our inventory had already supplied the necessary elements – with some to spare – for the additional stalls: the busts, the canopies, the misericords and seat-dividers. A closer scrutiny revealed that, though their general condi- tion was somewhat poorer than the first group's (which would mean more work, a rather tougher effort), this group too could be put together without requiring more than elementary repair.

When the new work was well along the way, we felt confident about taking the trip that we had thought about for quite a while and that would absent us for a lengthy period. The chief reason for our going was to have access to other archival and printed sources than could be found at Oviedo; another was to study the rest of the Gothic sets in greater depth. All of this would help us, we trusted, to fit the Oviedo assembly into a composite picture of Spain's figured Gothic stalls. In addition, a canvass of the socio-historic back- ground, in which we were very weak, was, we felt, indispensable for the exploration of those currents that might have influenced the choirstall iconography.

Before leaving, we prepared rough drawings of the arrangement of the breakdown pieces that were to be used in the stalls still remaining to be done and went over the selected elements (and substitutes in case of unforeseen problems) in the *Claustro Alto* carefully with Manuel and Luis, pointing out to them, as always, the sensitive details, the 'wounded' parts that must not be touched and those on the other hand that should be repaired. These prepara- tions were much easier to make than they had ever been. We had worked so well together, everything was understood without need of emphasis or more than a few words exchanged.

As our trip worked out, the visits to the other churches took place at the end. It was the third journey of its kind that we made, but there was much more leisure this time to hover over details, while our considerable reading of historical material often furnished insights that had been unsuspected before. Constantly, as we studied the different assemblies, we had the Oviedo stalls in our minds, freshened up by a big batch of working photographs that we consulted at every impulse, comparing, contrasting.

Oviedo, Sevilla, Plasencia, Zamora, Toledo . . . they were all like members of a great family, at times startling by their similarities, at others overwhelming by their differences. Comparing them with individual sculptures from 'our' stalls, we were pained to discover a number of inferiorities in the latter, overjoyed by their superiorities. And in the end, our concept of our book had expanded greatly beyond its original boundaries, pressed outward by the wonderful richness of Spain's figured Gothic stalls.

On our return to Oviedo after what seemed an exceedingly long absence, we faced the prospect of viewing the stalls with apprehension. We were intimidated by the thought of all the wealth from the other assemblies that we were carrying in our heads, which would serve as unavoidable challenges to our own pieces, to say nothing about the total beauty of such a marvelously preserved set as that of Zamora (one of the last re-seen), glowing in its burnished sheen that was reflected from the light that poured down into the central choir from the high chancel windows.

We arranged to make our first visit to the *Sala Capitular* by ourselves. We went in the morning so that the eastern sun, coming through the barred windows past which the revolutionary miners had entered almost half a century before, would be lighting up the twenty-one stalls without the aid of the spot. The first thing we noticed was that our suggested arrangement had turned out well, with eight stalls on each side and five at the center-rear. Also the coldness of the stone floor had been softened by a large beige rug. The great lectern from the central choir that we had seen in Uria Uria's painting and which had been banned from Bishop Martinez Vigil's new presbytery was here properly installed. It was all very friendly, very warm, yet somehow distant to us.

We sat down on the facing stone bench that rimmed the *Sala*, still hesitating to go up closer, feeling estranged perhaps by this monumental actualization of a dream. When we did rise to approach the stalls it was almost by inadvertence, drawn by the impulse of checking one of the reliefs. It was only while studying the familiar details that we became adjusted to the great ensemble and in that moment we knew the reason for our previous alienation. As individuals who had never worked in the visual arts, it was the stalls' overwhelming plasticity that had intimidated us. But now, in the smallness of their parts, they had come back to us, bringing a strange and wonderful feeling, akin to that felt by artists, perhaps, who have accomplished a creative act.

This excitement quickly abandoned us when, as we were examining the precious pieces, we found two glaring instances where the restorers had disregarded our instructions. They were both in small carvings, a side-relief and a handrest. The first was a hunting scene and the young man blowing his

horn had had his marred cheeks plumped out, despite our having foreseen this eventuality with an admonition. The other was more serious, altering the meaning of the carving in a ludicrous manner.

It was one of the most entrancing pieces of the entire set, a pre-'Renaissance' subject. Presented had been a warmly carved, naked female form that was passionately embracing with legs and arms the trunk of a tree. Below, the twisting roots prolonged her body's curvilinear course and, above, a great spread of dense foliage rose from branches which themselves seemed all astir with emotion. Unhappily the spirit's face had been hacked away, probably long ago, by some pious iconoclast. This barbarism Manuel and Luis had decided to repair by substituting something like a demon's head for the original, thus altering not only the hamadryad's identity but even her sex.

What these mutinous acts proved, we told ourselves, was that we had never actually convinced the restorers completely about our point of view. They had followed our indications when we were present though often secretly in disaccord. During our extended absence, they had suddenly felt free to impose their own instincts. Why leave a figure mutilated when a few touches could make it whole? They too had their sense of incongruity and believed in it implicitly. Before the splendor of the stalls, however, which owed so much to the dedicated work of these men, we began to wonder if our feelings of affliction might not be excessive.

This experience instructed us nevertheless regarding the ultimate realities of our efforts. We had tended to fuss like mother hens over the restoration and realized in a sudden insight that, however intimate our relationship to

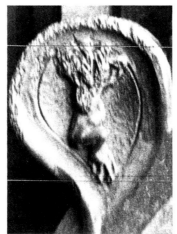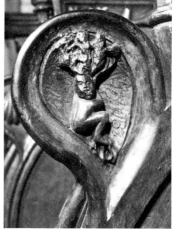

30. Oviedo Cathedral. Mutilated handrest of a hamadryad (before restoration).
31. Oviedo Cathedral. A restoration error: The hamadryad loses identity and sex.

this recreated art had been over the past nine months, the time had come when it would begin to live its own life, be subject to other influences than ours. We had, we realized, exercised a rather despotic control over it, always expecting adherence to our plans and ideas, though this was no doubt due to the fact that not many others were offered, aside from the occasional technical suggestions of the restorers.

Despite our self-abnegating mood of severance (we left Oviedo at the beginning of June 1980), we made sure to assert our last impact on the stalls, that of preparing the pattern and making the choice of the elements for the five upper stalls on which the restorers would begin to work as soon as fresh funds were available. There were still enough parts in fairly good condition for the lower halves of these stalls (which were duplicates of the corresponding sections of the others that had already been done), though a couple of substitutions would be needed, we knew, that would require only deft sawing and gluing operations.

For the upper halves of these upper stalls we had months ago laid out with Manuel Mariño and Luis Espino on the *Claustro Alto* floor the best preserved panels and crest ensembles, which were the major elements of this section. It was easy to find among all the other detritus replacements for missing finials and other minor pieces. Of figure carvings there were only six musician-angels that served as socles to as many small apostles and patriarchs that punctuated the lower hem of the overhang crest (see Fig. 22). They were almost all in surprisingly good condition.

This work was not to be done for quite a long time and when it was finally started it was in our absence. Meanwhile we had done what we could to activate the last donations, though we were delighted to hear that others, particularly Emilio Olavarri and Crisanto Perez-Abad, took the lead in this respect, winning important support from local people who joined the ever-generous International Fund for Monuments in helping to place the upperstall 'crown' on Oviedo's choirstalls. All this good news brought us closer to the stalls again, while at the same time reinforcing the sense of their having passed on to those who thereafter would have the primary claim to them. We felt that when we returned to see them in their final realization it would almost be as strangers.

Oviedo did not will it that way, however, even though the completion of the assembly was not to take place for almost two years. Its 'inauguration' was announced to us at last for March 15, 1982. The ceremony was held, significantly, we felt, at the University's assembly hall, the 'Paraninfo.' But this turned out to be an emblematic gesture that was swept aside by the taking possession of the newborn monument by what seemed to be the city's entire population, whose ardent embrace forced us – permanently – out of our isolation.

PART TWO

Spain's Choirstalls as a Mirror of its History

CHAPTER IX

A Panorama of Styles and Origins

It is surprising to discover, when one begins to study the history of Spanish choirstalls, that for the first two centuries at least they were mainly carved by Moslem (*mudejar*) artists. We are accustomed to associate the 'Moors' with art in Spain. But this ordinarily calls forth images of great monuments like the Alhambra of Granada, the Giralda of Sevilla or, in relation to 'Christian' works, such churches as were transformed from Moslem mosques like the Cathedral of Cordova.

Christian choirstalls done in *mudejar* style are infrequently found in Southern Spain, certainly not in that stubborn triangle that was 'reconquered' from the Moors only at the very end of the fifteenth century. With few exceptions the earliest Spanish stalls appeared in the north and were created by Moslem artists, many of whom had remained behind when the Christians swept most of their co-religionists beyond the Duero and the Tago. Architects and sculptors, carpenters as well as bricklayers, these men were the leading exponents of the Spanish building and decorative arts. Their *artesonado* ceilings, ornamented brick towers and painted tile walls can still be seen at Zaragoza, Teruel, Burgos, Toledo and numbers of other northern and central cities.[1]

What is especially strange about this background is that Moslems should have worked on Christian figurative art. So did Jews, for that matter, but not nearly to the extent that the Moors were involved. This kind of creative tolerance was part of the Spanish ambience of the period.[2] It did not, to be sure, outlive the violent Christian unification of the country and the inquisition that was one of its most characteristic manifestations.

Another important fact that one soon learns about the Spanish stalls is the relatively small number of them that are done in the Gothic style, whether furnished with figured sculpture or solely with decorative carving. Were there

others that disappeared, one wonders, victims of accident, neglect or change of taste? Was their rarity dictated by economy, national or regional preference, lack of skill or training? How indeed did these fabulous assemblages of talent and display come to be in the first place?

The subject is not overly rich in documentation but a few old texts that are at hand reveal that wooden stalls began to appear in several countries in the late eleventh and early twelfth centuries.[3] By the thirteenth, they were sufficiently widespread and solidly built for a few of them to have survived into modern times. Almost every western European country can show one or more of these early stalls, while Spain has a small fraction of such a set, three whole seats.

Stemming from the monastery of Bernardine nuns at Gradefes (Leon), this fragment was salvaged by the Museo Arqueologico Nacional of Madrid, which probably saved it from total decay. There is just enough left to indicate what must have been a handsome and sturdy structure, with some fine carved decoration in low relief showing on the seat struts and pillars. An author has claimed that these stalls once possessed misericords, but it is impossible to corroborate this conjecture from the deficient state of the present relic.[4]

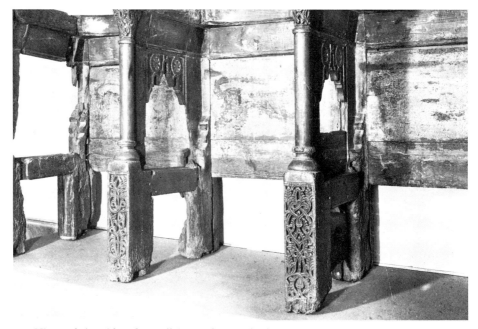

32. View of the side of a stall in *mudejar* style from former monastery of Bernardine nuns of Gradefes (Leon), now at Museo Arqueologico Nacional of Madrid. These *mudejar* remnants of the thirteenth century are the earliest existing stalls in Spain.

There are or were two other early sets in Spain done by Moslem hands, dating from the middle and the third quarter of the fourteenth century respectively.[5] The earlier group was formerly at Astudillo in the northern province of Palencia. The third, located at the Franciscan nunnery of Moguer,[6] is still *in situ* and, exceptionally for this art, is located deep in the south, close to Huelva and the Atlantic shore. The influence of the Moorish style of Granada is strong in this set, featuring floral and geometric patterns as well as typical half-bodied lions. But it also possesses religious emblems and high panels in marquetry, a feature that is still found in the stalls of Sevilla Cathedral, which were done a century later and probably by Christian artists.

The case of Astudillo ends on a tragic note, since this set, whose art has been called 'the most advanced *mudejarismo* in Spain,'[7] has left only four stalls at the Museo Arqueologico. The pity of it is that this superb assembly had survived late into the contemporary period. But in 1931, we are told, the monastery decided to sell the stalls to an antique dealer except for the four that were given to the museum. In these seats, and particularly in the overhang crest of the elegant stall-front casing, can be seen a remarkable fusion of Moslem and Spanish influences, including a rampant lion in the blazon of

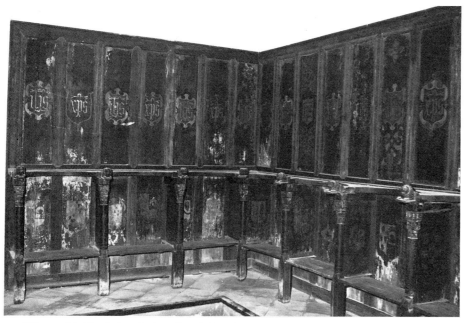

33. View of half of the choirstalls of the Franciscan nunnery, Santa Clara of Moguer (Huelva). It is the earliest assembly of stalls in position, dating from the third quarter of the fourteenth century.

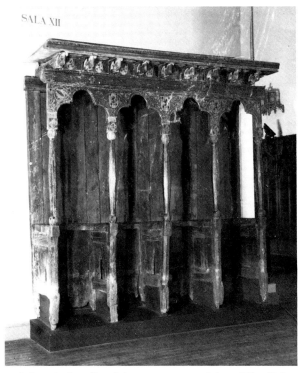

34. The four remaining choirstalls of the monastery of Astudillo (Palencia), now at the Museo Arqueologico Nacional of Madrid. The most remarkable feature of this mid-fourteenth century remnant is the crest, showing mixed Moslem and Spanish influence.

the donor, Doña Maria de Padilla, mistress of Don Pedro el Cruel, and decorated beams painted in a 'clear arrangement of Islamic origin, which borrows from the Gothic solely the naturalism of the motif.'

There are three other churches, all northern cathedrals, where Moslem artists are cited as working on the stalls, usually with Christian colleagues. All three sets date from the early years of the fifteenth century. At Huesca,[8] it was, curiously, the Spanish artist '*Maestre*' Beltran who did the painted ornament, which was usually *mudejar* work, in 'red lead, vermilion, egg-yellow and indigo-blue' with gilt trimming, whereas the sculpture of 'profiles' is here ascribed to a Moslem. Mahoma de Borja is the name quoted in the cathedral's *Libro de Fabrica*. It is the only record we retain of this interesting collaboration since the set itself was destroyed and rebuilt in the sixteenth century.

The fate of the stalls at Pamplona[9] was much the same. Done by Spanish and Moorish artists early in the fifteenth century, they disappeared in the sixteenth without a trace. In the case of Palencia,[10] we have the name only of

a Spanish artist, '*Maestro*' Centellas, who in 1410 contracted to do the stalls for 100,000 maravedis. But the full sum was never paid by Bishop Sancho de Rojas and the work was not finished until a century later. At the Seo de Zaragoza,[11] the archiepiscopal church, we return to a full Moslem-Christian collaboration, which left its mark in two elegantly ornamented *mudejar* doors in the stalls' upper register as a kind of ecumenical frame to the archbishop's throne which was done some decades later.

Moorish work virtually disappears from Spanish stalls thereafter for a lengthy period. The fact is that for about forty years we have little evidence of any stallwork whatever going on in Spain, whether by Moslems or Christians. Not even in artistically advanced Catalonia is there a sign of it through most of the first half of the fifteenth century, though during the second half of the previous century two spectacular examples of figured stall-art had already appeared in that region.

One of these, created around 1351-3 at the Cathedral of Gerona,[12] links the names of a Frenchman (*Maestro* Eloy) and a Spaniard (*Maestro* Ferrer). But this set unhappily has vanished, leaving only one magnificent relic, the bishop's throne, fully carved and figured in the finest Gothic style. The other set, that of Barcelona, is unquestionably one of the most remarkable figured groups in Spain and likewise associates the work of French and Spanish (as well as other) artists. (See Chapter X for a full discussion of this brilliant assembly.)

The nearly half-century break in stall production was too generalized to be accidental. It was in all likelihood due to the ruinous civil wars that raged over much of Spain during that period,[13] whose effects were compounded by intermittent recurrences of the plague. Stall-art was only a minor victim of these disasters and the 'missing' sets from this time were not, as we ourselves had once assumed, merely replaced by later models. They probably never existed. Other periods in any case, both before and after, all left works that we can study today.

When stalls come to our notice once again in the 1450s they are of a new kind, not previously seen in Spain outside of Catalonia though they had already been known much earlier in several other European countries. They are what we call 'figured' Gothic stalls and are characterized by the fact that the figures that appear in them have evolved from their purely decorative role in the earlier sets to naturalistic representations. Notably, larger statues of saints and prophets make their appearance in several of these assemblies.

This birth of a fresh style of carving in Spanish stalls would seem *a priori* to have required a new set of artists, trained especially in that kind of work. And this was indeed the case. They were at first brought in from other coun-

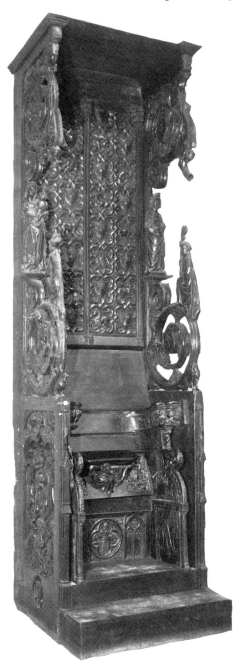

35. The bishop's throne of Gerona Cathedral, sole remnant of the choirstalls produced in 1351–3, under the collaboration of a Spanish and a French master. Now at the Cathedral Museum.

tries where this specialty had already developed to a high degree. In Belgium, Holland, France, West Germany, England and Switzerland, can be seen numerous full-figured sets from the early fifteenth or even the fourteenth centuries. It would be fifty or more years before this style was to mature fully in Spain. This occurred in the northern half of the country especially, where the Christian reconversion had been earlier and more firmly established.

Spain's leading source of stall artists during this period was Flanders.[14] It is fitting that the earliest set of this kind appearing in Spanish Castile was made by a sculptor of Brussels, Egas Cueman. With his architect brother, Hanequin de Bruselas, and others, he had come to Toledo shortly after 1445 in the first wave of Flemish artists who for the following fifty years or more exerted a preponderant influence on Spanish church-building and decoration.

Considering its historic importance, one would wish that the available information about Egas Cueman's pioneer assembly, produced for Cuenca Cathedral, were more complete. The loss of the original contract is not fatal, however, since a detailed entry in the church's Actas Capitulares[15] reveals that the stalls were begun in 1454, over the objections of the chapter, who insisted that the wood was still 'green.' Egas Cueman disagreed and was willing to sign a paper that he would take full responsibility for any untoward development. He had rejoined his brother at Toledo by 1460, when the stalls were presumably terminated.

It is difficult to get a proper appreciation at present of the Cuenca stalls, because of the many misadventures they met up with from the time of their creation.[16] The worst of these was when they were sold in 1754 and transported a hundred kilometers to the collegiate church of Belmonte. The shift seems to have caused much damage to the stalls and probably the loss of many of them, while subsequent deterioration must also have diminished their number. Nevertheless they possess some important sculpture, especially in the upper register, where the big panels are given over to scenes from the most dramatic moments of Scripture, all handled with striking originality. An example is a panel showing Cain killing Abel by biting his throat, a very rare interpretation.

Next in chronological order, Barcelona's second range of seats, done in 1456–59 by Matias Bonafe, adds little to Spanish figured stall-making and what it does offer was made in contravention to the contract arranged with this artist which distinctly forbade that kind of sculpture. But the two following sets, those of Sevilla and Leon, begun in 1464 and 1467, developed the stall-with-figures technique to such high competence that all assemblies following this style thereafter reflected the influence of these two groups.

Those stalls that used Leon's set as a model, particularly copying its large above-seat busts and statues of important religious personalities, were Zamora,

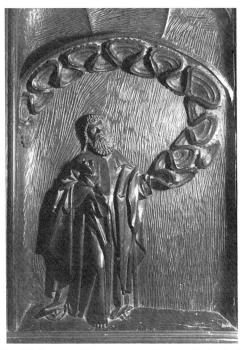

36. Collegiate Church of Belmonte. Provenance, Cuenca Cathedral. Upper-stall panel of choirstalls (1454–60). The first day of the Creation: God creates heaven and earth.

Astorga and Oviedo. The stalls done under the guidance of the famous Flemish master Rodrigo Aleman (Plasencia, Ciudad Rodrigo, Toledo and Yuste), on the other hand followed Sevilla's style, which substituted narrative friezes for the big figures in the above-seat panels. All of these stalls will be discussed later.

A few other assemblies separate themselves off in one way or another from each of the two leading groups of figured sets. Among these, the outstanding assembly is that of the monastery of Santa Maria la Real, at Najera in Logroño province. This handsome ensemble of sixty-two upper and lower seats falls somewhere between the Leon and Sevilla groups. Its identification with the former stems from its possession of above-seat busts in the lower stalls, of which it has unfortunately lost all but three, due to prolonged neglect, particularly during the political turmoil of the nineteenth century when the monks were forced to leave the monastery.[17]

Najera's upper stalls have no major figures, and never did apparently, save for the one that towers over the abbot's seat, a gigantic martial statue of the founder of the monastery, King Don Garcia. The decorative upper panels

96

tend to join the set to the Sevilla group, resembling particularly those of Ciudad Rodrigo, which also possess only a single big figure, that of St Peter. Notable frieze portraits, in pairs, shut off the panels at the base and include some extraordinary subjects, especially several splendid heads of black men whose presence there incites speculation. Lifelike portraiture is very rare in stall-art. At Najera, there is a stunning series in the misericords.

There are a few other Spanish sets that fit into the figured Gothic category, though each with certain reservations.[18] At the Monastery of Celanova, a few of its stalls are of the late fifteenth century, with upper panels in geometric designs but with figured misericords, handrests and roundels in the lower seats. Also having undergone late Gothic influence are the stalls of Villalon de Campos (Valladolid), done at the start of the sixteenth century, which is the

37. Santa Maria la Real of Najera. Frieze of an upper panel of the choirstalls (*c.* 1495), presenting two black men.
38. Santa Maria la Real of Najera. Misericord portrait of a nobleman.

97

dating too of the strange set at Santa Maria de Dueñas (Palencia). The dense, lush boscage of these Dueñas panels, in which naked savages swarm, can surely be traced to the sub-tropical landscapes that Spanish explorers had been seeing, or directly to the Mayan reliefs of Comalcalco. But their assimilation to a Gothic choirstall would be difficult to demonstrate convincingly.

Production of Spain's figured stalls took place in a period of blazing creativity, a majority of them having been begun or largely completed in the final decade of the fifteenth century.[19] However, choirstalls with figured carving were by no means the only Gothic assemblies created during this very short period. There were twice as many other sets produced, which, while lacking the concentration on figurative work, have much in common with the general style and spirit of the stalls that possess it.[20] Within their decorative orbit these other assemblies are endowed with a great attractiveness both in detailed carving and in overall monumental splendour. Among the finest are those at the Carthusian Monastery of Miraflores, near Burgos (1486–9), and at the church of San Tomas de Avila (1482–3). Both are linked with the name of Martin Sanchez, an Aragonese, the most renowned artist in this style. Indeed, most of the non-figurative assemblies have been ascribed to Spanish artists, who apparently were still expressing the traditional figureless inclination which had been acquired from their Moslem predecessors.[21]

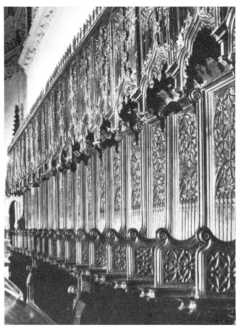

39. Miraflores (Burgos). Gothic choirstalls 'without figures'.

When taste began to shift to figured carving in the second half of the fifteenth century, the patrons of stalls seemed to vacillate for a while in choosing the new style. Those that did so must have found it more convenient at first to bring in foreign artists who had experience along these lines. But native men quickly acquired the new skills. By the third decade of the sixteenth century figured stalls had become widely accepted and were often made by some of the most talented of Spanish sculptors, men like Berruguete and Vigarny. These stalls were no longer in the Gothic mode, however. The smaller carvings especially assumed an often unrestrained and even pagan character.[22]

One result of this unbridled trend was to strip the later carvings of those themes which in the Gothic stalls are of such extraordinary social and cultural interest. The subject inventory that we had worked out at Oviedo was continued for the other figured sets, resulting in a fairly complete iconographic catalogue for Spain. Leaving aside some eight hundred carvings in the basically religious categories (busts, full figures, narrative scriptural friezes), the almost four thousand subjects that were recorded in the misericords, handrests, side-reliefs, roundels, canopies and border art revealed an extremely broad iconographic range, which we collated under fourteen headings. (We shall give more detailed references to these distributions while discussing the churches individually.)

TABLE I

SUBJECTS*	NO.	%
1. NATURAL ANIMALS	862	22.0
2. FANTASTIC ANIMALS; GROTESQUES	707	18.0
3. DAILY LIFE; DOMESTIC SCENES	400	10.1
4. PARA-RELIGIOUS SUBJECTS (INCLUDING VIRTUES)	329	8.4
5. COMBATS (INCL. ANIMALS); WARRIORS	307	7.8
6. FOLIAR; FLORAL; DECORATIVE	274	7.0
7. FABLES; PROVERBS; LEGENDS; LITERARY	255	6.7
8. VICES (INCL. SEX, DRINKING, ETC.)	172	4.4
9. HUMOR; RIDICULOUS SITUATIONS	134	3.4
10. WORK; PROFESSIONS	99	2.5
11. BIBLICAL	92	2.3
12. MUSIC; DANCING	91	2.3
13. GAMES; RECREATION	86	2.2
14. HERALDRY	80	2.0
15. MISCELLANEOUS	37	0.9
TOTAL	*3,926	100.0

*(*Exclusive of 800 religious busts, statues and reliefs)*

Standing out sharply in this listing is the great number of natural and mythical animals,[23] a preponderance that we had already noticed at Oviedo. Together with foliar and decorative subjects, almost half of the carvings (47 percent) are thus accounted for. In general we consider this group as having largely routine thematic interest except where anecdotic or symbolic interpretations are applicable. Thus a certain number of the animals and monsters may delineate vices but this must be explicit in the manner of their presentation or the context of their action to be so considered. Virtues as such are rarely presented and have been grouped together with other positive Christian attributes.[24] Vices, on the other hand, are far more numerous and have therefore been given a separate listing.

The avowedly religious themes (those stemming from the Bible or other pious sources) in these smaller carvings are only a tiny proportion of the total number, as can be seen in the Table: 2.3 percent. A considerably larger group (8.4 percent) are the previously identified 'para-religious' subjects. Together the two divisions make up almost 11 percent of the total. But there are important differences among the twelve churches as to the emphasis laid upon this area. Such themes at Barcelona, for example, make up an astonishing 26 percent ($2\frac{1}{2}$ times the average) whereas Zamora with 4.5 percent and Ciudad Rodrigo with 5 percent have less than half the overall proportion. Reasons for these variations can sometimes be determined and will be taken up when we consider these churches one by one.

Vices represent 4.4 percent of all subjects. These entail, to a major degree, sex offenses and drinking. Clerics are frequent targets in both types of transgression, which illustrates the remarkable fact that the church iconographers often used these carvings for an exemplary self-critical purpose, since the stall-art was directed at the clerics themselves, the faithful being excluded from the choir. When monastics were exclusive butts in a secular church (which often happened), the practice was less laudable! The authorities in our twelve churches varied greatly, however, in the stress they laid on clerical sinfulness.

Was this due to the varying personal anxiety of the iconographer or to a local situation, perhaps shortlived, that inflamed his criticism?[25] It would be hard to determine the reason for the accent laid by Plasencia's churchmen on sinful action, which bears on no less than 18 percent of its 'secular' carvings. Some modern church authors have suggested a curious reason for this prominence, which we shall examine later (in Chapter XIII). In contrast, we find an almost total lack of reference to the vices at Barcelona and a relatively small amount at Ciudad Rodrigo, less than 3 percent. Some churchmen evidently found alternative ways of pressing their didactic message on this score, at times by accentuating the positive rather than the negative side of conduct, as was the case at Barcelona. But the fact that a church has a low rate of recorded

vices in the stall carvings does not necessarily mean that the clerics or their flock were more virtuous! It might just as well have been that the iconographer happened to be less overwrought on the subject.

Of topical interest in the stall sculpture of all countries are the work scenes, which at times reveal unusual or even obsolete occupations. We have found their proportion ranging from 2.5 percent to 4.5 percent in the misericords of France, England and Spain.[26] The higher ratio in Spain may be due to the great preponderance of city cathedrals – nine of twelve – in this country's listings, which tended to increase the occurrences of urban trades. The relatively low incidence of literary subjects (6.7 percent) is worthy of note since some authors devote much effort in search of them while neglecting the more lowly sources of stall-art.

Portraits, that is, lifelike characterizations, do not appear very frequently in stall-art, as we have already mentioned. All the more surprising therefore is the great array of apparently close likenesses that are found in the handrests of Barcelona, women as well as men, all sharply and sympathetically delineated. The frequency of such carvings is matched in only one other place that we know of, the burgher-built collegiate church of Notre-Dame at Bourg-en-Bresse in Eastern France, where the heads of forty-two commoners are reproduced in the misericords, a reward for the payment by the principals of the cost of 'their' stall.[27] A much smaller number of portraits is found in the misericords of Santa Maria la Real of Najera.

Other comparisons of Spain's subject content with that of France and England sometimes corroborate old conceits about one or the other of these people. The English misericords, for example, are almost twice as strong in sports as the Spanish carvings, 4.8 to 2.6 percent. And English recreations are often picturesque: quintain-tilting, bear-baiting, cock-fighting, shot-putting, and there is even a wonderfully anticipatory scene of two men scrimmaging over a soccer-ball, at Gloucester Cathedral.[28] Among the French games on the other hand is one example, at the church of Champeaux in the Department of Seine-et-Marne, of a great English sports favorite, cricket, illustrating the way recreations and games were already shared far back in the Middle Ages.[29] But others remained native specialties, like the gambling match, *los chinos*, seen in a misericord at Barcelona, or bull-fighting, which is ubiquitous in the early stall-art of the Extremadura, as we shall see.

England's underseat carvings are far more highly endowed with heraldic symbols[30] than those of the other countries (7.4 to 1.9 percent for Spain, for example). Does this reflect the lasting devotion of that people to artistocratic traditions? It does in any case indicate the close relationship that patrician English families maintained with their local abbeys and convents. Surprising, on the other hand, and perhaps typical is the total lack of references to sexual

subjects by one English author who has indexed stall-art.[31] This puritanism was not shared by the original artists or their clients, however, as we were able to ascertain in our examination of many of the English churchstalls.

The reconquest of Spain from the Moors, which occupied so large a part of the efforts of the Spanish people for centuries, also exerted an uncommon influence on its stall-art. This expression reaches its climax at Toledo, where the returning chief of the Granada forces endowed a stupendous series of above-seat battle scenes sculpted by Rodrigo Aleman. Combat seems to have been on the minds and in the hearts of the entire Spanish people, however, expressing itself in all kinds of scenes of conflict, including those involving animals or monsters, which at times symbolized the 'heathen' enemy. Such subjects engrossed especially high ratios of the stall-art in the frontier towns of Ciudad Rodrigo, Plasencia and Sevilla: 9, 7 and 7 percent respectively.

Yet violence was the woof and the warp of medieval life, and one sees reflections of this in the art of all European countries during this epoch. So also could the 'life of the times' account for the enormous display of animals and monsters in the popular art of this period. Medieval people, even those living in towns and cities, were still close to the forest. And the numbers of monsters that peopled the stall-art were an image of their dreams – and nightmares. Psychology teaches us that this was man's way of seeking to subject the demonic other world: by chaining the shrieking gargoyles to stone and wood and thus holding them at bay.

A Delicate Spiritual-Worldly Balance

In studying the different 'personalities' of the figured stalls it is the peculiarities of style that count. Similarities are important for classification, but do not reveal quality, that special 'whatness' of a work that strikes the eye and heart. The fact that two-thirds of the twelve Gothic sets were made within a span of about forty years could have been a limiting factor in the search for individuality. But when we came to study the assemblies one by one we found characteristics nonetheless that set them each apart from groups that they were supposed to be close to. It was the variant attribute that stood out. Stalls were as different as people.

Barcelona's assembly has at least two reasons for being distinguished among the figured Gothic sets. The first is its early date, 1394–9, about sixty years prior to the next in line, Belmonte. The second is a corollary of Barcelona's geographical location, in the upper northeast corner of Spain, hence most subject to French influence. This is reflected in the names of artists who worked on the stalls. We know thirteen of them, possibly all there were, and a majority of them were French: Lorens; Jacme Brot; Jami lo Normant; Francesch Merate; Luch Despou; Antoni Canet; Berenguer Roff; and probably Jacme Comes. Four of these men worked for the full stretch that the stalls were in the making, under command of Pere Sanglada, a Catalan master, probably stemming from Gerona, one of the greatest of Spanish Gothic sculptors, who was equally skilled in stone or wood.[1]

We are fortunate in having a full set of dated fabric reports for Barcelona's stalls, which tell in punctilious detail the production record: work done, pay received, time consumed as well as some of the working conditions plus the stipulation that Sanglada was to make a drawing of the stalls on plaster for the canons, which has unfortunately been lost. This material has been carefully

transcribed by a group of University of Barcelona scholars, principally in the doctoral thesis of one of them, Maria Rosa Teres Tomas.[2] None of the other stalls has anything like this documentary record. For most there are only a few notices, like Oviedo's four entries. Belmonte offers a single archive, though one of great importance, as we have seen. The stalls of Rodrigo Aleman (Toledo, Plasencia, Ciudad Rodrigo) are better supplied but lack many pertinent details. The same is true of Sevilla. For the rest of the twelve sets there are only a few unsupported declarations that are hardly better than gossip.

Barcelona's stalls were done in three distinct periods, all of which added to their multinational character. Pere Sanglada's sixty-five seats extended over a single register at ground level and were probably set against the stone enclosure that had been built to hold them, starting around 1380. This central choir was provided with external sculptured decoration that was carved in 1391–4 by Jordi Johan,[3] reputedly a former slave who had learnt his craft from his master, Jaume Cascalls. Sanglada's stalls were supplied with misericords and handrests, which are still there, as well as some kind of above-seat structural

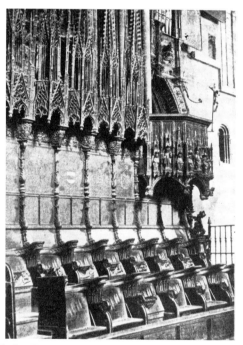

40. Barcelona Cathedral. View showing the three stages of the choirstalls. First row of seats, work of Matias Bonafe (1456–1459); second row, by Pere Sanglada (1394–1399); top, '*pinaculos*,' by Miguel Lochner and Juan Friedrich (1484–1497). To the right, the pulpit on which Sanglada also worked.

features, which have disappeared. They are referred to as 'tabernacles' in the *Libre d'Obra* (fabric record).[4] All we know about them from these documents is that they were painted, which is a distinctive enough trait, implying *mudejar* influence. But whether they were sculptured as well is not reported.

When, in 1456, the canons decided to have a second row of stalls made, Sanglada's assembly was set upon a platform and the new seats were deposited before it in the center of the choir. They were done by another Spanish master, Matias Bonafe, who had been instructed to keep his stalls very simple, the specific order being that he must refrain from making any figurative carvings. This is hard to account for on any other basis than taste, since Bonafe was paid 15 florins per stall (16,000 maravedis), which was about what sculptors in other churches received for figured seats. As it turned out, Master Bonafe did manage to match Sanglada's sculptured handrests with some of his own making. His misericords, on the other hand, were confined to foliar patterns.[5]

As their third component, Barcelona's stalls received at the end of the century a remarkable stretch of lofty spire-shaped canopies that were deposited on the top of each of Sanglada's seats. Heavily carved in ornate fretwork and bunched closely together, they convey a rather awkward, overdressed impression. They were the creation of two artists of Kassel, Miguel Lochner (1484–90), and his assistant, Juan Friedrich, who continued the series after Lochner's death, completing it in 1497.[6] The international imprint on Barcelona's stalls is not exhausted by these contributions however, other recognizable aspects being Flemish and English.

This mixture of stylistic influences was a result in part of the clergy's arrangements. There is on the record one important trip that Pere Sanglada undertook in preparation for his task, which was done at the request of the canons who cited as its express purpose his studying en route 'the most beautiful and impressive choirs.' Named in the document were the stalls of Gerona, Elne, Narbonne and Carcassonne,[7] all of which are located in or near France and suggest specifically its stylistic imprint. The stalls of Elne were hardly 'modern,' dating from 1294[8] (they have long since vanished). Those of Gerona, on the other hand, were produced (by named masters, one French, the other Spanish) only a few decades before Barcelona's, and their bishop's throne is still intact.

For another much longer voyage that Sanglada took soon after the first, a different purpose is given, but the artistic acquisitions are inescapable. The destination was Bruges and the order specified: 'to buy oakwood [*fuste de roure*] for the stalls.'[9] The indication that this was probably a different trip is suggested by the fact that Sanglada was paid separately for it, as he was for the horse ('*rozin*') that he rode on the journey, which cost '*12 libros, 13 sueldos and 11 dineros*.'[10] The idea that the master had to go that immense distance at a time

when, in addition to the ordinary perils of medieval travel, the Hundred Years War was ravaging various parts of France is daunting. What was the reason for risking it? Was it because, as has been suggested, the kind of wood that was needed for the stalls was not available in Catalonia?

It seems that this may have been the case and that the Barcelona area was indeed lacking in the hardwood that was indispensable for stall-making. Recent scholarship has revealed that most of Europe suffered at this epoch from penury in wood, whether hard or soft. The shortage had begun to be felt long before the fifteenth century, actually. The clearing of forests on a vast scale for the purpose of increasing tillable land had begun in the eleventh and twelfth centuries and, by the thirteenth, measures were already being widely adopted to protect the dwindling wood supply, an emergency that merely increased in later periods nevertheless.

The great maritime and shipbuilding industry of Barcelona, Spain's leading port, had early depleted its stock of wood, by the end of the fifteenth century and especially after the discovery of America, as Roland Bechmann has pointed out in a recent book: 'Spain . . . in her feverish construction of vessels needed to carry the gold from America and to assure her primacy of the seas, compromised for centuries her agriculture, her climate and even her survival. . . .'[11] We can understand, therefore, that Barcelona's canons should have found it necessary to import the wood for their new choirstalls, which could be sent advantageously from Bruges by the sea route, thus avoiding the enormous cost of land transport over even a relatively short distance. The cathedral's stalls benefited in this way in two recorded instances: for Sanglada's upper stalls in 1394 and for Matias Bonafe's lower ones in 1457–9. It was when the first stall-master was making the wood-buying expedition himself that he was able to study at length the pioneering work of the Flemish artists and to sustain their influence.

It is curious, however, that Sanglada's stalls, which make up by far the most important part of Barcelona's figured carving, should be assimilated as much to the English style as to the Flemish. This can be seen, for example, in the thin, elongated figures that were so much favored by the islanders in their delicate fourteenth-century alabaster sculpture and which Barcelona's stalls often match uncannily. The same affinity is found in another typical feature of English misericords, which is rarely duplicated elsewhere, but which Barcelona's underseat carvings possess. The English call it a 'supporter.' It is actually a supplementary carving that one finds on both sides of the misericord's central section to which it is often thematically linked. Supplied with these 'supporters,' Barcelona's misericords are at times indistinguishable from those of Lincoln, Ely, Gloucester, Chichester and other fourteenth-century English churches.

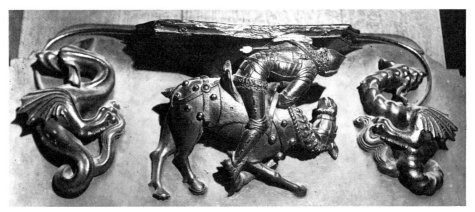

41. Lincoln Cathedral (England). Misericord of fourteenth century, 'The falling knight.' Note the two 'supporters' to left and right of central carving, an English specialty, shared by Barcelona's choirstalls.

It is intriguing to puzzle over where Pere Sanglada might have picked up the inspiration for these 'supporters.' Nothing permits us to assume that he visited England during his journey north. Nor can we say that he brought home with him an English master, whose name would have been included in the long list of artists that is available who worked on Barcelona's stalls. There was an English sculptor, Rainaldus de Fenoyll (Fenouil; Fennel), who has been identified as having worked at a monastery near Tarragona in the fourteenth century.[12] But the date was 1340, about fifty years too early for Barcelona's stalls, though not for Gerona's, which were done around 1350 and which also had 'supporters,' judging by the one remaining stall there (see Chapter IX, Fig. 35). In this respect, it must be recalled that Pere Sanglada probably had his artistic background at Gerona.

If, on the other hand, Pere Sanglada had seen examples on his trip north of 'supporters' in the Flemish stalls of Diest, Aarschot, Louvain, Walcourt, Hoogstraten or Bruges itself, supposing that one or more of these churches had possessed such features, we could not prove this today from their present appearance. For they are all 'new' sets that replaced the originals in the fifteenth or sixteenth century.[13] In any case the supposition is unlikely since the 'supporters' had for unaccountable reasons failed to find favor with the churchmen or sculptors of any other country. It was only in England that they established themselves as a constant stylistic 'necessity.' How the same thing happened in Sanglada's case at Barcelona, alone of all Spanish stalls, remains a mystery.

Pere Sanglada's reputation and his multiple responsibilities were translated

into monetary rewards that strike us at first as quite modest. He was paid $5\frac{1}{2}$ *sueldos* (sous; shillings) per day, whereas his assistants got from 4 to 5 sueldos. The smaller amount went to carpenters who did the general structural work, Maria Rosa Teres suggests, and the greater fee went to sculptors, who were usually designated as such.[14] In addition to his daily base pay, however, which in one year of 231 workdays totalled $63\frac{1}{2}$ *libros* (livres; pounds), Sanglada got a pension of 50 *libros*, which almost doubled his income. And there were other perquisites, perhaps.

In our study of French stall-work we found two methods of pay used, by the day and the piece. This same variation existed in Spain, though in most places during the period we are concerned with the system of piecework seems to have prevailed. This became the case at Barcelona itself for after Sanglada's group had worked by the day Matias Bonafe was shifted to payment by the stall. The 16,000 maravedis he earned was the same stipend that was paid at Sevilla twenty years later, in 1478, to a famous Flemish master, Pyeter Dancart.

When we began to study the iconography of Barcelona's stalls, we were struck by the grim sense of controversy, of polemical conflict that we found in them. There were strong religious overtones in this contestation, which reminded us abruptly that in 1391, only three years prior to the beginning of the work, an anti-Jewish pogrom of almost genocidal proportions had swept through Spain, reaching Barcelona in August, where the terror held sway for four days. The Jews took shelter in the New Castle, at the waterfront, with the aid of city officials who placed a guard there. This failed, however, to hold back the mass of armed peasants. Many of the Jews that were seized were baptized immediately; others who resisted conversion, which seems to have comprised chiefly women, were put to death.[15]

There is a highly dramatic misericord in the Barcelona stalls which appears almost to be commenting on these events. It presents three young women, who by their pious and submissive demeanor may have been meant to designate voluntary *conversos* who are in the act of being lapidated by two wrathful Jewish executioners. The presentation may seem oblique and contradictory to the reported happenings. But one must realize that topical church art would be more apt to convey a propagandistic note than serve as a medium of objective reporting. The misericord could, accordingly, have been seeking to rationalize Christian violence against the Jews by actually reversing the roles.

A number of other carvings resume the atmosphere of religious contestation that raged during this period. A second misericord illustrates the more placid form of disputation between Christian and Jewish divines that was commonly practiced in the Middle Ages at less agitated times. That it should be adverted

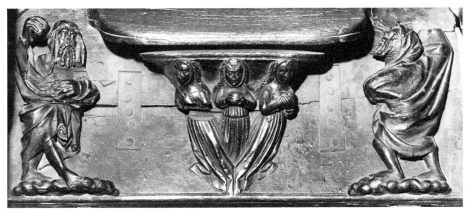

42. Barcelona Cathedral. Misericord possibly representing lapidation of three female *conversos* by irate Jewish 'executioners.'

to here may be a sign that a part of the clergy wished to eschew the prevailing rabid tendencies, by pleading for a more amicable relationship between the religions, which had long been traditional in Spain. But the spirit of the Church Militant prevails in Barcelona's choirstall art, as is shown in still another misericord where armed Christian women warriors are represented as being prepared to fight for their faith, which is symbolized by the cross and chalice that two other stalwart females in the 'supporters' hold aloft.

The general sense of doctrinal agitation that may have been felt by Barcelona's clerics at the time the stalls were made is further displayed by the extraordinary number of religious topics that can be found in them. There are almost a hundred such carvings, more than one-third of the total. This proportion is all the more amazing when one considers that Barcelona's art is limited to misericords and handrests, both of which are normally preserves of 'profane' expression. At Oviedo, for example, we counted only 6.5 percent of pious subjects in these categories, which is about average for the churches with figured Gothic stalls.

Barcelona's great number of religious themes in these usually secular media was no doubt prompted to some extent by the fact that its stalls lacked both the large religious figures or evangelical narrative reliefs that one finds in all the other sets. This deficiency could have encouraged its churchmen to use the only other available media as their vehicles for theological expression. Every possible religious or para-religious subject is depicted in the misericords and handrests: prophets, sibyls, apostles, saints, priests, monks, nuns, hermits, pilgrims, martyrs, Christian symbols, sermons, parables, sacraments, prayers, vices and virtues and an array of devils, witches and monsters, most of them

serving in the context of a struggle between Good and Evil and thus fitting into the prevailing polemical spirit of these stalls.

With much less space to work in than that furnished by the misericords, the handrests[16] usually confined their message to single figures, which were often set in an active posture however. One brilliant example found in the lower stalls portrays the mortal sin of Vanity in guise of a woman with a big double lavaliere of beads and a mirror in which to admire herself. And superbly histrionic is the artist's characterization of the vice of Lust, where, obedient to the savage scriptural command, 'If thy eye offend thee, pluck it out!,' a bearded man raises his fingers to the sinful orb, determined to carry out this punishment.

While the grapple with vice is amply represented in Barcelona's stall-art, the exemplification of virtue is by no means neglected. One cannot escape the endless featuring of prayer, of kneeling, the familiarity of the rosary, the Bible reverently held in silk-covered hands, the practice of the sacraments. Woman's stellar role is insistently stressed as the model for man to follow. Is it an unconscious accident? Yet, proper to the militancy of the time, her docile nature is often set aside in favor of a combative role that the male iconographers have assigned to her.

Symbolically, in one misericord, the two queenly women holding globe and scepter are given a lion each as their companions. Or again, they accost sword-armed grotesques with men's heads and roosters' bodies with their own fragile staves, confident of victory. Virtue is the mightiest of arms, other carvings proclaim. Possessing this alone, two other women have succeeded in capturing their corded monsters and set the iron rings on their necks. It is an

43. Barcelona Cathedral. Handrest of lower stalls: The Vice of Lust: 'If thy eye offend thee, pluck it out!'

act that is matched by the stalwart chatelaine who ties the devil to a cushion, according to the curious medieval prescription, while two officiants celebrate the triumph of virtue by intoning a psalm and sprinkling the embattled matron with holy water.

A positive role is stressed in the handrests as it is in the misericords, but under special evangelic tutelage. Already carved a first time by Pere Sanglada or his men, Matthew, Mark, Luke and John were strangely duplicated by Matias Bonafe. It was as though there could be no question but that each register of the stalls must have its own set, each winged figure – eagle, lion, cow or angel – being furnished with its reverberant scroll. The monotony of repetition caused no distress to the true believer. The self-same litany stemming from such illustrious sources never lost its efficacy, no more than did the attractiveness of the vision of an eternity in paradise filled with naught but psalmody.

One might think that the considerable number of misericords at Barcelona depicting caballeros and the life of leisure were meant to balance off the preponderance of religious themes, until one notes that the purpose of these carvings also is habitually homiletic. Sports that elsewhere would be simple diversions may take on here a morbid character. This is the case, for instance, of the misericord presenting a kind of hockey contest played between two men while lying on their bellies and striking the ball with paddles. The harried look on their faces seems entirely out of place until, suddenly, one sees the daggers that they hold firmly in their other hand. It is clearly a game of chance with life as the stake, a hazard of violent emphasis.

This ferocious intensity is doubled in the central scene of the carving, where two other men are playing the guessing game which Spaniards call *los chinos*. It has many modern variants, where the contestants conceal coins or fingers behind their backs and suddenly reveal them to their opponents. We were told that *los chinos* was prohibited by the authorities; late one night we noticed it being played on a dark corner near *Las Ramblas*. All activity stopped as we approached. In medieval times gambling was considered a mortal sin. It is so presented in Hieronymus Bosch's famous Hell panel of the 'Garden of Delights' at the Prado[17] and must be interpreted in that sense in this remarkable misericord at Barcelona.

It will be noticed that the caballeros in this carving and in many others are wearing strangely elongated shoes, a style that was harshly castigated by the clerics of the time. It is difficult for moderns to grasp the powerful moralistic animus of this condemnation. The shoes were probably regarded as one element of a kind of synergistic complex of sin. Profane music (and dancing) was another facet in these vice-conscious stalls of Barcelona and there are

44. Barcelona Cathedral Misericord. The Vice of Gambling. Condemnation of the amusements of the caballero class. Center, game of '*los chinos*', at sides, paddle hockey, accompanied with daggers.

scenes in which the two prohibitions are joined. In one of these the disingenuous nakedness of the couple in the 'supporters' is highly suggestive.

While the fancy clothes of the caballeros were a universal attribute of contemporary Spanish life,[18] it is of interest to point out that the same kind of dress appears in English stall-art of the period. At the New College Chapel of Oxford there are several carvings illustrating this, one misericord in particular[19] showing a group of five brawling young noblemen who are exact replicas of their Barcelona homologues, wearing the familiar long-pointed shoes and short striped tunics with the same big buttons down the center and on the sleeves. Their bushy hair gathered at the back is likewise repeated in both cases, as are the round-bladed daggers that they flaunt with violent intent.

That clerics should have been so exercised over these extravagances of dress and conduct may well have been because many young priests were strongly attracted to them, as is frequently reported in the church literature. This seems to be alluded to in another misericord at Barcelona that is marked by extraordinary emotional turbulence. Two richly attired caballeros have seized hold of a pair of howling monks as though seeking to drag them toward their own life of sin. The resistance of the victims is a vain show. Rather than pushing their aggressors away they hold tightly onto their arms, while their own pointed shoes reveal their secret willingness to submit to a dissolute life. The canon-iconographer responsible for this harrowing scene was clearly without indulgence for the young friars.

Two-fifths of Barcelona's handrests have a religious or moralistic meaning. But the remainder leave plenty of leeway for the development of secular

45. New College Chapel of Oxford (England). Misericord of five brawling young gentlemen. Note similarity of their clothes, hairdress, etc. to those of the *caballeros* in Fig. 46.

46. Barcelona Cathedral Misericord. A token resistance: Threat of the attraction of the secular life to the monastic community.

themes, which is particularly true of the carvings done by Sanglada's group: a woman ladling food from a pot; another making waffles: still another carding wool; a man sewing a shoe; a child wrapped in a quilt; a boy sitting on a camel; a beautiful lady in a garden; a woman playing a tambourine; a man and his dog; a chained dog, barking; a wolf with a rabbit in its jaws; a man loading a crossbow. There is a place for mystery too, like the graceful carving of two gambolling boys holding a bird on a cord. This may, however, symbolize the punishment of intellectual arrogance, in this case that of man's recurring dream of flight. Finally, one would expect especially to find some topical references to Barcelona's port life, which is the case in fact, as seen in a splendid

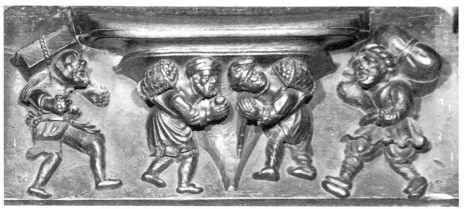

47. Barcelona Cathedral Misericord. The punishment of intellectual arrogance: The dream of flight and the tumble.
48. Barcelona Cathedral Misericord. Stevedores carrying loads at the port.

misericord of four stevedores carrying heavy loads, on back, on shoulders, on head, and moving in several directions to emphasize their 'busyness.' In another underseat carving boatmen are shown bringing their craft to shore.

Scenes from farm life are not lacking either, four handrests seeming to fit into a series known as the 'Labors of the Months,'[20] which frequently appear in other categories of church art from as early as the twelfth century. These subjects have been assigned a homiletic denotation based on the theological concept of 'redemption through work,' which we have interpreted elsewhere as having been inspired possibly by the motive of placating the great revolutionary movements of the serfs which were rife in medieval times.[21] From this viewpoint the Labors would be assimilated to Barcelona's focus on religious themes.

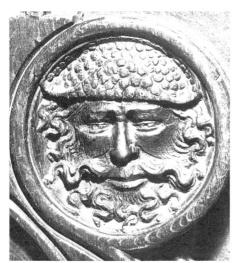

49, 50. Barcelona Cathedral Handrests (1456–59). Portraits of seafaring men, a topical subject of Spain's great medieval commercial port.

An utterly unique feature in these stalls, very rarely found elsewhere whether in Spain or any other country, is a series of realistic portraits. They are entirely concentrated in the handrests, ten of them in Sanglada's upper stalls and no less than forty-one in Bonafe's lower seats, where they make up almost half of the total. Aside from these 'likenesses', in fact, we find only two other categories of subjects among the lower-stall carvings: religious themes and fantastic animals or grotesques.

It is as difficult to account for this great mustering of portraiture in Barcelona's handrests as it is to explain the 'supporters' in its misericords. Still, one is rather inclined to imagine some social or cultural impulsion for the portraits, whereas the 'supporters' were probably due to stylistic emulation. One is tempted to suggest that Barcelona's background as a great commercial port may have helped to develop its art of portrayal. The important ship traffic no doubt brought a motley mass of people to the city from all over the known world and this rich variety of types and races could hardly have failed to sharpen the artists' vision, ripening a power of psychological observation that is seldom met with in the wood sculpture of that period.

Among these portraits at Barcelona, some of the most striking carvings are the remarkably evocative representations of seafaring men. Weatherbeaten and wearing exotic headgear, their rugged personalities speak out of their expressive faces and eyes. Eyes that are slit as if in permanent accommodation to the sharp, salt-laden winds; eyes that reflect a luxuriant remembered world

of wonders seen. These vibrant people of Barcelona's handrests, and their profound humanity, stand as a strong alternative to the mystical content of so much of its other carving.

But there is no disharmony between these two phases of Barcelona's stall-art. Created at a time when Spain, all of Europe in fact, was poised on the delicate breach of change, it is natural that it should reflect the double facets of this transition. So do the other figured Gothic stalls, as we shall see, this one stressing somewhat more the sacred part, that other the profane. So richly illustrated, these great assemblies are a perfect medium to capture man's dichotomous existence: the material and the spiritual, the here-and-now and the eternal, two intricately related worlds held in sensitive balance.

The Church's Artistic Reply to Heterodoxy

Our major interest in undertaking the study of Spain's other figured stalls was the desire to bring Oviedo's assembly out of the limbo into which its near destruction had cast it. Its partial recovery had established the potential basis of relating it to one or more of the other groups. An obvious beginning could be the choirstalls of Leon. Located just across the Cantabrican Mountains about seventy miles from Oviedo, the episcopacy of Leon had long maintained the closest relations with the Asturian diocese. That it should have exerted an influence on its cathedral art as well was a likelihood that would have been limited only by chance and opportunity. This would have applied particularly to the choirstalls, since Leon was a pioneer in the field, its set having been built a quarter of a century ahead of Oviedo's.

As has already been said (Chapter IX), one of the important characteristics of the stall-art of Leon and of the other churches that followed its lead was the possession of large figures, prophets and patriarchs, apostles and saints. These busts and full-length statues tend to give an overriding religious imprint to these assemblies, which obscures their other, largely secular art. The emphasis was intentional and was meant to stress an urgent message. If this were not so, it would be difficult to understand the presence of so many important Jewish personalities in a cathedral choir, all so beautifully carved and so prominently displayed. One might almost imagine the existence of a broad ecumenical conviction among the churchmen responsible for this amazing iconography.

This conjecture would be entirely wrong of course. For it was not the Old Testament *per se* that medieval churchmen were interested in, nor its stories, however fascinating they might be. 'The stupendous poetry' of the Old Testament was lost on the early Christian exegetes, as Emile Mâle has pointed out.[1]

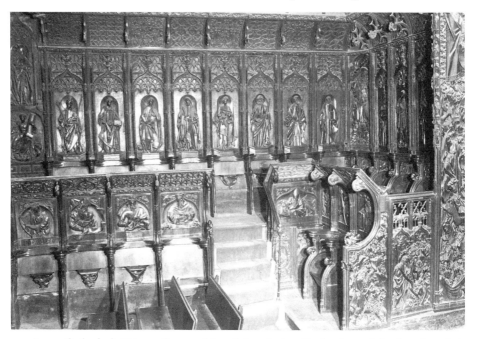

51. Leon Cathedral. View of ensemble of the choirstalls (1467–1481), showing their iconographic richness: the full-length religious figures in the upper-stalls, the busts in the lower-stalls, plus the wealth of minor sculptured features: misericords, handrests, roundels, side-reliefs, terminals, as well as the above-bust canopies, which are decorative.

What they saw in these ancient Jews was symbolic rather than substantive. According to their reading of scripture, it was what linked Adam and Abraham, Isaac and Jacob, Joseph and Moses to *Jesus and Mary* that gave them all their importance. The Old Law, as it was called, was nothing but a veiled prefiguration of the New Testament, its true meaning having only been brought to light by Christian interpretation.

Jesus Christ himself had started the process when he had linked Jonah's presence for three days in the whale's belly and eventual release with his own predicted resurrection from the tomb in that space of time. Paul, in his Epistle to the Hebrews,[2] explained that Jewish ceremonies were merely rehearsals for the Christian ritual. The evangels were pregnant with similar elucidations, St Matthew repeatedly referring to some act or word of Jesus as being done or said so that some writing of the Old Testament might be 'fulfilled.'

The search of scripture for its concealed meanings was intensified by the early doctors, Ambrose, Jerome, Augustine, Gregory the Great.[3] They not only demonstrated how the Old Testament patriarchs 'prefigured' the Messiah

118

by their experiences but also construed the mysterious sayings of the prophets as limning many of the basic doctrines of the Church. These verifications were collated in the high Middle Ages by Isidoro de Sevilla, Walafried Strabo and other early anthologists, then expanded and popularized by twelfth- and thirteenth-century writers like Honoré d'Autun (Honorius Augustodunensis), Vincent de Beauvais and Jacques de Voragine (Jacopo de Varazze, compiler of the 'Golden Legend'), who were the chief inspirers of the vast tide of symbolic art that engulfed the Gothic epoch.

Thus Isaac carrying the wood for his sacrifice would be shown with two transverse beams, an allegory of Christ bearing the cross. The murder of Abel by Cain, the firstborn, foretold Jesus's crucifixion by the Jews, jealous of their seniority. Moses's vision of the brazen serpent was a further figure of the crucifixion and Melchizedek's offer of bread and wine to Abraham was an image of the Eucharist. It was actually Mary that Moses saw in the burning bush, 'receiving the divine flame without being consumed.' And the immaculate conception was imaged by Gideon's golden fleece, on which the dew settled after passing through the air without leaving a trace. The prophets too were endlessly productive of revealed meanings: Isaiah predicting that a flower would blossom from the stem of Jesse (Mary); Jeremiah describing the grapes crushed in the winepress (the body and blood of Christ); Balaam foreseeing the star that would be born of Jacob (Jesus Christ). . . .

Deployment of the great carved biblical figures in a few Spanish choirstalls at the end of the fifteenth century was taken up and expanded in the sixteenth. Was this due to esthetic persuasion or the accident that artists arrived in great numbers from places where such figures had become the fashion? What then had brought on their popularity in their native countries? We are inclined to think that the appearance of the new type of choirstall figuration, even if partially answering an esthetic taste, responded to another motivation as well that was of far greater consequence to the cleric-iconographers.

More and more sharply, in the fourteenth and fifteenth centuries, the Catholic Church was assailed by heresy, until at last it found itself before the most serious challenge in its history, which imperilled many of its basic tenets and through them its institutional integrity. The Church's reply was manifold and one of its most powerful instruments was art. The great choirstall figures were an element of this response, both the allegorical Jewish figures and the Christian hagiographic giants serving to remind the faithful of the Church's divine origins as well as its extraordinary background of fifteen centuries of tradition, continuity and growth.

Carrying the direct burden of its message were the great Christian statues in the upper stalls, most of them repeated in all the sets: Mary (shown in

the Annunciation); the twelve apostles; Paul; close associates of Jesus, like Stephen and Mary Magdalene; the four evangelists; and about a dozen other prestigious later saints such as Catherine, Lawrence, Nicholas and Francis. One also found some Spanish favorites, Lucia, Barbara, Jerome, Anthony, Blase; and Christian warriors whose role had been elicited by the 'reconquest,' Sebastian, Martin, Claudius, and especially the archangel Michael, shown garbed at times as a caballero fighter. Santiago (James-the-Greater), who was earlier popularized in Spanish art as the '*matamoro*' ('killer of the Moor'), did not appear in this personification in the choirstalls, having assumed by then a more apostolic guise in keeping with his station as the patron saint of Spain.

The repetition of these important figures was supplemented by the occasional choice from a variety of minor saints who could swell the chorus of those attesting to the divine message. The apocrypha and the rolls of pagan witnesses were also culled toward this end. The appearance, for example, (at Astorga) of Nicodemus, author of the unauthenticated 'fifth' evangel,[4] was meant to recall Christ's descent into limbo to free the great figures of the Old Testament from their anomalous detention, whose liturgical role was described in the words with which Jesus was said to have addressed them: 'Come to me, all my saints who were my image and resemblance.'

Thus too was the inspired word of the great pagan visionaries[5] recorded, like that of the Tiburtine sibyl whose striking features could be seen among the lower-stall busts at Leon, haloed by her long-stranded berry-filleted hair and pointing a dramatic finger at a naked little Christ in a spandrel who is almost lost amid a thicket of twisting scrolls. These Roman oracles, whom Michelangelo brought to such brilliant realization at the Sistine Chapel, were comparative latecomers among art-employed forecasters of Jesus Christ. A similar posture was that of Virgil, Rome's leading poet, who appears in Zamora's stalls, holding a copy of his famous 'Eclogues' in which the Savior was 'announced.'

Though the other sets of the Leon group often duplicated its iconography, this by no means excluded originality, even in the treatment of the same subjects. These differences are usually so great as to rule out any chance that they could have been done by an identical artist or even the same workshop. Their diversity shows up not only in character attributes but also in props and inscriptions which are meant to emphasize important theological concepts.

Thus, at Leon, the inscription on Moses's tablets affirms the great innovator's monotheism which was already announced in the Old Law: '*Unum Crede Deum*.' Zamora's Moses, in contrast, promises that he will rouse the people. Psychologically, the patriarch is acutely varied in the four linked sets. At Leon he is sharp-featured, tight-lipped and stern, somehow close to the evangelical type of the Protestant divine. Oviedo's Moses, who shares with

Leon's the pointed, twisted horns, is nevertheless more humane than the other, sad rather than severe. And the traits of Zamora's emancipator have been further softened, his horns disguised beneath waving tufts of hair. His background setting, closer to Renaissance than Gothic in style, is copied in every detail by Astorga's Moses (dated *c.* 1520),[6] whose features have been frozen into a kind of manneristic mask.

Most of Zamora's other Old Testament figures, however, are imbued with all the fierce combativeness that the troubled times demanded. Robust and determined, their strength resides mainly in their intensely glowing eyes. Seers' eyes that are possessed by some stupendous vision, like Abraham's, round and enormous, that stare out of the great head enclosed in its patriarchal beard. Whether turned upward like those of Daniel or Ezekiel or downward like Nahum's or Zachariah's which are fixed on the inscribed words of their own prophecies, it is by their burning eyes that these characters of the Old Law mark the overwhelming nature of their discovery. So it is with Job whose trials are over, his fortunes restored; with intense restrained, inner force he unfurls the scroll bearing the tremendous message that was meant to give hope to all men: '*Ab Terra Resurrecturus!*'

But all of this is strangely altered in the upper-stall figures both at Zamora and Leon, where a qualitative shift has resulted in a kind of Peruginesque sweetness. At Leon, the instruments of martyrdom are carried so delicately

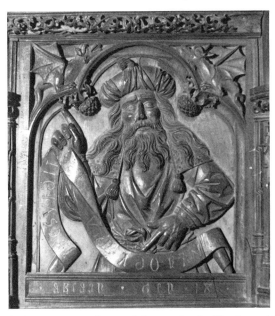

52. Zamora Cathedral. Lower-seat bust of the patriarch Abraham, his eyes of the seer centered on the 'one God' that he 'adored.'

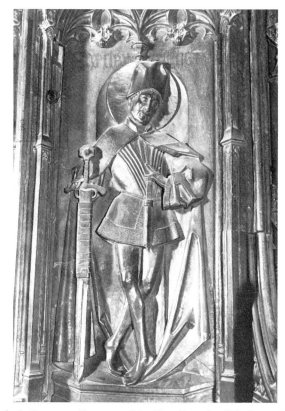

53. Leon Cathedral. Upper-stall statue of St Claudius, dandified warrior-saint, a strange symbol of altered esthetic taste.

as to render them innocuous. Particularly incongruous is the huge sword which is merely finger-touched by the warrior-saint, Claudius, whose elegant crossed legs and effeminate stance almost make one feel that irony was intended, which could hardly have been the case.

There could be very little doubt that these stylistic appearances were dictated by taste which was fast evolving away from Gothic severity and which affected the upper-stall art especially, which was usually done last. At Zamora the contrast between the lower and the upper figures is even more pronounced. The Christian personalities are marked by an incredible mawkishness: heads tipped sidewise, soulful eyes. The lack of virility in St Michael as warrior is almost ludicrous. The archangel seems an overgrown adolescent incongruously dressed in full armor who directs the point of his frail-staffed cross into a tiny Satan's craw with an almost apologetic gesture. But the theological significance remains intact, to be sure.

The fervent desire of the Church to restore faith in vacillating Catholics is reflected in other stall carvings besides the great figures, though the big majority of them are profane in iconographic content. At Leon, not only are the vices excoriated, but a series of important topical references are likewise given a religious sanction. Several of these may also have to do with the sharp challenges to the royal power that were prevalent in the fifteenth century. Isabel Mateo Gomez has conjectured that one of the side-reliefs showing a decapitation scene is probably a reference to a leading personage of the time, Alvaro de Luna.[7]

High constable under King Juan II (1406–54), he was later involved in the struggle of the nobles against national unification, which threatened their privileges. The execution is presented with dramatic verve in the presence of a number of what appear to be high military and political figures. There is no gesture of religious indulgence shown and it is left to the victim to make his own peace with God. His head, with eyes bound, is deposited before his kneeling body, while his hands are tipped as they supposedly were at the moment of his beheading.

This and several other scenes all have an inescapable sense of contemporary reference. That they should be found in the cathedral choir at Leon reflects the importance of this city and its church in the affairs of Castile and incidentally in the persistent civil strife that roiled that kingdom during the first three-quarters of the century. Divine intervention was required to end these sanguinary struggles, another carving seems to be saying which shows an angel halting a combat between a Christian fighter and a great diabolic opponent. Certain obscurities remain in this suggested interpretation[8], however, the most baffling one being that if the Church was so eager to sustain the desire for peace, would it have gone so far as to compact with the Devil?

Leon's stall-art not only shows concern for the great socio-political issues of the day (and we shall see other church assemblies doing the same), it is infused with moral sensibility, which vibrates under the aegis of that most valiantly virtuous of Christian saints, St Anthony. Gambling, which was often condemned by the contemporary church as the most dangerous of vices,[9] is castigated at Leon in the guise of a nobleman whom a demon is preparing to drag off to Hell. And other iniquities are posted in caustic and often cunning images: the glutton who needs a wheelbarrow to transport his enormous belly;[10] another who gobbles his food like an animal; the thief who cuts the priest's purse during confession; the leering sadistic monk who rides the naked buttocks of the student whom he whips. And there is a constant dinning away at drinking: the ephemeral joy of it; the maudlin states it imposes, as even in a Clarissan nun, or in a bestialized man who is strapped to a wine-barrel or another who lies in a tight embrace with a plump wineskin whose teat

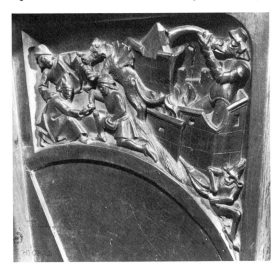

54. Leon Cathedral. Lower-stall side-relief. The Vice of Gambling. A demon prepares
to drag some noble sinners off to the waiting Hell.

he sucks as though it were his mother's!

And lust is there, too, a pillory of scorn, its victims both lay people and
clerics. At Leon a young prostitute bathes with a monk whose ambivalent
posture of mixed attraction and rejection gives the incident a melancholic turn.
A layman in the same action at Zamora makes a gay scene of it, with food
and drink and even a masseur to rub his back. Laic or cleric, the masculine
assault was often the same, by the surreptitious hand, the female's role being

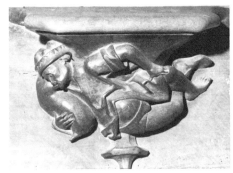

55. Leon Cathedral Misericord. A sado-erotic monk straddles the naked bottom of the
student whom he whips.
56. Leon Cathedral Misericord. The Vice of Drunkenness. A man in a glimmering sodden
world hugs a wineskin in a return to infancy.

57. Leon Cathedral Misericord. The Vice of Lust. A young monk puts on a show of resistance.

passive or resigned, particularly in the confessional act. The frankness of these scenes deludes the modern eye which tends to see lascivious or scatological subjects everywhere. But some are hardly scabrous, being actually medical gestures, as close scrutiny shows. This holds also for the peasant who shows his concern for his cow's well-being in lifting up her tail or where a monkey mimicks a doctor's observations.

The coarse carvings at Zamora of proctoscopic remedies are typical of much

58. Zamora Cathedral Misericord. The Vice of Lust, compounded by the so-called sin of 'Solicitation during the Confession.'

59. Leon Cathedral. Lower-stall Roundel Sculpture. An elegantly dressed physician prepares a clyster for an anonymous patient.
60. Leon Cathedral. Lower-stall Roundel Sculpture. Expert horsewoman, she rides her spirited mount without the aid of stirrups or bridle.

of the work in that assembly. At Leon, in contrast, the medical act is administered with dignity, as in the striking terminal scene of a Jewish doctor examining a vial of urine. Elegant too is the cloaked physician delivering the clyster to an anal aperture of anonymous appurtenance, an act that is often the source of uproarious imitation elsewhere. This exquisite roundel carving done by an unknown sculptor, no doubt a specialist in this difficult field, is matched by other gems of the same category at Leon, like the graceful male dancer; the musician with bagpipe and percussive; the two riders mounted on handsome horses, the woman sitting expertly without stirrups or bridle.

Leon's broad ethical preoccupation which inspired its carvings against depraved practices,[11] was almost totally ignored at Zamora and Astorga. A rare exception in a misericord of the latter happens to be one of the most wanton of subjects, a very realistic homosexual act between two men, which is treated in several other Spanish choirstalls, indicating the concern of the clergy on the subject for their own members also, which is corroborated, moreover, by the Inquisition's archival records. But in the main Astorga's art tends to evade moral responsibility to the extent of shifting censurious acts to amorphous creatures falling somewhere between demons and monkeys. Fully dressed and anthropomorphic, they are seen drinking, fighting or playing cards. One of the card-players is smoking a pipe, which could be an historical 'scoop' since the misericord is dated hardly a quarter of a century after Colum-

61. Astorga Cathedral Misericord (post-1525). The card-players. A prop that associates them with the 'New World' – a tobacco pipe.

62. Zamora Cathedral Ramp Sculpture. Woman washing her hair. Incitation to Vice of Lust or 'encouragement of hygiene?'

bus had first seen the Indians of the Antilles indulging this dissipation.

The catalogue of vices has varied considerably in time, both for the Church and its adherents. It is hard to agree at any event with the view that the beautiful carving on a ramp at Zamora of a naked woman washing her hair is an allusion to lust, as has been suggested by one author.[12] The argument is that the Church considered such an activity in a woman as being dictated by the desire to attract a man. The assumption must be, accordingly, that such a scene would be incongruous on a church stall if not seen as a warning against licentiousness. But placing this lovely female body in the constant view of canons and priests would be a peculiar way of sermonizing them on the dangers of sex. It would seem no more difficult to assume that the early churchmen saw the scene as an encouragement of hygiene, bathing having been very popular in medieval Spain, where it was an acquisition from the Moors.

There is, on the other hand, a considerable overlay of anti-Moslem sentiment at Zamora, which is most strikingly typified in a pair of handrests carved prominently on the bishop's seat. Two Moslem boys (recognized by their turbans) are seen here fighting, bitterly and dangerously. The one who is standing in a superior position seems to be preparing to take cruel advantage with his dagger on his opponent, who holds a weak purchase on his assailant's hair while slipping desperately beneath him. Meanwhile the pair of boys on the

 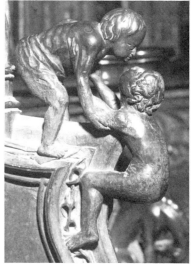

63. Zamora Cathedral Handrest Sculpture, one of a pair on the bishop's throne. Two Moslem urchins fighting 'without quarter.'

64. Zamora Cathedral Handrest Sculpture, the second of a pair. Contrasting act of a Christian boy, helping another in distress.

other seat-arm, in exactly similar positions, are engaged in a totally contrasting action. Sweet and gracious, the standing boy has reached under the arms of his companion and is proceeding to help him up. Is this not meant to be an object lesson of charitable conduct by Christian youngsters in distinction to the egoistic savagery of the young infidels?

It is a curious thing that the Virtues so rarely appear in choirstalls. This may be because sermonizing lends itself more aptly to the negative approach. Even in the morally-conscious set at Leon, Virtues are hard to find. The loveli-ness of Charity presenting her breast to a young animal makes one wonder why this example was not more contagious. Of all the sets in the 'Leon group,' Zamora's devotes the greatest interest to righteous acts, though they are of limited scope, dealing with the clerical community: hermits reading, praying and confessing; priests in lively 'disputation' before open texts; a teacher with the indispensable wooden ladle raised over his students' heads. Much more typical at Zamora, however, are the traits of merry-making and fighting. But there is no basic contradiction in the featuring of these opposing types of activity in the same set. Zamora's art is often rough, vulgar and disorderly, but it is rarely sinful in the doctrinal sense, its incidence of Vice being the lowest of all twelve sets: a mere 0.3 percent!

We had earlier assumed the existence of a separate category of four of the twelve stalls – the 'Leon group' – based solely on their possession of above-seat busts or figures. The question later rose, however, as to whether these sets truly constituted an ensemble with closer coordination among themselves than with other sets. To check how the various churchstalls were related to each other, a simple test was devised based on all the carved elements that are found in the figured assemblies. Five of them might occur in both the upper and the lower registers: misericords, handrests, side-reliefs, friezes and above-seat figures; whereas two others appear only in the lower stalls: canopies and roundels.[13] Thus we came up with an even dozen (five-times-two plus two) carved features whose presence or absence we recorded for each of the twelve sets. The degree of affinity between any two of them, we postulated, would be defined by the number of these elements that they had in common (see Table II).

The demonstration of a strong relationship among the four 'Leon' sets worked out surprisingly well by this method, with Zamora, Astorga and Oviedo[14] each sharing ten of the twelve features with the 'mother' assembly. As for Zamora and Astorga, the affinity between them was total – twelve out of twelve – which seemed to corroborate the view of various authors that Astorga's set, which was begun about ten years after the completion of Zamora's,[15] had closely patterned it throughout.

To complete the test, a comparison of the Leon assembly with the other major series of stalls, those following the Sevilla model (with narrative friezes instead of the big figures), was then tried. And here, the negative results were as consistent as the positive showings had been in the other group, with Sevilla, Plasencia, Ciudad Rodrigo[16] and Yuste all revealing a concordance of only five of the twelve features with those of Leon. Toledo's Gothic stalls[17] (which also belonged to the 'Sevilla group', though they were limited to a single register) showed a concurrence of no more than three of the seven carved elements when compared to Leon's lower seats.

Manuel Gomez Moreno and other authors in his wake have sought to draw a close link between the stalls of Zamora and Plasencia, even attributing the former to the hand of the famed Rodrigo Aleman, who is known to have been associated with Plasencia's assembly. Checking Table II, we find an immediate challenge to this suggestion since the two sets have a correlation in only six of the twelve carved features. The test of similarity falls down in the comparison of style as well, with subtle criteria like eyes, hair and head-covering as well as other elements showing great differences. Those supporting the claim of the Plasencia-Zamora affinity do so on the strength of a shared immorality in the subject matter. This is due to a misreading, however. While Plasencia's iconography is indeed preoccupied with condemned vice, its incidence being the highest of all of Spain's sets, 18 percent[18] (the nation's average is 4.4), Zamora's is by far the lowest, as we have seen.

It was evident, therefore, that the three derivative sets of the Leon group (Oviedo, Zamora, Astorga) had closely copied their model, while the other figured assemblies had slight correspondence with it. The unity of the Leon group was found to be limited, however, to the overall *composition and arrange-*

TABLE II: Correspondences among the twelve figured Gothic stalls as based on possession or lack of sculptured features. Degree of affinity is postulated on the number of positive and negative markings held in common. Note the high concordances among the four sets of the Leon Group and among the five sets of the Sevilla Group, both being listed in sequence.

Note also that possession of above-seat busts or figures and friezes is almost perfectly interchangeable between the two groups. In this regard, Ciudad Rodrigo is listed as being without a frieze in the lower register because the one it has is foliar and non-figured.

Only the twelve sets listed have been included in the category of 'Figured Gothic stalls.' Talavera de la Reina has been excluded because its sole carvings are misericords. Other sets (like Celanova) have likewise been excluded because of the confusion of Gothic and non-Gothic work or because of the serious doubts that they are Gothic (like Dueñas).

TABLE II

CHURCH & DATES	LOWER STALLS								UPPER STALLS			
	I. BUSTS	II. MISERI-CORDS	III. HAND-RESTS	IV. CANOPY RELIEFS	V. ROUNDELS	VI. FRIEZES	VII. SIDE-RELIEFS	VIII. FIGURES	IX. MISERI-CORDS	X. HAND-RESTS	XI. FRIEZES	XII. SIDE-RELIEFS
1. *LEON* 1467/68–1481 (?)	YES	YES	YES	YES	YES	NO	YES	YES	YES	YES	NO	YES
2. OVIEDO Pre 1492–Pre 1497	YES	YES	YES	YES	NO	NO	YES	NO	YES	YES	NO	YES
3. ZAMORA 1496–1507	YES	YES	YES	YES	YES	NO	NO	YES	YES	YES	NO	NO
4. ASTORGA 1515 (?)	YES	YES	YES	YES	YES	NO	NO	YES	YES	YES	NO	NO
5. *SEVILLA* 1464–1478	NO	YES	YES	NO	YES	YES	NO	NO	YES	YES	YES	NO
6. PLASENCIA Pre 1497–Post 1503	NO	YES	YES	NO	YES	YES	NO	NO	YES	YES	YES	NO
7. CIUDAD RODRIGO 1498–Post 1503	NO	YES	YES	NO	YES	NO	NO	NO	YES	YES	YES	NO
8. TOLEDO 1489–1495	NO	YES	YES	NO	YES	YES	NO	—	—	—	—	—
9. YUSTE 1498–1506	NO	YES	YES	YES	NO	YES	NO	NO	YES	YES	YES	NO
10. BARCELONA 1394–99 1456–59 1484–97	NO	NO	YES	NO	NO	NO	NO	NO	YES	YES	YES	NO
11. BELMONTE 1453/54–1460	NO	YES	NO	NO	NO	NO	NO	NO	YES	YES	YES	NO
12. NAJERA 1493(5) (?)	YES	YES	YES	NO	NO	NO	NO	NO	YES	YES	YES	NO

ment of the parts. A close check of the carving, on the other hand, revealed little kinship among the four assemblies! Even in the two sets so closely linked as Zamora and Astorga the resemblance was superficial, the Astorga artists appearing like heavy-handed apprentices or youthful imitators of their more mature prototypes.

In comparing the sculptural style of different sets the misericords have often been used, no doubt because of their general availability. Also, individual peculiarities easily surfaced in the underseat carving. It was a difficult form to work with even for the professional. Its small and horizontal field posed constant problems with reference to the size of figures, the relationship of their vertical and horizontal dimensions. The Leon artist, though highly skilled, was probably unfamiliar with this type of carving when he got his assignment and went about it as though he had much more room than was actually available, producing enormous figures that overwhelmed the spatial contours. Fortunately he had confined himself to single characters, but even these often had to be distorted to fit, twisted out of context, thrown on their backs.

Zamora's chief misericord creator, on the other hand, had solved these technical difficulties more deftly. His use of two or three smaller figures instead

65. Leon Cathedral Canopy Relief: Exotic personages inspired by discoveries and dreams of the exploratory period.

of one large one fitted perfectly into his narrative, highly communicative art. He was folksy, vulgar, gay, raucous, volatile in emotion, quick on the draw. One was impressed that the common people of the time (Flemish, in Zamora's stalls) were like that, curiously resembling the characters in Gerard Dou's or Adriaen Brouwer's paintings, though predating them by a hundred years or more.

The designer of Oviedo's stalls, like the creators of the other sets of the 'Leon group,' had, as we have suggested, been an obedient follower of the arrangement of the Leon set[19] while their sculptors had varied sharply in style and interpretation with those that had carved the pioneer assembly. This can be seen both in the larger figures and in the smaller ones, where nevertheless an occasional similarity of subject can be found, which could have been the result of simple copying, however. But the vast number of the profane pieces in the two sets are utterly different in their iconography as well as in their execution. There is nothing at Oviedo, for example, that compares with the complex narratives of Leon's full-panoplied side-reliefs with their tense, dramatic socio-religious overtones. Oviedo's carvings consist of the more usual fables, animals, monsters, foliar subjects and domestic scenes.

In one respect there was a close stylistic influence that Oviedo's stalls (as well as Zamora's) did absorb from their model set. They had taken eagerly to Leon's lower-stall canopies but far surpassed them in delicacy of design. Leon's heavily formed and crowded patterns were much lightened and aerated in both of the other sets. In the canopies of Leon and Zamora, however, a feature of great topical interest appears in the guise of strange, savage men, seen in a forest, veritable Calibans, no doubt inspired by the discoveries of the great exploratory period that was underway.

CHAPTER XII

Iconography of a 'Society at War'

Spain has suffered from excessive modesty in regard to its choirstalls, as indeed it has tended to do about other facets of its medieval esthetic creation. This is the fault largely of its dependent position during the long period of the political reconquest of its autonomy, which brought hordes of foreign builders and artists along with the soldiers, clerics and merchants to the reclaimed territories.

In particular, the tradition of the overwhelming role of Flemish artists in the production of Spain's figured Gothic stalls has lived on sturdily into contemporary times. Names such as Rodrigo Aleman, Pyeter Dancart and Juan de Malinas, together with other nameless suppositions, have given the men of Flanders an almost exclusive position in this tradition. We ourselves accepted this claimed preponderance until we discovered some of the exaggerations on which it was built, learning, for example, that Dancart's role at Sevilla was relatively minor compared to that of the Spaniard Nufro Sanchez, whose powerful pioneering architectonic influence even the great Rodrigo Aleman experienced.

Our realization of the very close coordination between the stalls of Sevilla and those to which Rodrigo Aleman's name is attached (Plasencia, Ciudad Rodrigo, Toledo and Yuste Monastery) resulted from an extension of our test of the 'twelve carved elements' to the other figured stalls of Spain. The 'discovery' was nothing short of breathtaking in the case of Plasencia (the first full set done by Aleman), where the association with Sevilla was total: i.e. in twelve of the twelve categories.

So complete a concordance between Sevilla and Plasencia (and only slightly less – eleven of twelve – with the other Aleman sets) could have been possible only under one of two conditions. Either the two sets were done by the same

artist or one of them had served as a pattern to the other. Since it has been established that Rodrigo Aleman began working at Plasencia in 1497 and that Sevilla's stalls had been practically completed almost twenty years earlier, the choice between these two possibilities seemed to be forgone: Sevilla's assembly had been the model for the other set.

This conclusion is fully corroborated when the two sets are examined architectonically, section by section. It then becomes inescapably apparent that Rodrigo Aleman had diligently reproduced Sevilla's stalls when designing the Plasencia set. Indeed the proof is spectacular. The evidence sticks out not only in the overall arrangement but also in many particulars, including some that would have seemed too minor to bother about. All this can be studied section by section as one lays reproductions of the two sets down together.

Starting at the overhanging crest, between the finials that crown the stall divisions, are first a looped series of inverted arcs, then a narrow intermittent frieze of varied filigreed patterns, below which is a group of suspended trilobar ogives. All these details are repeated in the two sets. So also are the protruding pillarets that frame the stalls, each bearing a small robed figure standing on a pedestal. Behind this jutting overhang one finds in both stalls a forward-curving quadrant which is decorated below by a rinceau followed by a heavy horizontal bar beneath which begins the great panel.

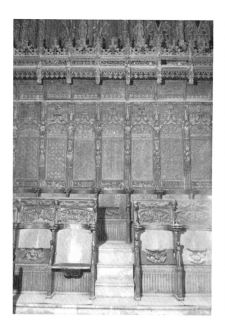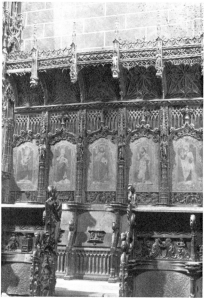

66. Sevilla Cathedral. Partial view of ensemble of stalls (1464–78).
67. Plasencia Cathedral. Partial view of choir ensemble (pre 1497–post 1503)

In this panel there are three differences between the two sets but they are minor compared to the resemblances. For one, the Sevilla hoarding is taller than Plasencia's but both top arcs are of the same type – accoladed, or inverted – and the divided space above them is filled in by small linked lancets. Another difference is that the framing pillars at Sevilla are adorned by two small figures, one above the other, while Plasencia's dividers have only one. Neither panel has a big sculptured figure, of course, both being decorated in marquetry, though Plasencia attempts a compromise with the Leon type of stall by putting large effigies of saints and prophets into the intarsia design. Both panels finish off at the bottom with carved friezes of narrative reliefs.

The lower seat assemblies of the two sets are exactly alike. Instead of above-seat busts in the lower stalls (such as one finds in the Leon group), there is both at Sevilla and Plasencia a second and larger frieze of narrative reliefs, which are framed by dividers at the tops of which are carved roundels. Hand-rests and misericords are featured in both sets, as they are in all figured Gothic stalls. But the spreading seat-arms are more unusual, both being formed in the same complex manner with three scooped-out parallel channels.

Thus can be counted in the two sets a succession of up to twenty shared details, an astonishing correspondence that could not possibly have been the result of that many 'accidents.' But the concordance of Sevilla's and Plasencia's

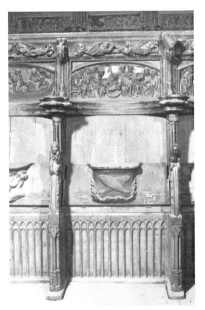 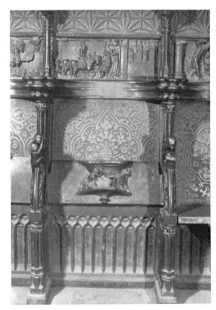

68. Sevilla Cathedral. Partial view of the lower-stalls.
69. Plasencia Cathedral. Partial view of the lower-stalls.

stalls does not end with these sculpted-structural patterns. The iconography of the two sets, particularly in the profane subjects, also has a strong liaison. An important reason for this, as we shall see, lies in the wealth of common experience that was shared by the regions of Andalucia and Extremadura, to which all but one of these choirstalls belong. And underlying it all was the 'reconquest,' which in the thirteenth century brought both these areas into the Spanish-Christian fold.

Central to the history of Spain as it is popularly conceived is this *'reconquista'* from the Moors, the final victory of the Christians over the Moslems. This scenario obscures the historic facts considerably, such as regarding Christianity's belated arrival in Spain and its relatively brief establishment under the Visigoths; the overrunning of the entire peninsula soon after by the Moslems in the early eighth century and their firm fixation in all but a small area of the northwest and northeast; and, finally, the many centuries required for their expulsion.

Even when the Christian counter-wave began to mark some real successes

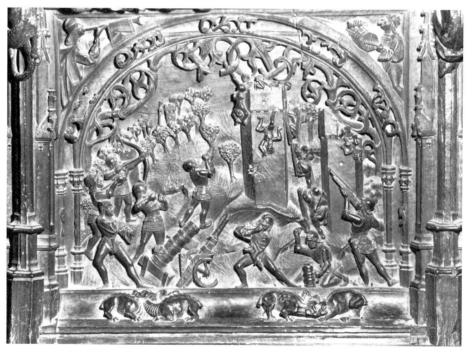

70. Toledo Cathedral. A scene from the Granada Campaign which features an attack by Spanish troops on a Moorish stronghold, demonstrating the variety of arms used, from a bow-and-arrow to a cannon.

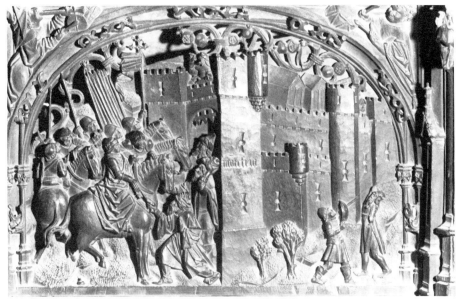

71. Toledo Cathedral. Surrender of Moorish city to the Spaniards. The Moorish chieftan bends a knee in handing the key to Queen Isabel, who though full-skirted does wear upper-body armor.

in the late eleventh century, its progress was discontinuous; it was not until the thirteenth century that the pace began to quicken. Then, within a few decades, a third of the peninsula, across its great breadth from the Atlantic to the eastern Mediterranean shore, was taken from the Moslems, who were riven by internal animosities. Their great metropolis, Sevilla, fell in 1248, but the impetus of the Christian drive abated soon after and their own bitter internecine strife stalled the conquest for another two hundred years at the marches of the kingdom of Granada.

It was during the absorption of this last territory at the southern tip of the peninsula that the conquest took on its most glowing colors of national unification, personified by Isabel of Castile and Ferdinand of Aragon, who a few years after their marriage in 1469 undertook the final Granada campaign. As told in the remarkable choirstall reliefs at Toledo Cathedral, one gets the sense of an unending series of *pro forma* triumphs. But the subjugation actually took ten years and even Rodrigo Aleman's romanticized episodes reveal a number of stiff battles, with Christian heroes falling from walls they sought to scale, and feature the alarming attempt on the lives of the illustrious royal couple, who entered history as 'los reyes catolicos,' the Catholic monarchs, with a radiance akin to sainthood.

After a long siege Granada fell at last in 1492, a date that universal history seems to have set aside. It was the year too when a Genoese captain with

three tiny ships flying Spanish colors made a short-fall landing which nonetheless opened the world to its remotest expanses and prepared Spain for its most scintillating epoch. Of different significance was another fateful event that same year, the expulsion of Spanish Jews.[1] Decreed by the two rulers on grounds of national necessity, it was followed a decade later by the ejection of the Moors. Thus was obliterated a brilliant, if largely adventitious, experience in religious and racial community that had been going on in Spain for several centuries.[2]

Andalucia's capital city was by its wealth and position the pivot of the final conquest of the Moors. The contemporaneous Jewish eviction was sparked by the Inquisition whose first tribunal was set up at Sevilla, where Tomas de Torquemada took charge in 1482.[3] The notorious Inquisitor General's chief task was to clear up the anomalous situation that had succeeded the great pogroms of 1391, which resulted in many Jewish deaths but even more 'conversions.'[4] The latter had brought an amazing re-establishment in the ex-Jews' economic and social status during the first half of the fifteenth century, when a great number of *conversos* rose to an elevated station, notably in the Church. Those who remained Jews, perhaps 200,000, were given the choice in 1492 (1483 in Sevilla) of converting or leaving the country. Three-fourths decided to go. But how 'sincere' were those who stayed behind and flourished? The Inquisition would have to decide.

The contagion of doubt and suspicion that accompanied this inquest echoes frequently in the stall-art of Spain. At Sevilla one particularly intricate and venomous piece appears in a frieze in which two composite monsters are seen to be devouring a death's head. Beneath the relief, spread on a scroll, is the puzzling name of '*Alboraique*.' Set on the path by an Arabist scholar who referred her to a book published in the 1480s titled *El Libro llamado el Alboraique*,[5] Isabel Mateo Gomez has explained the mysterious name as designating 'judaizing [false] *conversos*' who were 'Christians in name only.' To these counterfeit Christians an entire panoply of repulsive traits was attributed by *El Libro*, which are resumed as 'hypocrisy, cruelty, envy, deceit, heresy, ambition for high Christian positions without possessing Christian faith, racism, and, joining all, a contemptuous allusion to the origins of the [Jewish] people.'

References to the Moslems in Sevilla's art occur mainly in the form of combat scenes, in which heroic Christian knights are engaged against a series of terrifying monsters that symbolize demoniacal pagan power. The Christian warriors are often meagerly armed as though to stress the force of divine power that inhabits them. Hercules, curiously, is the Christian standard-bearer in a number of these contests,[6] including those against the Nemean Lion, the Bull of Erimathea and the three-headed dog guarding the Gates of Hades, all of which ostensibly represent the great enemies of the day, the Moors, whose

defeat would constitute a triumph of transcendent religious meaning.

This message broadens out significantly in another frieze relief with a socio-economic connotation. A defenseless Spanish shepherd is assailed by a gigantic griffin whose intended prey are his flock of sheep. But their defender is promptly there, a Christian warrior, his sword unsheathed.[7] Beyond its emblematic meaning of a combat between Good and Evil, one is reminded in this dramatic scene of a major reality of life on the Spanish frontier, the great sheep-grazing industry which had furnished one of the impelling motives of the conquest and which helps to explain the joint presence of these elements in a work of art of the time.[8]

Wool export of the newly developed merino stock constituted far and away the country's greatest resource. Since the thirteenth century, through absorption of the vast Extremadura regions of the southwest which were too rugged for regular farming but adequate for grazing, Spain's earnings from sheep-herding had increased enormously. The new lands gave graziers an area that was exploitable throughout most of the year by the practice of the five-hundred-mile seasonal shifts of their animals from north to south and back again.[9] Millions of sheep, under a well-organized guard, were involved. As long as the Moors remained entrenched in a neighboring region they could and did make damaging raids on the herds, against which the Castilian caballeros were the sole defense. This, then, seems to be the reality reflected by this striking bit of art, an economic necessity presented as an act of exemplary piety.

The exigencies of the drawn-out Spanish conquest had the fundamental effect of establishing the caballero fighters as a predominant class in the frontier world.[10] This extended to the towns as well, where they played a leading role

72. Sevilla Cathedral. Upper-stall Frieze. A griffin attacks a Spanish shepherd and his flock. A Christian warrior hastens to their rescue.

in the political life.[11] The primary necessities of the conquest proved a golden chance to these men who had been required to furnish literally only a horse and a sword plus the will to fight. Rewards were bounteous, especially in land, the easy acquisition of which made class-leaping relatively facile compared to the frozen proprietary conditions characteristic of feudal society in other parts of Europe.[12] Spanish life in the vast border territories took on the permanent atmosphere of a 'society at war,' which, blended with the type of pioneer existence associated with the grazing industry, created a milieu that was intriguingly similar to the pattern of life typifying the Americans' subjection of their own Far West, including its melodrama.

Over and above the caballeros' role in the conquest as it is depicted in stall-art are other carvings that stress their ordinary lives and especially their amusements.[13] These were to a great extent devoted to physical contests, even mortally dangerous ones, furnishing the same kind of exciting background that has given the Hollywood cowboy films their lasting appeal. Other facets of this turbulent existence were later recorded ironically in the stupendous epic of *Don Quixote*. But Sevilla's stall-art took it all very seriously, including the conventional scenes of courtly love and especially the tournaments and jousts. One of these, in another frieze relief, is fought between a woman and a man, the latter being overthrown, which may signify the apex of chivalry or a contest of holy tenor.[14]

It often happens that the daily work of men, especially when hazardous, is transported into sports. The bronco-busting American cowboys were anticipated several centuries earlier by Spanish bullfighting and by gladiatorial-type duels, both of which found their way into stall-art. An example at Sevilla is a combat to the death between a mailed fighter and an opponent who is stripped naked with only his sword as defense.[15] Other contests, especially numerous at the Cathedral of Ciudad Rodrigo, which is located in the depths of Spain's 'wild west,' shows a variety of styles of fighting and weapons used in combats that are all perilous. (See Chapter XIII)

It is often maintained that bull fighting in medieval Spain was a recreation confined to noblemen,[16] who fought in relative safety on horseback with the secondary aid of one or two plebians a-foot. But this claim is contradicted by choirstall carvings in the churches of Plasencia, Yuste and Sevilla. Outstanding is the brilliant misericord at Plasencia of a commoner on the ground preparing his bull for the kill. The exhausted animal waits docilely for the mortal stroke which the matador aims slowly and surely with his brutally set eyes.

Another sport illustrated at Sevilla, called '*gallumbos*', is said to have been practiced there for centuries and is still matched by like manifestations in several sections of Spain. As seen in an upper frieze, a great bull tied by the

73. Plasencia Cathedral Misericord. A matador prepares the death blow. (The sharp end of his weapon is missing)

horns is being dragged and pushed through the streets by men who by their shouted taunts and drum-beating are trying to rouse the animal's fighting spirit. It is plain that the bull is aged and heavy and hardly bellicose, a flaw that its tormentors are determined to correct so that he may furnish some recreation and even a little danger for the benefit of their dignity. While clerics were specifically forbidden to attend this sport,[17] it is hard to see in this detailed and pathetic scene on a church-choir relief any evidence of such a prohibition.

In the more than two hundred years between the conquest of Sevilla and the creation of the cathedral's choirstalls, the great city had evidently established a new personality which preserved various features of the earlier period as it did a large part of its monuments and art. In the cathedral's great central choir this development is featured stylistically in the arresting decoration whose dominant visual image is conveyed by the succession of geometric patterns of marquetry in the upper panels, a *mudejar* feature which had been eagerly taken up by the Spanish artists.[18]

No less revealing of this inherited background in the church's art are the 'scenes from life' that are displayed in the spectacular series of profane upper-stall frieze reliefs. One of the loveliest of these carvings presents a group of professional 'Moorish' dancers – one woman and three men – together with a male drummer who is deeply immersed in his art, reminding one of some modern jazz percussionist going off on a beat of his own. In all the dancers

74. Sevilla Cathedral. Upper-stall Frieze. A group of 'Moorish' dancers (Detail).

in fact there is the same narcissistic retreat into the whirling vortex of the dance. Their familiar gestures – hands on hips, slapping of the raised foot, the snap of fingers[19] – all fit into this internal concentration. Even the act of one of them who has thrown his arms and legs widely out in an apparently explosive impulse is actually expressing an ultimate introversion, for which he turns his back on the viewer and assumes a rigid catatonic stance.

Some Spanish authors remind us of the Church's traditional abhorrence of such music and dancing, which encouraged lust, they say.[20] Such a piece in the choir must therefore have a didactic purpose. Addressed to whom? To the clerics themselves, perhaps, to remind them of the constant perils faced by even the most devout of souls? Why then had the artist been allowed to carve this work so attractively? Lacking some contrasting, repulsive warning, it was worse than useless, constituting instead an ever-present temptation.

There are, on the other hand, in Sevilla's stalls a certain number of subjects whose homiletic message is unmistakeable. The Devil is often present, even dressed in the garb of a nobleman who reveals his club-foot; or inscribing the names of sinners on a long scroll; or helping to cut the hair of adulterous women encased in infamous barrel-skirts; or carrying another woman off to Hell, her sex seized by a horrid claw; or wheeling a venal cleric to the same place, accompanied by music! But just because he is there the Devil is not always victorious. Patient Job, stripped of his fortune and of his very clothes, retains all his piety though mocked by the Evil One. Translated into action, the combat of an armed knight against a monster or a centaur has the same pious merit and the man who rides a lion vouches for the victory of Virtue over Vice. On the other hand the woman who mounts a monster certainly signifies the opposite.[21]

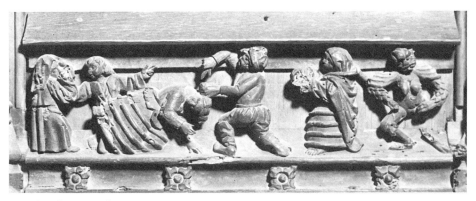

75. Sevilla Cathedral. Upper-stall Frieze. A devil helps punish adulterous women by shearing off their hair.

That the majority of subjects in the misericords, handrests, roundels and even the upper-stall frieze reliefs were non-religious did not trouble the clergy of the late fifteenth century, who were not averse to such thematic variety provided that the Christian message was amply conveyed elsewhere in the stalls. Still, when the upper seats at Sevilla were completed, the churchmen may have been concerned by the absence of religious statues or busts,[22] such as those that had recently been done at Leon. This may have been the reason for their decision to have a frieze created for the lower seats that would be devoted to the evangelical story.

Not only the iconography of this lower frieze was changed; the style itself was altered as though to be in keeping with the subject matter. But this alteration was unplanned and was probably due to the death in February 1478 of the artist, Nufro Sanchez,[23] who had been in charge of the stall-making task since 1464. Documents regarding this achievement are far from complete. The cathedral's *Actas Capitulares* date only from 1478 and there are but a few notices elsewhere givng some additional facts about the man who was certainly most responsible for the creation of the great assembly. He must have been a mature artist when, in 1464, he took over his father's post as the cathedral's master carpenter, for there is one entry of 1461 telling of his occupying with his family a house belonging to the chapter, which meant that he was already then working for the canons.[24]

But the real importance of Nufro Sanchez's contribution might have gone unnoticed were it not for an extraordinary attestation in the form of an inscription stretching across the bottom of one of the great upperstall panels right beneath an escutcheon bearing the arms of Leon and Castile, which probably designated this as the king's seat. The florid Gothic letters read:

Este coro fizo Nufio Sa(n)ches e(n)tallador q(ue) dios (h)aya – Acabos(e) ano de M-CCCC-LXX-VIII anos.
(Nufro Sanchez sculptor made this choir – May God rest his soul – Completed in the year of 1478).

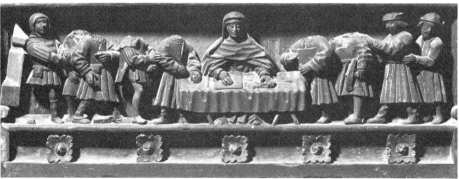

76. Sevilla Cathedral. Upper-stall panel over the king's seat with memorial inscription honoring name of Nufro Sanchez, master of the stalls.
77. Sevilla Cathedral. Upper-stall Frieze. The nine artisans of the choirstalls receive their reckoning from the head of the cathedral fabric.

The phrase, 'May God rest his soul', indicates that Sanchez was dead when the inscription was written. Perhaps indeed his death had recently occurred, which might in part account for the unique honor that was paid him. It has been suggested that there is a further reference to the master in this same stall,[25] together with the other sculptors that had worked with him, conveyed in the frieze relief just beneath the great panel, which clearly represents a payroll operation.

A dignified figure, in the robe and headdress of a churchman, is seated alone at the table on which are spread a book of records and a mass of coins. To the left and right of him are nine standing men, only three of whom have retained their heads. But their identity as workers is clear. One who has kept his head wears the familiar close-fitting sculptor's or mason's bonnet. Another holds a heavy blunt-edged hammer; still another the remnants of a chopping adze. The one who might be the chief of the group, a headless man, is standing at the right of the canon-paymaster ('*mayordomo*') and holds in his left hand what, at first appearance, looks like a chisel but which may have an alternative identification. For the man also carries a book of records, which he probably has been checking against the paymaster's figures. The object in the master carpenter's hand may therefore be an ink-holder.

Because of the seeming finality of the inscription, this scene has been interpreted as the last settlement of accounts passed with Nufro Sanchez and his co-workers. But the conclusion is contradictory if we heed the Actas Capitulares, which become available that same year. We learn from them that on March 11, 1478,[26] hence only a month after Nufro Sanchez's death, arrangements were made between an important group of canons and 'the masters of the new stalls' to check the accounts as to what money they had received, what stalls were completed and could be assembled, and '*what still remained to do*.'

It is highly probable that the men in the frieze are occupied with carrying out these directives. Since they could not have included Nufro Sanchez at that date, they were most likely the men who had worked under him, together with their new master who had taken the dead man's place and who is named in the document as a certain 'Dancart.' Two months later in fact, on May 5, 1478, Pyeter Dancart is said to have received his first payment, 40,000 maravedis, 'on account for work done on the stalls,' from the '*mayordomo de la fabrica*,' which is still the title used at Sevilla for the canon (or canons) in charge of its art and architecture.

On that same day, the continuing work was allocated in a new contract between a group of named canons led by their dean and the same Pyeter Dancart, which specified the rate of 16,000 maravedis to be paid 'for each stall done, high or low.' And the master promised that the new stalls would

be executed exactly like those already completed 'and not of lesser quality,' a pledge that he backed with his worldly goods, signing his name as did also two members of the chapter. On June 12, Pyeter Dancart received a further 50,000 maravedis 'on account' and on July 3 it was stated that one or two masters 'from the outside' would be called in to judge his work.

This was an interesting custom that we have seen mentioned several times in Spanish documents concerned with activities of this kind. The 'judges,' who were paid a commission, had the right not only to say whether the work was satisfactory but also to decide on its fee, which might result in either raising or lowering by an unspecified sum the compensation originally agreed upon. We learn in a later entry that Dancart's work was so highly appraised by these masters that his stipend was augmented by no less than 2,000 maravedis per stall, for a new total of 18,000 mrs each.[27]

On July 24, the chapter decided to assign 1,000 maravedis a day for the work 'still remaining to be done.' This implied that the stall-work may have been drawing to an end, or that its completion could be rather closely estimated. Indeed, on November 13, Pyeter Dancart was ordered to assemble in the choir all the seats done by his group. This probably included the archbishop's stall ('*la silla grande*'), which had been specifically assigned to Dancart at the set price of 36,000 maravedis. Other clearly final tasks given at the time were the last terminals ('*costados*') as well as the widening out of one of them that was found to be too narrow. Three days later all the stalls were in the choir and evidently paid for and 30,000 mrs added on account for the additional work that 'still had to be done' – a thirty days' stint.

There is every reason to believe that the stalls were finished at this point. At any event the Actas Capitulares are silent about them thereafter. For some years up to the end of the century the cathedral's *Libros de Fabrica* cite occasional small sums paid out for minor chores done on the stalls, until 1511, when a master named Gomez de Horozco got 5,000 maravedis on account for 'repairing' them.[28] This was probably following a recorded accident due to the collapse of part of the vault, when some misericords were apparently recarved, judging from the change in their style that we can still observe today.

It would be instructive if we could identify and hence compare the work done under Pyeter Dancart, a Flemish master, with that of Nufro Sanchez, a Spanish one. The former was in charge for hardly ten months while his predecessor held the reins for fourteen years. Nothing tells us however that Nufro, the church's master carpenter, worked exclusively on the stalls. We have a better idea in this regard for Dancart's group since we know how much money they received: a total of 120,000 maravedis in three payments and about 100,000 more over a period of about a hundred days at a rate of 1,000 mrs.[29] Calculated

at 18,000 mrs per stall we can thus account for about a dozen full units, excluding the archbishop's throne for which the fee was doubled and which may have been paid for separately.

It is a small enough part of the monumental assembly of 117 stalls and seems to rule out any major influence by the Flemish master on such fundamental elements as the upper-stall composition, including the great decorative crest, or indeed on most of the figured sculpture on this level as well. For the comparison of Pyeter Dancart's sculptural style with that of Nufro Sanchez there seems to be only one category that can be studied to some advantage: the friezes in the upper and the lower stalls. It is almost certain that Nufro was responsible for the former, which means that Pyeter's imprint must be sought for in the latter.

The upper reliefs are imbued with a certain naïveté which by no means mars their great charm and narrative acumen. They are simple but elusive, quaint but subtle. In comparison to the lower frieze they are lacking in technical sophistication, however (see Fig. 77). Robes fall in even vertical folds, sleeves are bunched in the same repeated manner. There is little variety in facial expression either and actions are curtailed as though to avoid more difficult-to-carve confrontations. Individual figures are set apart and always occupy but a single level, for which the exiguous height – hardly six inches – seems to have served more as an excuse than a necessity. A few of the upper friezes, however, are much freer in style and were done by another hand, probably that of Nufro's successor, who would therefore have been working on the stalls before Nufro's death.

The lower frieze – Dancart's – is almost twice the height of the other, allowing for as many as three tiers of figures arranged in skillful perspective. Drapery too is complex and adroitly responsive to pose or action. In the *Washing of the Feet*, Peter's creases assume a complex but dominantly horizontal cast, while Christ's draped lines follow sensitively the curved back, the bowed knee, and are supply gathered above the wrist so as to avoid the water.

Body form is likewise broadly developed in full Italianate flair, as in the *Flagellation*, where even Christ's naked torso has muscularity though it is more daintily elaborated than his scourger's great shoulders and biceps. Facial features especially are delicately varied, different individuals reacting with marked distinction to the same stimulus.

The apostles in the *Last Supper* are all preoccupied with the ignoble acts of eating and drinking: biting into a pudding, tearing at a piece of meat, tipping pitcher to lips. But the awesome fatality hangs over all and suddenly strikes one of them with horror, causing him to throw his head back and raise his eyes demandingly to Heaven.

If we accept the arithmetic evidence of his earnings, Pyeter Dancart could

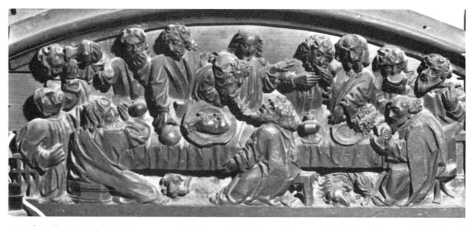

78. Sevilla Cathedral. Lower-stall Frieze: *The Last Supper*. 'The ignoble acts' depicted of eating and drinking are meant to obliterate the 'awesome fatality.' Elements of a new type of sculpture seen here: realistic expression and dramatic confrontation of characters.

not have done more than a fraction even of these lower reliefs, those associated with the dozen or so stalls that he and his group were supposed to have been paid for. There is however another possibility, that he had begun to work on the stalls some time earlier, under Nufro Sanchez's direction. He could have concentrated from the beginning on these lower seats, of which fifty-three remain, too many for even a substantial group of carvers to accomplish in ten short months, but which would have been possible if Dancart had started a few years before, retaining his anonymity until the Actas Capitulares began to appear, in 1478. This would account for the fact too that this 'unknown' artist should be given the primary responsibility for the stalls after Nufro Sanchez's death.

There are other reasons to think that Dancart was hardly a come-lately to the stall-work. His rise would otherwise have been too fast after his assumption of control. Sixteen thousand maravedis for a stall was normal pay and it was unusual that this fee should have been increased by $12\frac{1}{2}$ percent (2,000 mrs) within two months. Even more revealing of the high esteem for Dancart's skill was his being given the assignment of the archbishop's seat. And, finally, when the stalls were completed and the cathedral authorities decided that it was time to start the great reredos, never surpassed for monumentality in Spain, it was this Flemish master who was called on to make the drawings.[30]

There is one other category of sculpture that Pyeter Dancart was probably responsible for, the lower-stall roundels. They are located at the top of the short pilasters that divide off the seats of these stalls, which we have ascribed

to him. Carved back to back, the roundels are among the most delightful features of the entire assembly and were thereafter copied by most other churches, reaching a high point of imagination and ingenuity at Plasencia, where they were not the only debt that the great Rodrigo Aleman would owe to Sevilla.

This kind of innovation has been the repeated contribution of Sevilla's stalls, which constitute the first completed figured Spanish set that has remained with us. Presented in a brilliant blend of marquetry, figurative carving and decorative design, they are featured likewise by a rich mixture of artistic derivations. This complex background would typify most of the figured stalls of Spain: Moorish, French, Flemish, Burgundian, German, Italian, probably English (Barcelona), and not least, Spanish. And upon these assemblies, the architectonic and sculptural splendor that was first displayed at Sevilla by Nufro Sanchez and Pyeter Dancart was to leave its indelible mark.

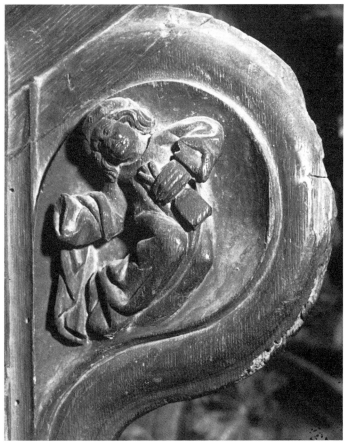

79. Sevilla Cathedral. Lower-stall Roundel. Male dancer making his own 'time.'

Images of Spain's 'Far West'

There are many mysteries about Rodrigo Aleman's life and quite a few about his art. But the latter exists! We have no idea on the other hand of where or when he was born.[1] Or when he came to Spain. And yet we know more about Rodrigo Aleman than we do about any other maker of the twelve figured stalls. For those of Leon, Oviedo, Zamora and Astorga, we do not even have their names.

As far as the record is concerned, Rodrigo Aleman was 'born' artistically fully grown, one might almost say, in Toledo, where from 1489 to 1495 he did that cathedral's lower stalls, fabled for their Granada reliefs. And suddenly this sculpture established him – at least for history – as the greatest practitioner of this unique and splendid art.

It is not known either when Rodrigo Aleman died though it was probably after 1512, when a bridge that he had started at Plasencia in 1500 was completed and inscribed in his name. In-between he did other major works for which we have documentary citations and even a detail or two about his comings and goings. However, in the chary manner of history in its allusions to so many great artists, it is all little enough and sometimes downright ludicrous.

There is one fable, for instance, about his having run foul of the Catholic Church for having boasted of his talents, while denigrating God's.[2] According to this commonplace among artists' legends, Rodrigo Aleman was imprisoned for his blasphemy in the cathedral tower at Plasencia, where he made friends with the birds, which graciously offered him their flesh to feed on and their feathers to make wings with so that he might fly to freedom. But unlike Daedalus he was punished for his arrogance.

Other legends about his life are more easily believed perhaps but no less apocryphal, which has not discouraged a number of modern writers, especially

churchmen, from propagating them. These authors have disregarded the lack of documentary proofs or the fact that these stories first appeared at least a century after Rodrigo's death. Typical is one recent fabrication about the reason for his having been 'arrested' by the Inquisition. It had nothing to do with his irreverent boasting or his having been recalcitrant about his Christian duties, as happened with another nearly contemporary artist, Esteban Jameta, whose appearance before the holy office is recorded in its Cuenca archives.[3]

The fantasy regarding Rodrigo Aleman's arrest is based on the totally gratuitous assumption that he was a 'judaizing' *converso*,[4] meaning one of those converted Jews who continued secretly to adhere to their supposedly abjured beliefs and practices. Several of Rodrigo's coworkers on the Plasencia stalls must have been in the same case, the hypothesis goes on. Infuriated by the measures directed against the Jews in 1492, they conspired to take revenge by introducing elements into the stall-art that were contrary to Christian doctrine, and would therefore mislead true believers.

However ingenuous the alleged motivation might be, it was easy enough to find a few illustrations to 'prove' the artist's insidious intention, by arguing a link between some religious subject of an above-seat frieze, let us say, and the profane theme of the misericord below. The under-seat carvings are frequently mischievous enough, and chance could take care of the rest in two or three instances among the fifty or more stalls. Thus at Plasencia the frieze carving of Pilate washing his hands was associated with the misericord of a

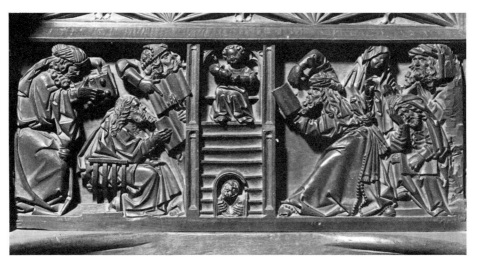

80. Plasencia Cathedral. Lower-stall Frieze: Young Jesus debates the Jewish doctors. Allegedly anti-Christian rendition: that Jesus receives a prompter's cues.

pig dipping its trotters in the toilet bowl into which a monkey was evacuating. And Christ preaching in another relief was joined up with a fox sermonizing to chickens.[5]

Now and then an interpretation of this sort would appear more serious, as was the case of the scene of young Jesus disputing with the Jewish doctors, in which a churchman, Vicente Parades, writing in 1910, told of having discovered a kind of prompter's box in the stage-like setting. The innuendo, he argued, was that the ugly little man with the open book was there to prod Jesus's answers, which would truly have been an insolent denial of his divinity. But the prompter might with far more reason and credibility have been trying to help the rabbis, who are shown having a desperate time of it with the smiling, confident little boy.

In more recent years, a Plasencia Cathedral dignitary, M. L. Sanchez-Mora, argued that Rodrigo Aleman revealed his secret anti-Christian animus by picturing churchmen in 'vile' and 'obscene' postures. There is no question but that one finds examples in his sculpture of clerical drunkenness, irreverence and even sexual vice. But the same is true of a number of Spanish stalls (and those in other countries) that could not possibly have all been due to Rodrigo Aleman's hand![6]

If these clerics had meant to convey a subversive impression about *conversos* by disregarding such figures as Santa Teresa, Luis Vives and many other outstanding Christians of Jewish derivation, their choice of Rodrigo Aleman as a notorious example was a poor one. Rodrigo had to be shown to have done his dastardly work by ruse and subterfuge, but such was not the case with the author of the famous 'tragicomedy,' *La Celestina*, which was exactly contemporaneous with Rodrigo's stalls (the second edition, of 1500, was published in Toledo when the sculptor was active there) and which enjoyed a spectacular success. Written by an acknowledged *converso*, Fernando de Rojas, the play fairly bristles with offbeat social and religious notions which are enunciated with forthright and even challenging candor.

Most surprising of these anomalous views are those that are scathingly critical of the self-regarding nobility. Not even the play's lovers, Melibea and Calisto, are spared de Rojas's caustic treatment. It may be meaningful that their most affecting scenes were added in a later rewriting. But this did not erase the impression of the young nobleman as an incredible poltroon, whose single courageous act is nullified by an ignominious tumble from the top of a ladder. Melibea follows him in death through suicide, a sinful act that remains uncensured.

The most virulent outpourings of upper-class hatred stem from members of the one other social group with which de Rojas is concerned: the underworld of prostitutes and pimps. Among these the young woman Areusa gives

greater proof of character than any other personage in the play. She castigates those who lay claim to 'virtue' not by their acts but by their 'noble lineage.' 'We are all children of Adam and Eve,' she declares and bluntly explains the choice of her profession by her rejection of the servile condition that had been forced on her. 'How cruel it is always to have the word "*Señora*" in one's mouth!' she recalls. Her final act, plotting the murder of Calisto whom she blames for her lover's death, she frankly describes as a desire for 'vengeance,' which does indeed bring the tragic resolution of the imbroglio.

The recent discovery by a scholar of a document revealing that a man who was probably the son of Rodrigo Aleman had been called before the Inquisition may give renewed encouragement to fantasy about his life and motives.[7] The case, which was heard in 1524, originated with Rodrigo Enrique's wife, Catalina de Baños, who had been condemned for unspecified reasons, put on an ass and flogged through the streets of the city (presumably Cuenca). Furious, the husband threatened officials of the holy office with drawn sword and as a result was himself brought before the tribunal, from which he received a minor penalty.

In his testimony, Rodrigo Enrique, a sculptor himself, disclosed hitherto unknown and at times mysterious facts about Rodrigo Aleman's family relations. His mother (Rodrigo Aleman's wife), he reported as having heard, was named Mari Lopez, daughter of Juan Zolita, and was a native of Villaescusa. Why had Enrique only 'heard' these things? Had he never known his mother? Was he ashamed of her? One has a sense that this may have been so because of the countering pride with which he declared that his father was a *flamenco e hidalgo* and because he evidently found it expedient to add that he himself was not a *converso*, unless this was a formal demurrer that all 'Old Christians' who came before the dread tribunal were expected to make.[8]

With so many dark and sinister hints that have been offered regarding Rodrigo Aleman's life, it is a relief to be able to fall back on the one or two comforting facts given by his son. That the great artist could still be referred to as a 'knight' as late as 1524 seems evidence enough that he did not terminate his life ignominiously as a prisoner of the Inquisition. And his being definitely identified as 'Flemish' should end the tiresome polemic concerning his nationality that has long centred around his name.

Though there are numerous details about Rodrigo Aleman's creative accomplishments that have not been clarified, there is still a good deal that has been certified through documents and contracts and dates that have been delivered down to us. We can in fact draw up from these sources a fairly complete chronology of his work, which is the more welcome in that the same is hardly possible for any other Spanish stall-carver.

CHRONOLOGY OF RODRIGO ALEMAN'S WORK[9]

1489–1495	TOLEDO CATHEDRAL: 52 lower stalls. The assignment may have carried him as much as six months into the last year, working on final details such as corner niches, terminals, stairs leading to the upper stalls, etc.
June 1495– June 1497	There is little information about this period except for two minor items for 1496.[10]
June 7, 1497	PLASENCIA CATHEDRAL: Contracts to do the two stalls for the *'reyes catolicos,'* within one year.
June 9, 1497	PLASENCIA: Contracts to do a great triangular lectern simultaneously with the two stalls. It has disappeared.
July 10, 1498	CIUDAD RODRIGO: Contracts to do two sample stalls, then to continue with the rest. It is doubtful that he fulfilled this contract at this time.
1498–1500	TOLEDO CATHEDRAL: Works on the chancel reredos, carving half of the lowest register. Work begins after July 1498, ends early 1500.[11]
1500	TALAVERA DE LA REINA: Carries a 'model' for a reredos here. Nothing more is known about it.[12]
1500	PLASENCIA: Does drawings for the new bridge.
March 27, 1503	PLASENCIA CATHEDRAL: Has been working on its stalls for an unknown period. On this date, officials from CIUDAD RODRIGO ask Plasencia Chapter to share Rodrigo Aleman with them.
1508	PLASENCIA: Minor repairs cited on stalls, suggesting that they are completed. Rodrigo Aleman's name is not cited, however.
1512	PLASENCIA: Bridge is completed; is credited to Rodrigo Aleman in an inscription.

One of the riddles of Rodrigo Aleman's stall-making career is the relative smallness of his fees. Throughout his performance on his three sets that we know of it always hovered around 10,000 maravedis per stall. Curiously, too, his work at Toledo was not 'judged' by experts until the final full year, 1494, when the fee was 'corrected' to 10,380 mrs.[13] This is still far below the payment – 18,000 mrs – that Pyeter Dancart got for Sevilla's lower stalls. It is hard to believe, from the evidence of the sculpture, that Rodrigo's work was considered that much less skillful or that Dancart worked faster: payment in any case was by the piece. All we can conclude is a difference in money values between the two cities. It is known that the cost of living in various sections of Spain often differed greatly, as did the earnings of craftsmen and laborers.[14]

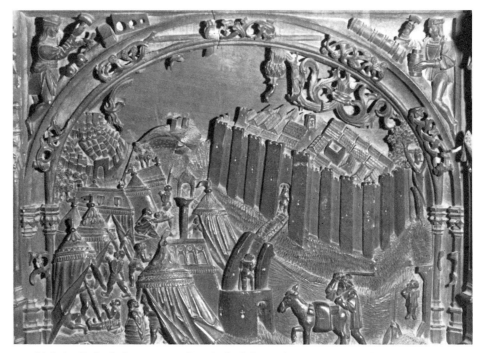

81. Toledo Cathedral. Lower-stall Relief of Granada Campaign: Life in Spanish camp outside a walled city. Note spandrels at upper left and right of artisans fashioning cannons and cannon balls.

Did the Sevilla set make greater demands on an artist than Toledo's? It seems to us that the reverse could be argued since Aleman's stalls not only have everything that Dancart's possess but can boast the imposing series of fifty-two scenes[15] recounting the 'Reconquest of Granada.' These great low reliefs are all a veritable turmoil of figures in action or pose, with splendid architectural settings and landscape backgrounds containing a vast variety of individual scenes and meticulously recorded details, one example being a remarkably evocative view of the bustle of life in the Spanish tents, including a barrel-skirted camp-follower in conversation with a solider. There are also delightful lintel carvings and spandrels featuring participants of all kinds in the Granada events as though shown in close-up: warriors, standard-bearers, black drummers, buglers, Moslems, even artisans busily fashioning cannons and cannon balls (see Fig. 81).

Indeed it is almost impossible to believe that Rodrigo did all this sculpture himself (if he did nothing else!) in the span of about six weeks that must be allotted for each stall, calculated over the documented period of 1489 to Janu-

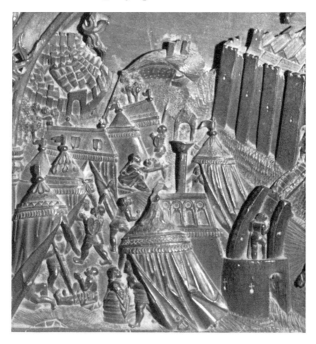

82. Toledo Cathedral. Lower-stall Relief of Granada Campaign. Detail (enlarged) of life in a Spanish encampment, showing in foreground a conversation between a camp-follower and a soldier.
83. Toledo Cathedral. Granada Strip-Frieze. Turnabout World: Rabbit cooks dog.

ary 1495.[16] It is certain that he had assistants, for no man could have earned 10,000 mrs by his own work in so short a period. But the others would have had plenty of detail chores to do. As for the sculpture itself, the high skill remains constant, testifying to a master's hand.

It was a sad chance that the man who inspired the Granada series should have died just as they were being completed. Cardinal Pedro Gonzalez de Mendoza, known as the 'third ruler of Spain' (complementary, that is, to Ferdinand and Isabel), held the archbishop's throne at Toledo from 1483 to 1495 and led the Christian forces in the Granada conquest.[17] He must have regarded the sculptured series as a personal testimonial of highest political

and religious consequence. Because of the multitude of realistic details contained in these scenes, it has been suggested that Rodrigo himself had participated in the campaign, if only as an observer with his sketchbook.

Rodrigo Aleman may have been meant to continue the Toledo stalls into the upper register[18] but this project was in any case halted by Mendoza's death. There seems to have been no acute need for these seats, since there was an old set there already, which accounts for the several '*escaleras*' that Rodrigo was asked to make at the end of the program, one of which is described as 'mounting to the archbishop's seat.'[19] It was not until fifty years later that the new upper stalls were done, by Alonso Berruguete and Felipe Vigarny,[20] whose marble-pillared Renaissance structure overwhelms the modest Gothic seats of Rodrigo Aleman, which still retain their original position.

It was two years after he had completed his work on Toledo's lower stalls that Rodrigo Aleman began his activity on what was to be his masterpiece, the choirstalls of Plasencia Cathedral. His contract with the canons, dated June 7, 1497, curiously called for the creation of only the two royal seats (intended actually for Ferdinand and Isabel)[21] of this assembly, which presumably were the first ones to be produced. The contract set the fee for each stall at 30,000 maravedis which could be increased to 35,000 – 'and not more' – if the work 'should merit it.' Here at last the master's skill seems to have been fully acknowledged, his remuneration almost equalling that of Pyeter Dancart for a task of like importance.

Some of the other provisions in the contract are particularly interesting since they reveal professional practices of the time. We learn, for instance, that Rodrigo had drawn a sketch of the stalls and had recorded the dimensions on it, which he pledged to adhere to exactly and that the work would be 'perfect and spotless.' He also promised to complete the task within a year and was assigned seven men to help him, which might seem excessive if we forgot that this by no means mandated the full year for all of his assistants. Most would be specialists operating on individual details such as the marquetry figures of the upper panels or the high pinnacles carved in delicate openwork tracery.

Rodrigo Aleman had probably obtained the Plasencia assignment by recommendation of Enrique Egas, his 'architect' at Toledo Cathedral,[22] who had been asked to do the drawings for the new church at Plasencia. Why Rodrigo should have been called on to start working on the stalls so soon is puzzling since the choir space would not be ready for some years.[23] Construction of the new cathedral was started at the east and was no doubt meant to continue on the ground from which the old church would be cleared section by section. But the building advanced slowly. Its chancel was not vaulted until 1533/34

and by 1578 only the transept and a single bay of the nave were terminated. Then the new work was sealed off by a brick wall (see Fig. 67 in Chapter XII) and the project abandoned, permanently as it turned out.

'Economic reasons' were alleged, a surprising argument at the time when American gold and silver were pouring into the mother country.[24] But Rodrigo Aleman's stalls had by then long since been completed, having been produced actually to fit into two bays of the old church. From here they had been moved, at an unknown date, to a space near the new chancel, and then transferred again, in 1568, to their present location, nestled against the 'temporary' brick wall that separates the two forever incomplete church halves. There must have been much difficulty in re-positioning the stalls into the single bay of the new nave which was almost twice the width of the old one and for which the seats had to be recut and reassembled. One can see numerous signs of rupture and rejunction in the stalls today. All of which in any case was foreign to the original arrangement of the old church.

The question rises, though, when did Rodrigo Aleman actually make the Plasencia stalls? When had he found the time? There are two countering documents that argue that the master had to be very busy elsewhere right after he was to have completed the two seats for the king and queen. Exactly the one year in which he had pledged to finish them had passed when, on July 10, 1498,[25] we find him signing a new contract with the canons of Ciudad Rodrigo Cathedral. This is very strange unless Plasencia's officials had decided to put off completing their own stalls until the new church had advanced sufficiently to enable Rodrigo Aleman to fit the entire assembly into its intended position. Since this would not be possible for many years the stalls were eventually done for the old church anyway, as has been said.

The Ciudad Rodrigo contract called for Rodrigo Aleman's services immediately. It is an amazing document. According to its provisions the artist agreed to produce two model stalls, one high, one low, for the top price of 10,000 maravedis each. More than this the sculptor would not get for the rest of the stalls, no matter what the masters who 'judged' the two models said about their value. If they rated them as worth more, it was up to the artist to cut the cost of the stalls down to the 10,000 maravedis level since, in any case, the church would not pay him more than that. The canons' language was circuitous and full of medieval legalisms, but what it meant was clear: Rodrigo Aleman was called on to pare down the sculpture to the bare minimum. The Ciudad Rodrigo set, however splendid its sculpture, shows the results of these restrictive prescriptions.[26]

It is difficult to see why this by now highly esteemed artist consented to such outrageous terms. We would be inclined to think that he never intended to fulfill the contract were it not for his '*contento*' that he added to it. He

may have been short of money or waiting for the decision on what he must have seen as a far more desirable assignment, working for the metropolitan church of Toledo.[27] It came through, in fact, sometime in that same year, as a joint task with other men for the creation of the cathedral's great reredos. Rodrigo's part consisted of three important scenes in the lowest register[28] – the *Decapitation of St Eugene*, the *Last Supper* and the *Mount of Olives* – which can still be seen today. The big job carried him through 1499 and into 1500, when he was paid off for his share of the work.

It was at some time during 1500, we believe, that Rodrigo returned to Plasencia to resume the interrupted stallwork.[29] Whether some of his assistants of 1497 had continued at this task while he was away is not documented.[30] There are some recognizable stylistic differences in the stalls but the carving of other artists could have been done just as well after Rodrigo's return as in his absence. At any event the master's participation on Plasencia's major sculpture is amply verified, as will become evident in the sequel.

It was not until after March 27, 1503, on the other hand, that Aleman began working on the stalls of Ciudad Rodrigo, that is, five years after he had signed that mysterious first contract with this church. We have this firm information from an agreement that was reached in 1503 between this cathedral and Plasencia calling for a curious arrangement to share the artist's services.[31] Rodrigo, it is clear, was under a primary contract to the Plasencia chapter, which permitted his being loaned out to the sister church for unspecified but apparently lengthy periods. Ciudad's spokesman in the negotiations, Juan de Villafañe, pledged his 'person and possessions' that his church would recognize Plasencia's prior claim to the master's efforts and would send him back whenever he was asked for. This gage was evidently kept and the result was the completion by 1508 of the two most brilliantly carved of Spain's figured Gothic stalls, with Rodrigo Aleman doubling as sculptor and master-of-works at both.

Rodrigo Aleman's name has also been associated with the stalls of other churches (usually apocryphally) and particularly with those of the Hieronymite Monastery of Yuste, which is located in the Plasencia diocese about twenty miles from the episcopal seat. But nothing could possibly betray the master's hand in this work. The set itself, seen structurally and decoratively, is attractive. But its sculpture is crude, especially compared to Rodrigo's superb carving. All we can say is that Yuste's artists worked in the aura of the Plasencia master, reflecting his thematic influence if not his talent.[32]

The sculpture that can be most solidly ascribed to Rodrigo Aleman is the Granada series at Toledo. But these scenes are quite unique and one would not expect them to furnish precise clues to the work in the other sets. Still,

in the Old Testament friezes at Plasencia we find architectural and landscape features as well as military action scenes that come straight out of the Granada series. In the same sense the upper-panel border carvings at Ciudad Rodrigo are strongly reminiscent of Toledo's wonderful little strip-scenes beneath the Granada reliefs (see Fig. 83).

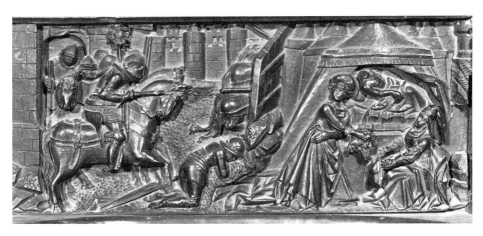

84. Plasencia Cathedral. Lower-stall Frieze: '*Judith cuts off Holofernes's head.*'
85. Ciudad Rodrigo Cathedral. Upper-stall Panel: Similarity of border carvings to Granada Relief series strip-scenes. (See Fig. 83)

There are also various individual pieces that can be paired off both for subject matter and interpretation. Some are found in all three sets, others in only two. And even when no such concrete correspondences exist there often remains a kind of homogeneity in the sculpture that is persuasive. This can be illustrated in the random choice of two larger pieces of ramp carvings at Ciudad Rodrigo and Plasencia, one representing two men fighting for a church bell, the other showing two men simply sprawling in a disorderly manner. The meanings of both are obscure but they are imbued with the same sculptural

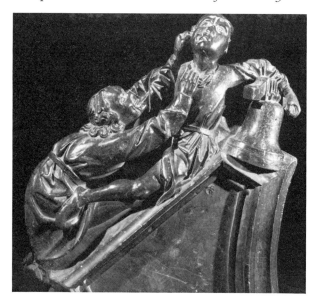

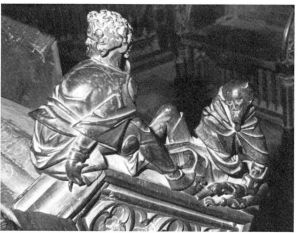

86. Ciudad Rodrigo Cathedral. Ramp sculpture of two men fighting for a bell.
87. Plasencia Cathedral. Ramp sculpture of two men in a disorderly setting.

intensity that binds them inescapably. Rodrigo's sculpture at Toledo, done when he was probably fresh out of Flanders, bears marks of that country's typical iconography, such as the woman on a ramp who pulls on her panties, a challenge to male supremacy, and especially the sitting man about whose cloak a cluster of egglike forms seems to be echoing the roisterous Flemish proverb: 'He shits eggs without shells.'

To try to set a foundation for Rodrigo Aleman's style, we can start off with the two great stalls of the '*reyes catolicos*' at Plasencia since it is almost certain that he did the carving on them both. When we study these seats we find what seems a minor detail on one, the king's seat, which is immediately intriguing. This is the front edge of the misericord bracket, which has the unusual shape of a triple cusp. It is the only underseat rim at Plasencia that has that form. And there are none like it at Ciudad Rodrigo either. Only at Toledo do we find the three cusps – in all the seats.

88. Plasencia Cathedral Misericord: Mystery of the seat with tri-cuspidal edge.

The coincidence is meaningful, for it forges a link between the two sets, Plasencia and Toledo. That link is most likely Rodrigo Aleman. That it should occur on what was probably the first stall done by him at Plasencia after his completion of the Toledo set makes the tie more binding, even if the abandonment of the tri-cuspidal style after that leaves part of the puzzle unresolved. We cannot help thinking that if the documents had been lacking that have firmly established such a bond, this hint would probably have turned people's minds in that direction, seeking the proofs that might be present in the sculpture. One of these proofs is right at hand on the king's seat, in fact, unveiling a subject that is a persistent preoccupation in Rodrigo Aleman's work.

It presents a monk who at first sight seems to be engaged in a commendable activity: reading his Bible. But a second look corrects this impression. He is not reading at all. His eyes are wandering, indeed they are glimmering and the reason for their misty look is readily noticed: the wineskin which is snugly lodged between his legs. One might conclude that the artist was handing a gratuitous chiding to the clergy. But the charge would be unfair, for he has

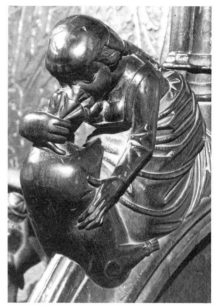

89. Plasencia Cathedral. Ramp Sculpture of false virtue masking a vice: Drunkenness.
90. Plasencia Cathedral Ramp Sculpture: Woman depicting the Vice of Inebriety.

castigated laymen also for this vice of drunkenness, which the Church regarded as one of the most dangerous of all since it opened the door to many others: laziness, neglect of duty, profligacy and lust. Rodrigo Aleman flays them all.

Even women are repeatedly seen in this context, which in itself appears to be a topical reference as pointed as a sociological text. The way two of them on a pair of handrests or ramps are shown drinking seems unmistakably 'drawn from life': they sink their mouths into the open throats of wineskins whose porcine bodies they clutch in a desperate embrace.[33] One of these pieces is at Toledo, the other at Plasencia. Rodrigo's inventiveness on the subject of drunkenness atttains a high point of satire in two other carvings (at Plasencia and Ciudad) which present three wineskins posing as monks and chanting to the theme of '*Vino Puro.*' The scene at Plasencia is orchestrated by a demon.

If it amazes us to find Rodrigo laying so special a responsibility on the clergy, it must be recognized that this was done with the canons' consent and that our blame should be mingled with a certain respect for the churchmen's courage in permitting these critical references to their own community. In the same vein one wonders what more effective manner there could be of pillorying clerical hypocrisy than the claw-footed cowled figure on a Plasencia ramp who sings so lustily from his hymnal? Even hidden thoughts are exposed

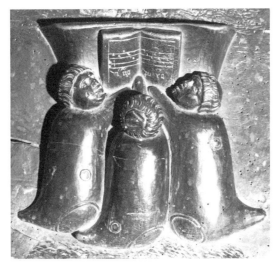

91. Ciudad Rodrigo Misericord: Wineskin-monks intoning a hymn to '*Vino Puro*.'
92. Ciudad Rodrigo Misericord: A bishop above, a monster below.

in the Franciscan who shuts *his* book the better to invite a lascivious inner image, revealed by the code of his thumb stuck between two forefingers. These two pieces are at Plasencia but there is another at Ciudad Rodrigo which is even more audacious since it hits at a mitred bishop, who is fitted out with a monster's body.

Rodrigo Aleman did not shrink at even the most extreme cases, the 'abominable sins' – masturbation and homosexuality – which we know from the

167

93. Toledo Roundel: Unmasked, unmutilated, the 'abominable sin' of homosexuality.

Inquisition records were punished in both laymen and clerics.[34] The same was true of heterosexual transgression which Rodrigo also freely castigated. The women's depicted reactions vary from a whacking rejection to an eager acceptance. Some young housewives act coyly in reaction to the advances of clerics, but the scenes are not indulgent for the latter. These lashing messages could not have been lost on the canons and prebendaries who occupied the stall-seats when even a high church dignitary is shown in the posture known as 'solicitation during confession.' Chastisement reaches its paroxysm at Plasencia in the blaze of an *auto-da-fe* that is set for an adulterous couple.

The relative frequency of references to the Jews in the carvings of Plasencia and Ciudad Rodrigo reflects their abundance in the Extremaduran population.[35] This enterprising people had taken advantage of the resettlement opportunities that were presented by the conquest of this region in the thirteenth century. Following the grave anti-Semitic events of the fourteenth century, when orthodox Jews lost most of their social and economic gains, the *conversos* more than made up for the dispossession, assuming an important station in a number of the cities.[36] This included the assumption of high religious posts, as occurred at Plasencia, which had a *converso* bishop in the mid-fifteenth century, Gonzalo de Santa Maria.

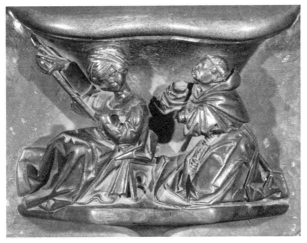

94. Plasencia Cathedral Misericord: A woman bends an ear to a cleric's advances.

But this anomalous state of affairs was not fated to last. It was in fact the leading cause for the rekindling of the anti-Jewish flames, as happened at Toledo where the ex-Jews' political and social prominence became the rallying cry of the great uprising of 1449 that was led by the hidalgo, Pedro Sarmiento. In 1473, the massacre of Jews and *conversos* at Toledo was tolled off by the city's church bells that called the peasants from the surrounding countryside to assemble in the cathedral.[37]

Almost inevitably such a sharp shift in the social climate would have its effect on art. It is repeatedly seen in Rodrigo Aleman's sculpture. Far from showing sympathy for Jews, as has been alleged by some recent church writers, Rodrigo followed the anti-Semitic trend, though with more subtlety than was customary. This is remarkably illustrated in the old Jew that he carved for the second handrest on King Ferdinand's stall at Plasencia. Canon Manuel Lopez Sanchez-Mora has described this man as having been sculptured 'with special respect.'[38] It is a patently distorted view meant to support his contention that Rodrigo was himself a concealed Jew, who by depicting Jews favorably was 'avenging [himself] against the Church.' But this great humped figure, with beaked nose and trailing beard, bowing over to caress a *goose*, was not meant to create respect or indulgence for the Jewish people. No more so was that other handrest that Rodrigo sculpted here, of a rich Jew clad in a fur-lined robe – but whose legs are chained!

These Jewish personalities, anti-Semitic though they might be, were not lacking in humanity. They were far from the virulent representations that one finds in the German art of the time, particularly in graphics.[39] The German

artists found a special delight in associating the Jew with the pig, as though his refusal to eat that animal's flesh were meant to conceal far more repulsive tastes. Thus he was often shown drinking directly from a sow's udder or even feeding on her excrement. These supposed scatological preferences of the Jews were presumably adopted from the pigs themselves with which they were assumed to have a strong affinity.

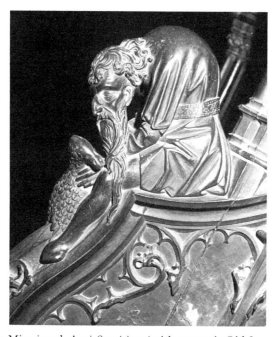

95. Plasencia Misericord. Anti-Semitism 'with respect': Old Jew with a goose.

In the large number of pigs that Rodrigo Aleman carved, some do have these repulsive tastes, like the sow seen playing with a monkey's excreta, or the astonishing carving, likewise at Plasencia, of a young woman exposing her raised buttocks to an ecstatic pig. But in a number of other scenes Rodrigo tried a totally different tack, presenting pigs as highly sophisticated creatures that are engaged in intellectual activities, such as study, writing or disputation of a text.[40] What prompted these amazing portrayals?

We suggest that, however subtly, the artist was still adverting to the pejorative association of the Pig-and-the-Jew. The clue lies in the Spanish word *marrano*, meaning swine, which in the racist ambience of the time came to have the connotation of 'false Jewish or Moorish convert.' The cultured postures of Rodrigo's pigs reflect obliquely the sense of guilt that many educated

96. Anti-Semitism by Metaphor: The Jew and the Pig (Old German graphic, *c.* 1470).

Christians are said to have felt about the Jewish persecutions, in recognition especially of the important place many Jews had attained in Spain's intellectual life. To these doubts or regrets Rodrigo's sardonic carvings seem to be saying: 'However clever, a pig (Jew) is still a pig (Jew)!'[41]

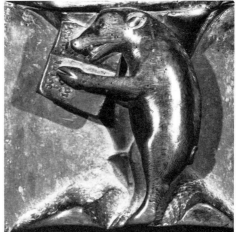

97. Ciudad Rodrigo: Rodrigo Aleman's 'revolutionary' presentation: *The Learned Pig*.
98. Ciudad Rodrigo. *The Learned Pig*: 'Counsellor Greedy' comments a text.

99. Ciudad Rodrigo. One of pair of 'gladiatorial' opponents: Preparing to lunge.

The height of Rodrigo's sculptural power came in his work at Ciudad Rodrigo. Here, besides half a dozen of his educated pigs[42] (which are matched by one or two others at Plasencia and Toledo), there is an equally brilliant series of what might be called 'gladiators.' One finds analogous illustrations of fencing and wrestling in Italian and German manuals of the period (as also in a famous Spanish work by Alfonso Martinez).[43] But these drawings are academic abstractions which could not possibly have inspired Rodrigo's vibrant, vehement carvings. One feels that the latter could only have been drawn from direct observation, enhanced by the artist's fertile imagination.

The sculpture appears at times almost too ferocious to have been true, but it is amply supported by verbal descriptions in the contemporary literature. A sixteenth-century German fencing instructor, Fabian von Auerswald, when describing in his book the 'new style' of fighting that he had initiated early in that century speaks of having abandoned the 'long tradition . . . of unimaginable brutality, [such as] seizing the hair or sex organs, and strangulation . . . [as well as] the use of arms. . . .' Danger was the prerequisite of this sport, which in Spain had the ancillary purpose of training Granada warriors, a majority of whom had been drawn from the Extremadura.[44]

After Granada, the habits of the 'society at war' continued to pervade Spain's

100. Ciudad Rodrigo. Second of pair of 'gladiators': Set to withstand the attack.

south and west. The tournaments that were its most popular diversion were 'fought on foot as well as mounted, with sword, mace or spear,' another author states.[45] These are the arms that Rodrigo's fighters use in five great misericords, four of which were evidently carved in pairs. In one of them the two contestants, each with short sword and shield, have taken their stance. One man is preparing to lunge forward, his eyes sharp and ugly, his mouth uttering a savage cry, while the other has spread his legs wide to receive the onslaught, covering his body with his shield, his pointed weapon addressed for an opportune thrust.

101. 'Attack and Defense with the Sword' (an old fencing manual illustration).

In the other pair the combat is near its end. The one man, overthrown, has lost his sword and holds on to his shield which will give slight succor against the violent impact of his opponent's spear. The terrible vulnerability of a beaten man is drawn with even more intense horror in the last scene in which the contestants have been brought into mortal proximity. The raised mace of the victor is ready to fall on his prone victim, who puts up his arm in a useless gesture. But it is his terrified eyes and especially his cry of anguish that are unforgettable in that last, eternally prolonged moment before death.

The men of the great grazing lands of the Extremadura were attuned to daily violence. The entire enormous stretch of land that had been conquered from the Moors was largely granted to the military orders, who parcelled it out to veteran fighters whose activity was exclusively devoted to the open range.[46] This kind of life is very familiar to us in our own country, if only from the cinema, with its roundups, brandings and mobile control by horse and cowboy (*vaquero*).[47] Its recreations, based on the tumultuous *rodeo*, are akin to the wild medieval sports that Rodrigo Aleman carved for the choirstalls of Plasencia and especially Ciudad Rodrigo.[48]

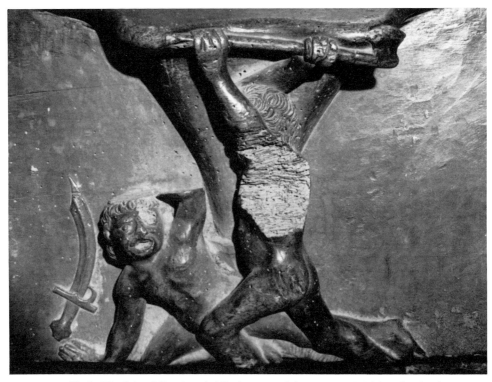

102. Ciudad Rodrigo Misericord. The last act of the contest: Waiting for death.

Small wonder that the sculpture of the latter is almost a totally secular art, with neither religious frieze reliefs nor large figures (with one exception, St Peter) in the entire set. A dozen or so angels in the roundels seem at first view to be a pious interpolation. But closer observation shows them to be strange angels indeed, with clipped wings, their sex showing, and they are engaged in quite un-angelic acts like eating a fruit, working, etc.

Piety was not the leading characteristic of Rodrigo's Aleman's other choir-stalls either. Though, as we have shown, he was certainly not anti-Christian or anti-religious, it was in works reflecting the actual world that he shone most particularly. The themes that he confronted, besides the usual ones of mirth and fantasy that are typical of this profane art, also included subjects of burning topical interest. Rodrigo always exceeded the purely necessary, as in the Granada scenes, where the repetitious acts of combat and surrender were livened by innumerable little vignettes of daily life. Even when embracing handed-down ideas, he treated them with imagination and passion. He was an intuitive humanist as well as realist and left a glowing record of his adopted country such as no other Spanish artist of his time had duplicated.

And yet it is certain that this greatest of Spanish choir-sculptors, birthplace unknown, date of entry into Spain also, was indebted for the acquisition of many facets of his skill to native artists, as when he closely duplicated the Sevilla assembly in form and detail. This had put him into a kind of apprentice-ship association with Nufro Sanchez, the Spanish Sevillan master, which appeared to strip Flemish artists of their reputed primacy in this field.

Hardly so! For we have come to see, as fact added to fact, that Spanish stall-making has had a composite development, to which skilled artists of many countries have contributed. Not the least of these were the Flemish masters, of whose constellation we now know Rodrigo Aleman to have been the brightest star. Our own stalls of Oviedo shared in this blend, as witness those mysterious men adverted to by the canons of 1492 in the Actas Capitulares as 'strangers,' whose precious increment can again be admired today, at least partially, in the *Sala Capitular*, thanks to the timely restoration of a number of these stalls. In the small number of such figured Gothic sets that still remain in Spain's dwindling patrimony, no artist, known or unknown, has made a more lustrous contribution than Rodrigo the Fleming.

CHAPTER XIV

Spain's Dwindling Patrimony of Choirstalls

Nothing could be more illusory than the durability of choirstalls. Mightiest of church art-works, they have been among the most fragile in resisting destruction. Revolution, heterodoxy, expediency, esthetic revulsion – all these have taken their toll. But nothing has done greater damage to the stalls than the abuses of their presumed guardians, the churchmen.

It was at Leon Cathedral, sister church of Oviedo's San Salvador, that we first learned that Bishop Martinez Vigil's attack on the central choir was hardly unique. When we had begun to study Leon's set, we were delighted to find what we considered an ingenious solution to the 'obtrusiveness' of the central choir. This was in the form of a double glass sliding-door fitting into the roodscreen which opened the view all the way, past stalls, transept and presbytery, to the surging reredos in the distance. Thus the major disadvantage of the typical Spanish choir-in-the-nave, against which Oviedo's prelate had clamored so irascibly, had been obviated, rendering its removal 'unnecessary.'

How great was our surprise therefore to learn from several canons that Leon's chapter were now considering to do away with their choir. As far as we could make out, the sole reason was the frigid temperature of the church's interior, which for a number of months each year made even an hour's presence in the choir a torment. We could attest to this fact ourselves, but wondered why the choir could not be heated instead, at a cost that was utterly out of measure with the value of the stalls. Oh, they would be carefully preserved, we were assured, some going to the *Santisimo*, the heated chapel where the morning canonical mass was held, the other half to the *Sala Capitular*. Exactly as had happened at Oviedo, we observed bitterly.

Leon's stalls had not started in the nave. They had been housed for almost a century in the presbytery after their completion in 1481 when the idea of

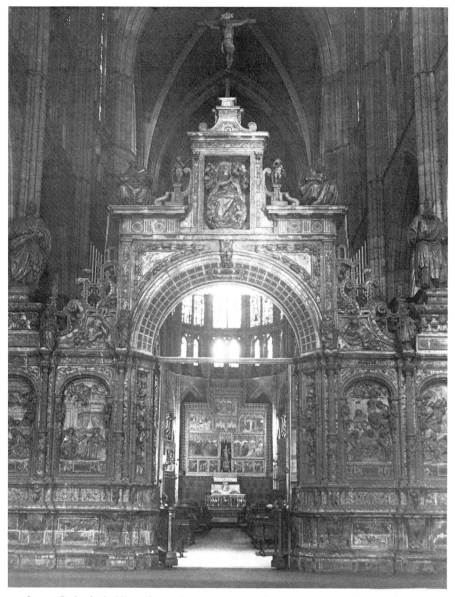

103. Leon Cathedral. View from the west, through the open roodscreen, beyond the central choir and looking toward the reredos at the east.

shifting them to the church center was first raised by the bishop. We learned about this from a letter in the cathedral's archives that had been addressed in 1560 to the prelate and his chapter by King Philip II,[1] who reported that

he had been disturbed by rumors of contemplated changes in the position of the choir. Philip spoke both as sovereign and as canon, a post that the royal house had held at Leon for a lengthy period.

The churchmen had already made tests and demonstrations, the king's letter further informed us. One of the changes considered, it went on, was 'to move the said choir to the central nave.' This, Philip told the clerics unqualifiedly, 'it is not proper to do,' arguing that if the nave were cut off by the new choir, 'it would lose the grace and distinction that it now enjoys.' It was somehow gratifying to find the monarch taking so forthright an esthetic view of the matter, even though it was actually anachronous since this was a period when nave-centered choirs were becoming more and more popular in Spain.

The imperial command seemed in any case to be heeded by Leon's churchmen, who appeared to content themselves by arranging for a heavy stone roodscreen to be erected (completed in 1574) that shut off the choir at the transept.[2] Thus was accomplished what presumably was the chief purpose of the proposed change: the canons' desire for isolation from the outside disturbances during their frequent offices in the choir. But the urge for innovation was by no means allayed by this adaptation. It was only ten years after the roodscreen had been built and a new prelate had mounted the cathedra that the idea of the transfer was again raised, this time by the bishop alone.[3]

For Leon's canons had by this time (1584) assumed a violent opposition to the project, to the point that Bishop Francisco felt called on to threaten them with excommunication if they refused to furnish the finances for it from the fabric fund.[4] They appealed over his head to the highest juridical authority of Rome, alleging that their bishop was 'given to perpetual disputes and experiments' and that his sole interest in the proposed alteration was 'to have a more ample station for himself where he would be visible to all the people.'[5] How much like Oviedo's Martinez Vigil this sounds!

The canons' argument evidently prevailed. In any case the choir was not transferred to the nave in that year of 1584. It was not until one-hundred and sixty-two years later, in 1746, that this took place.[6] It was long past the time actually when the fashion for central choirs had been at its height. The tendency was now moving in the opposite direction. Confinement of the clergy was frowned on. This was even more true in other countries, in France notably, where the choir-in-the-nave had never taken hold. Here, around 1700 or a bit earlier, a veritable assault on the roodscreens that shut off the presbyteries had begun. The avowed purpose was to 'open up the choir' to the faithful. Within a few decades some of the most stunning of France's sculptured Gothic stone screens were demolished, at Notre-Dame de Paris, at Chartres, and at a multitude of other churches.

At Leon Cathedral, on the contrary, when the choir was shifted to the nave

in 1746, the Renaissance roodscreen was moved from the presbytery and re-erected there, stone by stone, statue by statue, relief by relief. It was the opposite of exposure apparently that Leon's canons seemed to be seeking. But this was not yet the end. A century and a half later, in 1891, the idea was advanced to reverse the operation of 1746 and to bring the choir back into the presbytery![7] It must be said that the initiative did not come from the clerics this time, but rather from some lay authorities and in particular from the director of the large-scale renovation that had been undertaken at the cathedral.

But a majority of Leon's churchmen fought off the proposal,[8] rejecting the offered esthetic arguments in harsh, uncompromising terms that were to be repeated again and again by other clerics during the contemporary period, though usually for the inverse reason, that is, as the justification of the most extravagant acts of vandalism rather than in opposition to them:

> *'We are lovers of art but not idolators of it and we maintain that insofar as the House of God is concerned the needs and conveniences of the divine cult must take precedence over all esthetic questions.*[9]

Nevertheless Leon's churchmen accepted the offer made in 1913 by a wealthy nobleman, the Conde de Cerrageria,[10] to pay for the installation of the sliding glass doors in the roodscreen, which had a purely esthetic motivation. However it was not fated to content the cathedral canons overlong, for it appears today that they have decided to abandon the position that they maintained in 1891 and are prepared now to obliterate their central choir, an act that they had so emotionally opposed at that time.

There is hardly a single one of Spain's twelve figured Gothic stalls which has not undergone one or more and sometimes many changes of this kind. Several have experienced radical alterations of style, often in only one of the registers, as was the case at Toledo where a Renaissance upper section was carved fifty years after Rodrigo Aleman had completed his ground-level Gothic stalls. The upper range at Barcelona had a similar metamorphosis early in the sixteenth century. Things were somewhat different at Plasencia where, as we know, Rodrigo's Gothic stalls were fitted into the old church, even though it was known that they would eventually have to be reassembled in the new Renaissance edifice that was even then being built.

At Astorga,[11] similarly, where the stalls' late-Gothic section was done around 1515–23, it was only a quarter of a century later, in 1547, that they were much altered and shifted to a new choir that was erected in the course of the rebuilding of the cathedral. At Yuste[12] the Gothic stalls were broken

up in modern times and a majority of them distributed to two nearby parish churches, from which they were later reclaimed – with losses – and reestablished in the monastery's upper choir. Najera's set, now likewise installed in the choir loft, also shows signs of important casualties and rearrangements.[13]

In the case of the great choir assembly of Sevilla, the collapse of the vault above the stalls, in 1888, that wrecked a number of them almost doomed the rest.[14] The stalls were roughly disassembled and thrown helter-skelter into a depository (the San Francisco Chapel) where they gathered dust and termites. The idea began to be aired then that the assembly should not be brought back into the choir since this would require a general and costly restoration. About ten years later this thought was abandoned, however, and the stalls were reassembled in the central choir after a reckless repair that entailed much crude recarving. The total neglect that succeeded has brought a large part of their precious sculpture to a state bordering on decay.

Two other Gothic sets of figured stalls were not made for the churches in which they are now lodged. The small remnant in the Ildefonso Monastery at Talavera de la Reina[15] was acquired around 1750 from the local Collegiate Church of Santa Maria which had decided to have a new assembly produced. The abandoned stalls, though now decimated and in bad repair, are delicate and charming, surely more attractive, we cannot help thinking, than those that replaced them, which at any rate were destroyed by fire in 1846. The original stalls, which may have been created as early as 1461, which would make them among the oldest figured sets in Spain, are unfortunately not much esteemed by the Augustinian nuns at the Ildefonso, who admitted that they were planning to sell them to help finance the enlarged quarters that they needed for their rapidly growing *colegio* (school).

The other set that had to find a new home was originally created (in 1454) for Cuenca Cathedral, where it served for three hundred years before being unloaded on the Collegiate Church of Belmonte (see Chapter IX). Even before the transfer to Belmonte the stalls underwent a variety of changes. When at last, another renovating bishop, Jose Florez Osorio, decided, in 1753, to have new stalls made, it was on the argument of the old ones being 'antiquated,' their iconography 'indecent,' an esthetically obtuse viewpoint that overlooked much fine sculpture and especially the imaginative interpretations from the Old and New Testaments in the above-seat panels (See Fig. 36). No more alert to this interesting art were the new owners, apparently, who made strange misarrangements in the biblical sequences when they reassembled the stalls in their church which they had obtained as a give-away bargain.

As one pursues the fortunes of medieval choirstalls in Spain into contemporary

times,[16] one gains the impression that their status was probably never as aleatory as it has been in the twentieth century. This has continued into recent decades, in apparent refutation of the idea of a growing sensitiveness in the world regarding the preservation of art. Did the Franco regime, which favored ecclesiastic authoritarianism, tend to encourage willful decisions by the clergy? The fact is that years before Franco, deliberate acts of vandalism to church-choirs were already rife. At times they were carried out by highly esteemed architects and scholars, men like Antonio Gaudi (at Mallorca Cathedral) or Puig y Cadafalch (at the Seo de Urgel). It was during the Franco epoch, moreover, that what would have been the most scandalous act of dilapidation, aimed at the incomparable central choir of Barcelona, was successfully resisted by a fervent surge of popular protest.[17]

Actually such proposals had been brought forward at Barcelona Cathedral again and again, ever since 1578,[18] when a wooden model of a suggested new choir was prepared. But it was not used after all, which is not so surprising, for this was a period when churches one after the other were adopting the contrary arrangement of shifting their choir to the nave. Nevertheless agitation for the choir's transfer out of the nave sputtered intermittently at Barcelona during the following centuries, becoming persistent after the mid-nineteenth. In 1910, under the impulsion of the so-called 'liturgical restoration' movement that was animated by Pope Pius X (1903–14), the proposal was renewed, resulting in a heated polemic that engaged all social groups of the city. This appears to have saved the choir for several decades. In 1943, when the proposal was again mooted, 'a few newspaper articles sufficed to discourage the agitation.'[19]

In 1951, however, the approaching assembly at Barcelona of the International Eucharistic Congress brought the issue back insistently. Church authorities pointed out in dismay that the cathedral could not properly house the vast sessions unless the central choir were cleared away.[20] But the opponents of the measure resisted being stampeded. The hierarchy took up the charge again in 1958, preparing their campaign this time in the most sophisticated modern manner, with a public exhibition of the project accompanied by a broadside of publicity in all the media.[21]

Its dialectic remained strangely solipsistic and antiquated, however, quoting church authorities as though their mere assertions would still be considered magisterial. Pope Pius XI (1922–39) was cited as saying: '"Art for art's sake" is not admissible in the temple and must be subordinated at all times to the needs of the liturgy.' Did this mean that the Church was preparing a general reexamination of all old art? There was a hint that the new movement was in fact aiming at a kind of Cistercian iconoclasm since even the great reredoses, those proud splendors of Spanish churches, were characterized as the 'fruit of liturgical decadence,' whose magnificence relegated to a secondary rank

'the table of the sacrifice [the altar].'

Opponents of the demolition took on a straightforward esthetic stance in defense of the cultural patrimony. They represented a great majority of those who intervened in the controversy,[22] among whom were the highest figures of Catalan artistic and historic expertise: Juan Ainaud, Augustin Duran Sanpere, Vicens Vives, Jose Gudiol Ricart. It was heartening to find, in the context of a military dictatorship, so universal and exalted a passion being stirred up by such a theme. And once again Barcelona's magnificent choirstalls were spared.[23]

Will the waning Gothic stalls of Spain find an equally inspired defense at the next challenge? Is it not possible that from the bosom of the Church itself some enlightened voices will rise to this purpose? We cannot help thinking of men like those we have come to know at Oviedo – Dean Demetrio Cabo, Magistral Emilio Olavarri, and others – who will surely give due weight to great esthetic values when ranged against expediencies in behalf of the ritual, which might be forgotten within a generation. The joyful outcry of the entire community of Oviedo at the recent inauguration of its reclaimed stalls should vouch for such a heartening expectation.

104. Oviedo Cathedral. Eighteen of the twenty-eight upper and lower stalls that have been reestablished in the *Sala Capitular*.

And yet there is still a long road to travel, as Manuel F. Avello, the city's 'official chronicler,' implied in an eloquent account of the event. This sensitive man, it appeared, had been disturbed all his life by the esthetic losses due to what he qualified as '*la piqueta incivil*' and '*la piqueta inreligiosa*,' dual destroyers whose names are impossible to put into English but must be described figuratively as the wielders of the ravaging instrument – the pickaxe – when grasped in the hands of civil or religious authorities. Our story, given at the inauguration, of the step-by-step ruin of Oviedo Cathedral's choirstalls had called forth various troubled memories in him of the willful desolation of other local treasures, despite the efforts of an enlightened few to save them.

One of these which carried his racking thoughts back half a century had robbed the cathedral square of its 'most beautiful and pathetic surroundings, its humble porches and multicolored facades.' And there were many others. The entire country indeed had suffered terribly from the unceasing desecration of its artistic patrimony, and continued to do so: 'Spain is one great gaping wound through which its treasures are pouring.'[24] Yet a dim flicker of hope seemed to light up in Don Manuel's thoughts. Would the partial reclamation of Oviedo's choirstalls serve as a 'splendid lesson' for the future? he asked. One is not certain of his answer. Perhaps it was sufficient that the question should be put.

Over the ages there have been many destroyers of art: natural disasters, the never-ending calamity of war, arguments of utility, changes of taste, cultural insensitivity. In a world that is fearfully unbalanced in development and possession, economic exigencies have at times understandably been given a free rein in the obliteration of art, such as occurred in the construction of the Aswan Dam in recent years. But there have been far more utterly inexcusable losses due to reckless city planners, road-builders, self-proclaimers of 'progress,' in even the most advanced countries. The dangers to man's cultural patrimony know no boundaries.

Possession, whether individual or institutional, can no longer be considered an unchallengeable claim. The Church particularly has been shielded in this regard by the cloak of holiness, but we have come to know that this often conceals arbitrary, unthinking or foolhardly acts. The concept of a common ownership of the cultural heritage has been taking hold in the modern world. It will no longer brook irresponsibility of any kind but will leap to the defense of what belongs to all. Champions will be rising up at every hand to save the wonders that have been created by mankind and that are as essential to life as food and drink and shelter.

Notes

INTRODUCTION NOTHING TO START WITH

1 Pelayo Quintero Atauri, 'Sillas de coros españoles,' *Boletin de la Sociedad Española de Excursiones*, Vol. XV, No. 172 (June 1907), 85–6.

2 'Daños y perdidas sufridas en [la Catedral de Oviedo] durante los sucesos revolucionarios de Octubre de 1934,' *Academia de la Historia*, Madrid, November 1934. The main report is by Manuel Gomez Moreno and is accompanied by a number of excellent photographs.

3 Joaquin Manzanares Rodriguez, 'Oviedo artistico y monumental,' in *El libro de Oviedo* (Oviedo, 1974), pp. 142–3.

4 It was the first of the important restorations undertaken at the cathedral after the Civil War. Ramon Cavanillas reports that this was done in 1938–42 (*La Catedral de Oviedo*, 1977).

5 This was probably where the chapter library had been located. Manuel Gomez Moreno, in 'Daños y perdidas sufridas, etc.,' published in *Diario de Madrid* (November 11, 1934), has a caption under Lamina VIII, showing the wrecked *Camara Santa* and the northwest angle of the cloister, which notes: 'Above is the chapter library.'

6 The International Fund for Monuments, whose main office is in New York, is an unfunded organization which nevertheless has built up a remarkable record of important restorations in a number of countries, financed by donations of its art-minded members and other sources. (Its name was recently changed to World Monuments Fund).

7 The '*Claustro Alto*' (high cloister) is a misnomer. Actually it is an extra storey that was added to the cloister enclosure in the eighteenth century. Its windows overlook the cloister.

8 This was the Spanish *Patrimonio*, a section of the Ministry of Culture, which, as we would eventually learn, did not have nearly the same authority over art monuments as is enjoyed by the French *Monuments Historiques*. It was never necessary to report the loss. On our next return to Oviedo, we found the St Peter quietly nestling among the other above-seat busts in the *Claustro Alto*!

9 Asociacion de los Amigos de la Catedral de Oviedo. We were to find Señor Perez-Abad del Valle a devoted and hard-working head of this organization, which made a much appreciated contribution to the restoration of the choirstalls.

10 The Joint Committee (*Comite Conjunto*) was a facet of the 'Treaty of Friendship and

Cooperation between the USA and Spain.' Its co-presidents were Amaro Gonzalez de Mesa, director-general of cultural relations of the Spanish Ministry of Foreign Affairs, and Serban Vallimarescu, American Embassy Counselor for Public Affairs.

11 Manuel Gomez Moreno, in the already cited work, was the first to observe that the miners had not touched the cathedral's archives when breaking into the adjoining *Sala Capitular*, whose stout walls had prevented the fire's spread to the shelves where the precious parchments and other documents were stored.

CHAPTER I CERTIFICATE OF BIRTH

1 The full title of the two articles, which can be read in manuscript at the cathedral archives, is given jointly as: 'Informe sobre la silleria del coro viejo: (A) Construccion, Documentacion, Descripcion y Juicio, por D. Francisco de Caso, catedratico de historia. (B) Desmonte, Traslado, Destruccion y Conservacion parciales. Documentacion, por Raul Arias del Valle, archivero encargado,' September 1978.

2 Francisco de Caso Fernandez, *La Construccion de la Catedral de Oviedo (1293–1587)*, Universidad de Oviedo, Departamento de Historia Medieval, Oviedo 1981.

3 Manuel Gomez Moreno, *Catalogo Monumental . . . de Leon* (1927). The document that the author referred to specified, he asserted, that Juan de Malinas 'occupied a house [belonging to] the cathedral chapter in that very year that the stalls were begun,' meaning 1467, which was actually the date of a papal bull on the subject.

4 Evidence of Bishop Juan Arias de Villar's connection with the stalls is discussed later in the text and notes.

5 We will see later that Oviedo's choir assembly originally consisted of forty-five upper and thirty-five lower stalls, or a total of eighty. No actual 'proof' of these figures exists, except in the writings of nineteenth-century authors, who, curiously, at times differ as to the exact number of stalls there were. Francisco de Caso told us that he had discovered that there was a great amount of money available for the construction in the period around 1492, which was the medial point of Juan Arias's tenure. The prelate was a wealthy man and stood high in the councils of Ferdinand and Isabel, whom he could likewise count on for important donations.

6 For a fuller description of this subject, with sources, see Chapter X.

7 A.C.O. Actas Capitulares de 1497, folio lxv, recto. A peculiarity of this and the other pertinent documents will be noticed: the fact that they are entries from the chapter's minutes and not from the fabric records, where they are often found in other churches. In any case, these do not appear at Oviedo until 1530.

8 As, for example, Octavio Bellmunt y Traver, et al., in *Asturias, su historia y monumentos, etc.*, who when discussing the role of Alonso de Palenzuela made the remark: 'to whom we owe the principal part of the work of the choir. . . .'

9 The three archival entries in question are the following:
 (1) A.C.O. Actas Capitulares de 1492, fol. ix, recto, Feb. 17.
 (2) A.C.O. Actas Capitulares de 1492, fol. x, recto, no date.
 (3) A.C.O. Actas Capitulares de 1492, fol. xxix, recto, March 30.

10 Francisco de Caso characterizes Herrera as the 'authentic animator of the works' (*La Construccion de la Catedral de Oviedo*, p. 245).

11 A.C.O. Actas Capitulares de 1492, fol. x, r.

12 A.C.O. Actas Capitulares de 1492, fol. xxix, r.

13 Julian de Paredes, in *Las antigüedades y cosas memorables de las Asturias . . .*, c. 1694, was one of the earliest to refer to the great amount of construction that was done in Juan Arias de Villar's term ('. . . en cuyo tiempo se hizo gran parte de la Santa Iglesia'), 'as

can be seen by his coat-of-arms being placed in various parts,' and which he identifies as 'a fleur-de-lis in the middle of four scallop shells.'

14 Fermin Canella y Secades, in *El libro de Oviedo* (1887), speaks of the inscription 'over the arch of the entrance,' dated February 1498. This and other mural inscriptions dating sections of the edifice are given in the excellent little guide prepared by German Ramallo, *Guia de Asturias* (Leon: Editorial Nebrija, 1979), pp. 44–8.

15 For the 'slow start' through 1300–1450, we could point to the fact that only the cloister was built in the fourteenth century, while the chapel of Bishop Gutierre de Toledo, the first element done in the cathedral proper, was not undertaken until late in that century. Productivity accelerated somewhat during the first half of the fifteenth century, when the capilla mayor and the two chapels at the north and south transepts were built.

16 Ramon Cavanillas, in *La Catedral de Oviedo* (1977), cites two examples of the fund-raising efforts of Bishop Palenzuela. At the synod of 1471, the prelate had a decree adopted granting for a period of ten years half of all vacant benefices to the fabric, which meant that new prebendaries received only half pay during that lengthy period. Another familiar gesture was the sending of a revered cross and chalice from the *Camara Santa* out on a fund-raising tour, in 1485, the reason given being a great lack of funds due to the expenditures. According to Francisco de Caso, Palenzuela had much trouble with the chapter over his imposed assessments for the construction. He himself bequeathed a hundred thousand maravedis to the building fund at his death, in 1485 (*op. cit.*, pp. 226–9).

17 Santos Garcia Larraguete, *Catalogo de los pergaminos* ... (1957), No. 302, July 13, 1234. A corresponding document on the Toledo side exists at the Biblioteca Nacional de Madrid, Department of Manuscripts, MS. 13024, Toledo, fols 134–135, 3 Idus Julii, 1234. It was brought to our attention by the scholar, Guido Konrad de Konesheim, to whom we express our thanks.

18 Juan Arias de Villar nevertheless had great difficulty in keeping the cash-flow supplied for his construction campaign. Francisco de Caso claims that the prelate's immense urgency to build and to produce artistic works consumed funds that were meant for other important purposes (*op. cit.*, p. 254).

19 Ciriaco Miguel Vigil, *Asturias monumental*, 2 vols (1887), pp. 2–3.

20 Vigil evidently made an error in his count of these rear lower seats, reporting that there were eight of them, which would have given a total of thirty-six. Other early writers list thirty-five, which was no doubt correct, as we shall learn from the inventory. Thus, Ceruelo de Velasco, in *Apuntos historicos* ... *de la Santa Basilica de Oviedo* (1872), reported that 'there are below thirty-five other (stalls), in the middle of which is that of the president (dean).'

21 The work is by Jose Maria Quadrado, *Recuerdos y bellezas de España* ... *Asturias y Leon* (1855), who in a later edition (1885) gives a detailed description of the stalls, especially the upper ones. The artist, F.J. Parcerisa, did illustrations for the 1855 edition, which included two important engravings of the central choir of Oviedo seen from the exterior. Pascual Madoz (*Dictionario geografico-estadistico-historico de España*, 1849) is one of several early authors who describe Oviedo Cathedral's stall-art (even the misericords) in glowing terms.

22 J. Alvarez Amandi, in *La Catedral de Oviedo* (1929), reproduces this photograph of the bishop's seat (No. XX).

23 The central-nave location of the Gothic choir was by no means its original position in all Spanish cathedrals, as we shall see in Chapter XIV.

CHAPTER II ICONOCLASM BY SUBTERFUGE

1 Pelayo Quintero Atauri, 'Sillas de coros españoles,' *Boletin de la Sociedad Española de Excursiones*, Vol. XV, No. 172 (June 1907), pp. 85–6.

2 A.C.O. Actas Capitulares, Enero 1894–Septiembre 1905, folio 7, r, February 16, 1894 (date when bishop's letter of Feb. 10 was read to chapter).

3 The full details of Martinez Vigil's long letter are not given in the minutes (Actas) but in a separate report, dated February 22, of a meeting of the so-called *Consulta*, which was a small, special committee of the chapter that considered such questions, prepared replies, which were then brought to the canons for their decision.

4 The local daily newspaper, *El Carbayon*, ran a rather full report on the bishop's project in its edition of January 25, 1894, two weeks before he sent his letter to the chapter, ending with great praise for Martinez Vigil, whose name was placed on the roster of Oviedo's greatest prelates of '*pasados siglos.*'

5 The *Consulta*'s proposed reply to the bishop's letter is given at the end of the verbatim reproduction of this letter in its report of February 22 to the chapter.

6 Actas Capitulares, fol. 43 v., January 25, 1895. The bishop merely asked why he had not heard from the chapter regarding his proposal.

7 Actas Capitulares, fols 44–44 v., February 1, 1895: date of the chapter's reply regarding the architect, Miguel Laguardia.

8 Actas Capitulares, fols 72, 72 v, 73, October 11, 1895: when Laguardia's report was read to the chapter.

9 Actas Capitulares, fol. 82, January 31, 1896. After reading the bishop's 'ultimatum,' the chapter decided at the same session that 'with or without' Laguardia's report, they would send the bishop their reply.

10 Actas Capitulares, fols 86–89 v., March 7, 1896.

11 Actas Capitulares, fol. 85, March 4, 1896.

12 Actas Capitulares, fols 169–169 v., 170, June 18, 1898.

13 The *Consulta*'s report was prepared July 4, 1898. It was adopted with slight alterations by the chapter on July 6, whose reply to the bishop bears that same date. See Actas Capitulares, fols 174–176 v.

14 Luis Menendez Pidal, the architect and restorer, who was particularly active in Oviedo and Asturias, writes in *Los monumentos de Asturias: su aprecio y restauracion* (1954), about the San Fernando Academy that it 'designated the architects assigned to direct, under its high supervision, all works on the most important edifices and especially those that possess a definite artistic or historic interest.'

15 Actas Capitulares, fols 176 v.–178 v., July 8, 1898. The sweeping rights of bishops over the assignment and decoration of choirstalls, Martinez Vigil admitted, was granted in a decree issued thirty years after the Council of Trent and not by that body itself (fol. 178).

16 Actas Capitulares, fols 179 v.–181, July 15, 1898.

17 Actas Capitulares, fol. 235 v., April 3, 1900.

18 Why the long delay? Martinez Vigil, in his own revised *Estatutos de la catedral* (published in 1892), listed the cases when the bishop must obtain the consent of the chapter, adding that this was likewise required 'for any other subject or affair by which this holy church is placed under an important obligation or from which its interest or those of its chapter may receive a certain prejudice. . . .' By these, Martinez Vigil's own words, could not a strong canonical case be made against his project – provided the chapter had the desire or will to do so?

19 Actas Capitulares, fol. 270 v., June 18, 1901.

20 Actas Capitulares, fols 288 v.–289, March 18, 1902. This is the first indication that we

have that the central choir has been destroyed, the stalls, roodscreen and grill cleared away. Only the organs have been left hanging, no doubt looking obtrusive and out of place.

21 Actas Capitulares, fol. 335, October 9, 1903. The entry says that the case materials were to be used 'to make altar-pieces.' But Raul Arias del Valle, the archivist, told us that this was a pious exaggeration. Not included among the *Claustro Alto* cast-offs were the two major pieces from the organ assemblies, an ecumenical balance of King David playing his harp and St Cecilia with 'her hands on the manual,' as described by Ceruelo de Velasco in his book, *Apuntos historicos, etc.*, 1872.

22 Actas Capitulares, fol. 37 v., August 20, 1906, and fol. 34 v., August 1, 1906. – These and the following listings are all in the succeeding volume of the Actas Capitulares.

23 Actas Capitulares, fol. 38, August 31, 1906.

24 Actas Capitulares, fol. 122, November 9, 1908.

25 Actas Capitulares, fol. 132, March 11, 1909.

26 Actas Capitulares, fol. 161 v., September 20, 1909.

27 Actas Capitulares, fol. 355, August 16, 1904.

28 Luis Menendez Pidal, *Los monumentos de Asturias, etc.* (1954), pp. 34ff.

29 In his *Estatutos de la catedral de Oviedo* (1892), in the thumbnail sketch that he recorded of the accomplishments of Juan Arias de Villar's successor, Juan Daza (1498–1503), Martinez Vigil said: 'He ordered the construction of the iron grill which closed off the choir,' proving that he was aware of the fact that the central choir *belonged to* the 'primitive church' to which he kept proclaiming that he was eager to 'restore' the cathedral, which had supposedly been 'so crudely deformed' by the building of that choir. If that was his true purpose, why did he not mention the other elements that had been added in the seventeenth and eighteenth centuries, including all the chapels, the ambulatory, and much else? Would he have advocated clearing them away as well?

CHAPTER III SPAIN'S 'OCTOBER': DESTRUCTION OF THE UPPER STALLS

1 Manuel Gomez Moreno, 'La catedral de Oviedo. Daños y perdidas sufridas en este monumento nacional durante los sucesos revolucionarios de Octubre de 1934,' *Academia de la Historia*, Madrid (November 9, 1934). The story is told twice in this account, the second time (pp. 11–16) with some additions, including the item about the robbing of the cashbox.

2 Actas Capitulares, volume of 1933–9. The account of the 1934 and 1936 events, written by Arturo de Sandoval y Avellon, chapter secretary, is an added section that was recorded on August 20, 1941.

3 Anonymous, *Monumentos asturianos restaurados . . .* (1978), gives an excellent account of the destruction that took place in the *Sala Capitular*, in October 1934, and also shows some good photos of this destruction.

4 Aurelio de Llano Roza de Ampudia, *Pequeños anales de quince dias: La revolucion en Asturias, Octubre 1934* (Oviedo, 1935. Reprinted by the Instituto de Estudios Asturianos, Oviedo, 1977), pp. 152–3.

5 The literature of this period is rich and includes writers of different nationalities and viewpoints. The Oviedo events are more sparsely treated and many of the reporters are hopelessly uncritical, especially those who wrote early and without the correctives made possible by the lapse of time. J.A. Sanchez y Garcia-Sanco's recent work, *La revolucion de 1934 en Asturias* (1974), seems to give a fairly objective overlook of events from the rcvolutionaries' viewpoint.

6 Aurelio de Llano, *op. cit.*, p. 30.

7 This certainly was no longer the case in 1936, when the cathedral tower was carefully prepared for both offensive and defensive action, as described by Arturo de Sandoval, in the Actas Capitulares, 1933–9.

8 Arturo de Sandoval says that the soldiers in the cathedral got water from 'supplies in the sacristy.' The newspaper *El Carbayon*, in its first issue after the revolt, published on October 18, puts it more picturesquely, stating that 'the heroic patriots refreshed their hanging (*'resacas'*) tongues by sticking them avidly inside the holy recipients.'

9 The description is by Francisco Prada in his chapter in the collected volume of narratives (*Caminos de sangre*), titled 'Varios episodios de unos dias tragicos.' The volume is dated December, 1934: Madrid.

10 Aurelio de Llano gives the name of the marksman, who was 'the heart of the defense in the upper part of the tower,' as 'Sgt. Jesus Diaz Serna' (p. 30), rather than 'Lopez.'

11 Manuel Gomez Moreno, in his report published by the *Academia de la Historia* (p. 11), states that the cathedral's defenders 'hardly took notice of the cloister or its dependencies. They thought that the door [from the corridor near the south transept] leading to the cloister actually gave out into the street, so they were not surprised to hear noises of people there until a revolutionary disguised as a guard suddenly appeared. . . .' The defenders' poor orientation indicates that they knew nothing about the layout of the church compound, no doubt because they were from outside of Oviedo and had been hastily pressed into this service.

12 Bombings of civilian populations in several Asturian towns were reported as early as October 9, the most devastating occurrence being at Gijon, where Manuel Grossi Mier estimates that at least six hundred people were killed (*La insurreccion de Asturias*, 1935 and 1978, p. 65). Aurelio de Llano sighted his first planes flying over rebel positions on October 7, and reported a first bombing attack on October 10 and civilian bombing on October 11, when 'a trimotor dropped a bomb on City Hall Square, killing twelve people and wounding twenty-seven' (pp. 31, 61, 73).

13 Manuel Grossi Mier, p. 62. – This author attributes the miners' demand to blow up the cathedral as due to anger, explaining that 'the enemy was causing us a great number of casualties' ('el enemigo . . . nos produce gran numero de bajos'). – Another possible motivation was suggested to us by David Ruiz, university professor and author: 'Dynamiting was considered a revolutionary act.'

14 Manuel Grossi Mier claims (p. 87) that the Communists voted with the other representatives to abandon the city. The Communists deny this, as in the report of the party leader of Asturias, Carlos Vega, at a meeting of its central committee held soon after these events ('Informe al Comite Central del Partido Comunista de España de los sucesos desarrollados en Asturias durante el movimiento revolucionario de Octubre de 1934,' Apendice II of J.A. Sanchez y Garcia-Sanco's book). Aurelio de Llano (p. 65) maintains that Gonzalez Peña's proposal was overruled by an angry group of revolutionaries who broke into the Committee meeting. Peña and his supporters left and a new Committee was set up under Communist leadership. The dynamiting of the *Camara Santa* took place some hours later, though there is no evidence of a relationship between the two events.

15 Aurelio de Llano, *op. cit.*, pp. 96, 98, 99, 109, *passim*.

16. *Ibid.*, p. 69.

17. Manuel Gomez Moreno, *op. cit.*, p. 12.

18. Manuel Gomez Moreno requires three full pages to detail the destruction and loss wrought by the dynamite, in addition to eighteen remarkable photographs.

19. Joaquin Manzanares Rodriguez, in *Itinerario monumental de Oviedo*, (1960), claims however that the cathedral's stained-glass was destroyed by canon bombardment in the siege of Oviedo during the Civil War, in 1936–7. It is hard to think that Gomez Moreno, who was on the scene so soon after the October 1934 dynamiting, could have been mistaken

about so obvious a loss as the cathedral's excellent glass. It seems true, however, that the destruction in the church interior was much greater during the Civil War, as several writers have reported. Thus Joaquin A. Bonet, in his *Reconquista: Reportajes de la Asturias roja* (1938), listed 'considerable damage in the chapels of Velarde del Carmen, the Assumption, the Sacristy, and to the great reredos, as well as the total crumbling of the cupola of the Santa Barbara Chapel.'

20 Aurelio de Llano *op. cit.* (pp. 34–5) tells of this firing at the tower while Manuel Grossi Mier (*op. cit.*, p. 48) explains how the detonators were found to be unusable because of their being the wrong caliber.

21 Antonio Ramos Oliveira, in *La revolucion española de Octubre* (Madrid, 1938), quotes Leon Trotsky as saying that the Russian 'October' was hardly as sanguinary as the Asturian revolt, whereas the Austrian uprising was confined to only one district as against Asturias's farflung hostilities (pp. 119ff).

22 Aurelio de Llano, 'Numero de Muertos y Heridos de la Fuerzas Leales' (p. 209); 'Numero de paisanos muertos y heridos' (p. 210).

23 *Ibid.*, p. 115.

24 Canon Arturo de Sandoval lists thirty-four clerics killed during the October uprising, including eight boys from an *Escuela Cristiania* and six seminarians.

25 Luis Menendez Pidal, *Los monumentos de Asturias: su aprecio y restauracion desde el pasado siglo* (Madrid, 1954), p. 32. Besides destroying the transept window, the author reports, Martinez Vigil also had the façade glass ripped out to give more light, and there were other acts of vandalism that he attributes to him.

CHAPTER IV THE LOWER STALLS GET 'LOST' IN THE CATHEDRAL

1 Joaquin Manzanares Rodriguez, 'Oviedo artistico y monumental,' in *Libro de Oviedo* (Oviedo, 1974), pp. 142–3.

2 This was Luis Menendez Pidal in his already cited work, *Los monumentos de Asturias, etc.*, 1954.

3 This article has already been cited several times.

4 This demand was reported by Bernard Guetta, in the September 5, 1980, issue of the French newspaper, *Le Monde*.

5 We are grateful to our friend, Maria-Jesus Pollado Garcia, of Oviedo, for having called this song to our attention.

6 Arturo de Sandoval, Actas Capitulares de 1933–9.

7 Manuel Fernandez Avello, 'Reportaje de la catedral de Oviedo y su torre,' in *Boletin del Instituto de Estudios Asturianos*, Año XI (1957), No. XXXI, 189–221. There is an accompanying photograph showing great damage to the tower and to the Santa Barbara Chapel.

8 Joaquin A. Bonet, for example, in his *Reconquista: Reportajes de la Asturias roja* (Gijon, 1938).

9 The photograph is in Enrique Rodriguez Bustelo's *Comentarios y notas sobre arquitectura y arquitectos del renacimiento en Asturias* (Oviedo, 1951).

10 Essentially the same photograph was used in the article published in 1957, by Manuel Fernandez Avello, cited above.

11 Santos Garcia Larraguete, *Catalogo de las pergaminas, etc.* (1957).

12 Luis Menendez Pidal, *op. cit.*

13 See Chapter XII.

CHAPTER V PROBLEMS OF THE RESTORATION

1 Dorothy and Henry Kraus, *The Hidden World of Misericords* (New York and London, 1975 and 1976).
2 The restorers' preliminary cleaning and disinfection have been described by them, in an article by Raul Vazquez de Parga in the Spanish *Selecciones del Reader's Digest* (September 1981), as follows: 'To begin with, the cabinetmakers [*ebanistas*] cleaned the wood with a liquid with an ammoniac base and soaked the pieces with a disinfectant (Xylamon-Meta carcoma) to kill the wood-worms. They then injected a transparent fluid (a kind of resin) into the holes caused by the insects. When this substance hardened, all the soft parts became consistent. . . . Since the Krauses had prohibited sandpapering or scraping, the cabinet-makers used pig-bristle brushes to remove the grime.'

CHAPTER VI PIECING THE NEW CHOIR TOGETHER

1 Aurelio de Llano, *op. cit.*, p. 100.
2 *Ibid.*, pp. 102–5. Ramon Rodriguez Alvarez, vice-director of the Biblioteca Universitaria of Oviedo, told us that all the books of the library (*c.* 60,000) were destroyed. There were about 3,000 volumes in another section of the university that were spared. After the reconstruction, the Biblioteca was resupplied by gifts (especially from the Conde de Toreno) and purchases (an important one being the library of the Marques de Pidal).
3 Ciriaco Miguel Vigil, *Asturias monumental*, 2 vols (1887).
4 Ceruelo de Velasco, Juan de Cruz, *Apuntes historicos y descriptivos de la Santa Basilica de Oviedo por un curioso capitular* (Oviedo, 1872), p. 23.
5 Leopoldo Alas (Clarin), *La Regenta*. (Republished in frequent editions by Alianza Editorial, Madrid, starting in 1966.)
6 Jose Maria Quadrado, *Recuerdos y bellezas de España* (first published in 1855 and republished several times since, most recently in 1977). The two engravings were, apparently, taken from drawings by the artist Parcerisa done on a trip through Asturias, in 1850.
7 Ceruelo de Velasco, *op. cit.*
8 Isabel Mateo Gomez, *Temas profanos en la escultura gotica española. Las sillerias de coro.* (Madrid: Instituto Diego Velazquez, 1979), p. 192, and Fig. 193. She explains that Professor German Ramallo was able to photograph a few parts of the stalls 'that are visible in their present storage' (pp. 22–3).
9 The restorers reported to us one day that in checking among some seat sections for possible use they had found several of the seat-backs that were heavier than the others and with large rectangular holes hollowed deep into their tops. Could not these have belonged to the preserved upper-stalls, the big holes having been meant to bear their heavy panels?
10 J. Alvarez Amandi, *La Catedral de Oviedo* (Oviedo, 1929), p. 55, foot-note. Another observer who reported having seen remnants of the upper-stalls was Arturo de Sandoval, who in his memorandum of 1941 mentioned 'a fragment of the Gothic stalls in the Santa Eulalia Chapel.' Some observers tended to distinguish the upper-stalls as 'Gothic' because of their filigreed crest.
11 The full list of these intarsia inscriptions is given in Ciriaco Miguel Vigil's work, Vol. II, Lamina XIV.
12 We should recall, for example, that Octavo Bellmunt y Traver et al. in *Asturias, su historia y monumentos, etc.* (1895), declared that it was Bishop Alonso de Palenzuela 'to whom we owe the principal part of the work of the choir.'

CHAPTER VII A MUSEUM OF FOUR HUNDRED CARVINGS

1 Hans R. Hahnloser, *Villard de Honnecourt* (Vienna: A. Schroll, 1935), p. 145, and Fig. 48.

2 H.W. Janson, *Apes and Ape Lore in the Middle Ages and the Renaissance* (London: Warburg Institute, 1952), p. 42.

3 It should be understood that the 419 carvings represent the totality of all those recorded in our inventory. (It is well to remember, too, that at least half of Oviedo's carvings disappeared in the flames of October 1934.) Many of these were not used in the new assembly or even repaired. The numerical distribution of the 419 carvings in our inventory was as follows: above-seat busts, 35; spandrels, 70; misericords, 41; side reliefs, 114; handrests, 101; canopies, 32; upper panels, 11; small crest figurettes, 15. We had often spoken with Emilio Olavarri and others regarding the importance of continuing the work of cleansing and consolidating these remnants after all the usable stalls had been completed. The cathedral *fabriquero* was excited by the idea of using a number of these pieces as the nucleus of a 'Capitular Museum.' We were pleasantly surprised on the occasion of a more recent re-visit to Oviedo when Don Emilio took us up to the *Claustro Alto* and showed us the entire expanse of the storerooms patched, cleaned and painted. 'Here is our museum!' he proudly declared.

4 The 'Asturian bear,' which has been called 'almost a regional totem,' is seen three times in the Oviedo choirstalls.

5 An illustration of this subject in a French carving can be seen in our book: *The Hidden World of Misericords*. The subject is a great favorite among English misericords, a number of which are listed in G. L. Remnant's *A Catalogue of Misericords in Great Britain* (Oxford, 1969). A splendid example at Norwich Cathedral is reproduced in that book, Pl. 12a.

6 The complex symbolism of the carrying of the great grape-cluster by Moses's scouts returning from the Holy Land is carefully analyzed by Emile Mâle in his *L'art religieux du XIIIe siècle en France* (Paris, 1902), p. 176. However, he does not record any rapacious crow that descends to attack the cluster, an incident which we have interpreted as a perhaps unique departure from the usual presentation.

7 The fox is rarely seen performing on this instrument, which is a far more usual occupation for the donkey or the pig. Typically Asturian, the bagpipe (*gaita*) appears seven times in Oviedo's stalls.

8 The traditional interpretation of the siren is that of a seductive female creature who leads men to perdition. There is in European stall-art a greater consistency to this viewpont than with most other references to mythical subjects. However, in the great majority of sirens that we have seen in stall-art, there was not the slightest guile or evil intent evident; they had become through repeated representation formalized objects of display, whose sexuality itself was usually subdued.

9 In English misericords, pigs are indexed 20 times in G.L. Remnant's *A Catalogue of Misericords in Great Britain* (Oxford, 1969), 14 of which are in ordinary activities like eating, being slaughtered, etc.

CHAPTER VIII A KIND OF CONSECRATION

1 Though various versions of the bagpipe have been known the world over (the Asian steppes, North Africa, 'Celtic' regions like Ireland, Scotland, Wales and Brittany), there is no doubt that the northwestern Spanish provinces had a special cult for it. Julio Caro Baroja has written that the Asturian 'uses the bagpipe as a fundamental instrument' (*Los pueblos de España*, 1976).

2 In 1954, when Luis Menendez Pidal told of seeing the stalls in the *Claustro Alto*, which

is the earliest date that we have found of this identification, he mentioned that the bishop of the time was Lauzurica (*op. cit.*, pp. 34ff.). The dean in that period was Jose Cuesta Fernandez, who published his excellent *Guia de la Catedral* in 1957.

3 The full title of the organization is the Comite Conjunto Hispano-Norteamericano para Asuntos Educativos y Culturales (Joint Spanish-American Committee for Educational and Cultural Affairs).

CHAPTER IX A PANORAMA OF STYLES AND ORIGINS

1 In Toledo, there are at least ten *mudejar* churches or churches adapted from mosques, in addition to many magnates' houses done in Moorish style. They date from the fourteenth and fifteenth centuries, according to the work by Santiago-Sobreques Vidal and Guillermo Cespedes del Castillo, *Patriciado Urbano* (Barcelona: Editorial Teide, 1957), 380, Vol. II de la *Historia Social y Economica de España y America, dirijida por J. Vicens Vives.*

2 This tolerance was a two-way passage, as can be seen in the art of the *Sala de los Reyes* at the Alhambra, done in the late fourteenth century, showing Christian and Moorish noblemen and women jousting, hunting and playing chess. (See on this Angus McKay, *Spain in the Middle Ages* (1977.)

3 The earliest mention of the misericord by name that has turned up occurs in a document of the eleventh century, from the *Constitutiones Hirsaugenses* of the Monastery of Hirsau, Germany (J.-P. Migne, *Patrologiae Cursus Completus*, Vol. 150 (1854), *Caput* XXIX.) The misericord as object is cited in a letter to the Abbot of Besançon by S. Peter Damian (988–1072). See *Beati Petri Damiani . . . Opera Omnia* (Parisiis: Caroli Chastellani, 1642), Vol. III, pp. 290–3: '*Contra sedentes tempore divini officii*' ('Against the use of seats during divine offices').

4 The possession of misericords by Gradefes has been asserted by an outstanding writer on Moslem art in Spain, Leopolodo Torres Balbas, in his series of reports that appeared in the journal *Al-Andalus*, XIX (1954).

5 *Ibid.*, pp. 203–18.

6 A recent book on the history of the Moguer nunnery was published by Juan Miguel Gonzalez Gomez, *El monasterio de Santa Clara de Moguer* (in 1978). The author devotes a few pages to the stalls.

7 L.T. Balbas quotes this description of the stalls by an author who saw them before they were sold away: Emilio Camps Cazorla, *Sillas del coro de Santa Clara de Astudillo* (1932). The description at the end of the paragraph ('en una clara organizacion de origen islamico, tomando del gotico solo el naturalismo del motivo') is from Maria Teresa Sanchez Trujillano's 'La silleria mudejar de San Nicolas de Madrigal de las Altas Torres,' in *Cuadernos de la Alhambra*, Vols. 15–17 (1979–1981), 249–53.

8 Ricardo del Arco, 'El arte en la catedral de Huesca: la silleria de coro,' *Vell i Nou*, Epoca II, Vol. X (January 1921), pp. 387–92.

9 Regarding Pamplona's stalls, see Balbas, *op. cit.*

10 Regarding Palencia's stalls, see Pelayo Quintero Atauri, *Sillerias de Coro . . .* (2nd Edition, 1928).

11 For the Seo de Zaragoza, see Pelayo Quintero Atauri, in *Boletin de la Sociedad Española de Excursiones*, Vol. XV–XVI (1907–8); L.T. Balbas, *op. cit.*; and Anonymous, 'Sillerias de Coro Españoles,' in *Boletin Esp. de Excursiones*, Vol. IX (1901), No. 97, pp. 49–52, which names the Moorish artists that are cited in the *Libros de Fabrica* (1412).

12 Mariano Oliver Alberti, *La Catedral de Gerona* (1973). The stalls were made over in the sixteenth century, the author reports, but the bishop's throne was preserved intact.

13 In our studies of French stalls we found a similar thing happening throughout the

fourteenth century. While we were able to collate fourteen sets that were produced during this period, they were entirely elementary in style, which we attributed to the Hundred Years' War, which deprived churches of funds for building and decoration and reduced the overall quality of the work.

14 It was also the source of many works of art, brought in by Spanish merchants, who had established an important colony at Bruges before 1267 (Maria del Carmen Carli, 'Mercadores en Castilla,' *Cuadernos de Historia de España*, Vols XXI–XXII, (Buenos Aires, 1954), pp. 146–328).

15 *Libro de Actas de 1453 a 1463*, folio 11 vuelto: 6 March 1454. The document was published by Maria Gonzalez Sanchez-Gabriel in 'Los hermanos Egas de Bruselas en Cuenca: La silleria de coro de la colegiata de Belmonte,' *Boletin de Arte y Arqueologia de Valladolid*, Fasc. XIII a XXI (1936–9), 21–34; and more fully by Miguel Angel Monedero Bermejo, in 'El Coro de la Colegiata de Belmonte,' *Separatas de la Revista Cuenca*, not dated.

16. A full account of the various shifts and changes of the Cuenca stalls can be read in the work of Jesus Bermejo Diez, *La Catedral de Cuenca* (1977). We are grateful to him for making available to us a copy of his study.

17 The Najera stalls have been discussed by Pelayo Quintero Atauri in his *Silleria de coro, etc.* (1928), and at greater length by Isaac Guadan y Gil in his *Silleria de coro alto. Monasterio de Santa Maria la Real de Najera* (1961). Both authors mention a report by a certain 'Madoz' (no doubt Pascual Madoz who published a *Diccionario Geografico-Estadistico-Historico de España*, in 1849), to the effect that the stalls were created in 1493 by two brothers named Amutio, whom Guadan y Gil identifies as judaizing *conversos*, who contrived to insert Jewish ritualistic symbols into the stall-art. – The information about the forced desertion of the monastery came from the church guardian, Fr. Marino Martinez Izquierdo. That about the Amutio brothers stems from data transmitted by Jovellanos from an archivist, P. Bujanda, according to Agustin Duran Sanpere and Juan Ainaud de Lasarte, writing in their '*Escultura Gotica*,' in *Ars Hispaniae*, Vol. VIII, (1956), p. 28, which dates the stalls as of 1495.

18 The stalls of Celanova are discussed in J. Jose Martin Gonzalez's *Sillerias de coro* (Vigo, 1964); those of Dueñas, by the same author in his article, 'La silleria de la iglesia de Santa Maria, de Dueñas (Palencia),' in *Archivo Español de Arte* (1956).

19 These include Toledo (1489–95); Oviedo (pre-1492–pre-1497); Najera (c. 1493–?); Zamora (1496–1506); Plasencia (pre-1497–post-1503); Ciudad Rodrigo (1498–post-1503); Yuste (1498–1506).

20 We have gathered from various sources a list of 27 Gothic stalls without figures. Several of these have disappeared or left only a few vestiges when redone in post-Gothic style. These stalls, roughly dated, are: 13 C: Gradefes. – 14 C: Astudillo; Moguer. – Early 15 C: Cathedrals of Huesca; Pamplona; Palencia; and Zaragoza. – Second half of 15 C: Ucles; S. Tomas de Avila; Miraflores; S. Juan de los Reyes; Sta. Maria de Huelgas; Iglesia de Avalos; Oña; Iglesia de S. Andres; Sta Maria del Campo; Iglesia de Jatiel (Teruel); and the Cathedrals of Tarragona; Tarazona; Siguenza; Coria; Segovia; and Mondoñedo. – Early 16 C: Villalon de Campos; and the Cathedrals of Granada; Tudela; and Palma de Mallorca.

21 Among these, some of the best-known include: Antonio and Francisco Gomar, brothers, who did the set at Tarragona Cathedral (1479–92); Juan Millan, creator of the stalls at San Juan de los Reyes at Toledo (1494–6), which were burnt by Napoleon's troops; and a pair of artists whom we hear of as 'los Sarinenas,' who carved the still extant stalls of Tarazona Cathedral (c. 1483–8).

22 An example are the stalls of the church of the Virgen del Pilar, at Zaragoza.

23 The high incidence of animals and monsters is found in the stalls of all countries, reaching a total of almost 50 percent in the indexed misericords of England, while the misericords

of Spain registered 40.5 percent in our listings. Our results in France were unfortunately faulty due to an error in our survey questionnaire.

24 A man (or a lion) in conflict with a monster can define the struggle between Good and Evil, hence constitute a virtue.

25 That the concern of church authorities regarding clerical sinfulness was justified is revealed by several entries in Leon's Actas Capitulares. In one entry of 1476, the bishop orders the canons and other clerics to give up their 'public women' ('*mancebas publicas*') in 15 days or be fined a silver mark which would go to the building fund! In 1482, the prelate repeats his decree. In 1478, the Actas list what strikes us as a humorous order, which must have been taken seriously nonetheless: that clerics must cut off their pigtails (Tomas Villacorte Rodriguez, in *El cabildo de Leon . . . siglo XII–XIX*, 1974).

26 The French figures stem from our own studies and surveys whereas those from England were obtained from G. L. Remnant's *A Catalogue of Misericords in Great Britain* (Oxford, 1969).

27 Dorothy and Henry Kraus, *The Hidden World of Misericords*: 'The Burghers' "Self-Portraits"' (pp. 123–6).

28. Among the sports identified in the Index of Remnant's book.

29. *The Hidden World of Misericords*, Fig. 43. It is from the church of St-Martin, at Champeaux (Seine-et-Marne).

30 A few sets in England have misericords that are largely given over to heraldic references, as can be seen in Remnant's *Catalogue*.

31 This tendency to omit indexing sexual or even amatory subjects can be seen in Remnant's otherwise exhaustively informative *Catalogue*.

CHAPTER X A DELICATE SPIRITUAL-AND-WORLDLY BALANCE

1 In France it was very rare to find Gothic stall-carvers who also worked in stone. Pol Mosselmen, a Flemish artist who was the chief sculptor in the group that carved the great assembly of Rouen Cathedral, was an exception. Pere Sanglada's work in both media has been authenticated, as was that of Antoni Canet, a French artist who also worked on Barcelona's stalls. But the practice was evidently not widespread, as we can gather from an interesting case reported by Beatrice G. Proske (in *Castilian Sculpture*, 1951), of a wood-carver having been designated to judge the work in stone of Simon de Colonia, at Valladolid, and was challenged by the architect who questioned his qualifications.

2 Maria Rosa Teres Tomas, 'Pere Ça Anglada, maestro del coro de la catedral de Barcelona: Aspectos documentales y formales,' *Revista del Departamento del Arte* (Univ. de Barcelona), No. 5 (Sept. 1979), pp. 51–64. The author credits the work of a group of scholars under Professor F.-P. Verrié, who did full transcriptions of Sanglada's and other sculptors' work from the *Llibre d'Obra* (fabric record).

3 Sra. Tomas gives as source of 'mestre Jordi' the *Llibre d'Obra*, 1389–1390, fol. 66 v. She reports that earlier stalls existed, which must have been moved when Sanglada's seats were installed. She cites several minor jobs that were done on these stalls from 1383 to 1389, indicating that the decision to create the new assembly ws an afterthought. On the other hand, the bishop's throne that was sculptured in the prior period was retained. (Juan Ainaud de Lasarte, Jose Gudiol Ricart, F.-P. Verrié, *Catalogo Monumental . . . La Ciudad de Barcelona*, 1947.)

4 *Ibid.*, XX de maig, divendres (Friday, May 20, 1395).

5 *Ibid.* Sra. Tomas quotes this direction from the contract, adding that some of the wood for the second set was brought from Flanders (as had been done by Sanglada) and suggesting that the latter wood was of better quality than Spain's. A recent author has produced

evidence of another possible factor involved here, the increasing rarification of wood in many parts of Europe during this period due to excessive deforestation and lack of replanting. (See Note 11 below.)

6 Sra. Tomas points out that Lochner had worked on the tympanum of the Puerta de la Piedad, which indicates that he sculptured both in stone and wood, a facility that was rare among stall-makers, as we have already noted. Pointed canopies, done as much as a century earlier than those of Barcelona, can be seen in some English churches, notably at Lincoln Minster.

7 Sra. Tomas, Apendice Documental: Documento Num. 1.

8 M. Durliat, *L'art en le règne de Mallorca* (Mallorca, 1964), pp. 240–1, as cited by Sra. Tomas.

9 Apendice, Documento Num. 1.

10 Apendice, Documento Num. 2.

11 Roland Bechmann, *Les racines des cathédrales* (Paris: Payot, 1981), pp. 93–100; 106. Other Spanish churches are known to have imported Flemish wood for art works: for instance Sevilla Cathedral for its great reredos (Maria Fernanda Moron de Castro, in *El Retablo de Sevilla*, 1981, p. 125).

12 This information was graciously given us by Professor F.-P. Verrié.

13 The earlier Belgian stalls that we have seen do not have supporters either.

14 Sra. Tomas, 'El taller de Pere Ça Anglada . . .' (pp. 5–7). This section 2 of her article contains the data regarding the names of artists, their work and pay, etc.

15 A well-known French scholar has reported that in the Barcelona pogrom of August 1391, which lasted four days, it was the women who were most resistant to enforced conversion, many of them going to their deaths rather than submit (Philippe Wolff, 'The 1391 Pogrom in Spain,' *Past and Present* (1971), No. 50, pp. 4–18).

16 It should be noted that despite the definite prohibition in Matias Bonafe's contract to do any figured carving, we do find such sculpture in the handrests.

17 A number of authors have commented on the gambling section in this famous work by Bosch, as for instance Wilhelm Fraenger in *Le royaume millénaire de Jérome Bosch* (French edition, 1966).

18 Many authors tell about the luxuriousness of upper-class clothing during the fifteenth century in Spain, notably Santiago Sobreques Vidal, in *Patriciado Urbano*, Vol. II of *Historia Social y Economica de España y America* (1957).

19 The misericord in question is reproduced in Francis W. Steer's brochure, *Misericords at New College, Oxford* (Phillimore and Co.: London and Chichester, 1973), p. 11.

20 Isabel Mateo Gomez, *Temas profanos, etc.*, pp. 228ff.

21 Henry Kraus, *The Living Theatre of Medieval Art* (Indiana University Press: Bloomington, Ind., and Thames & Hudson: London, 1967 and 1968), pp. 100 ff.

CHAPTER XI THE CHURCH'S ARTISTIC REPLY TO HETERODOXY

1 Emile Mâle, *L'art religieux du XIIIe siècle en France* (Paris, 1902), p. 192. His chapter on 'Le miroir historique: l'Ancien Testament' (pp. 161–209) gives a consummate treatment of the relationship of the Old Testament to the New as handled in medieval art.

2 *Ibid.*, p. 164: 'Epistle to the Hebrews,' Chapter IX.

3 *Ibid.*, pp. 167ff.

4 Emile Mâle, *op. cit.*, pp. 261–3. The great figures of the Old Testament whom Christ freed were those who because of their early appearance had been deprived of their deserved places in heaven. Nicodemus is remembered also for his sad role in the deposition of Christ from the cross.

5 Emile Mâle, in *op. cit.*, p. 202, tells how on Christmas or the Epiphany, it was common

in the Middle Ages to display a kind of dramatic procession in churches of the prophets who had given witness of the divinity of Christ. Each would answer to the calling of his name and speak out his prediction. Mâle adds: 'Even the "Gentiles" were called on to give their witness. Virgil recited a verse from his mysterious eclogue (*'Jam nova progenies coelo demittitur alto'*), the Sibyl sang her acrostic canticle on the end of time. . . .'

6 There is nothing solidly known about the dating or authorship of the Astorga stalls except for the frontal frieze that was added to the high crest in 1547 and is definitely Renaissance work. The Gothic part (with later admixtures) is dated around 1515–23 by Manuel Gomez Moreno, who reports that Juan de Colonia (Cologne), 'sculptor,' was at Astorga during the latter year, which is hardly a proof of his participation on the stalls. This same author says that Astorga's stalls are about ten years later than Zamora's.

7 Isabel Mateo Gomez, *Temas profanos, etc.*, pp. 273ff.

8 That of Isabel Mateo Gomez, in *op. cit.*, pp. 182–4.

9 Wilhelm Fraenger, when discussing the Hell panel in Bosch's *Garden of Delights*, examines in detail the section devoted to gambling, which he characterizes as the most pernicious of sins (*Le royaume millénaire de Jérôme Bosch*, Paris, 1966).

10 This iconographic interpretation of the glutton was already used in a somewhat earlier misericord at Cuenca Cathedral (now Belmonte).

11 We must likewise take into account the destruction by modern clerics of much of this type of art. An example at Zamora itself of a doubly anti-monastic subject which has disappeared allegedly showed a monk and a nun 'in such a posture that the dean felt impelled to smash it with a hammer' (*'en tal acto y postura que un señor dean se creyo en el caso de romper las figuritas a martillazos'*) as Francisco Anton reported (*Estudio sobre el coro de la catedral de Zamora*, 1904, 67–8), his source being Vicente de la Fuente's *Historia de las sociedades secretas de España*.

12 Isabel Mateo Gomez, *op. cit.*, pp. 382–3.

13 The total numbers of these various carved features in the figured stalls of Spain (thirteen assemblies, including that of Talavera de la Reina) collated by us were: handrests, 923; misericords, 803; spandrels, 397; roundels, 337; large figures, 325; lower-stall friezes (found only at Sevilla, Toledo and Plasencia), 284; upper-stall friezes, 264; side reliefs (found only at Leon and Oviedo), 263; small pilaster figures (found mainly at Sevilla, Plasencia and Oviedo), 261; above-seat busts, 207; canopies (only Leon, Zamora, Oviedo and Astorga), 148; upper-stall border scenes (only Ciudad Rodrigo), 82; sculptured terminals, 59; sculptured ramps, 35.

14 Oviedo has no large upper-stall figures but the original iconographers sought to supply a partial substitute for this lacking feature by the insertion of pertinent inscriptions from key Old and New Testament representatives.

15 The dating of Zamora's stalls is obscure. Francisco Anton, writing in 1904 (in *op. cit.*) but without giving his sources, claims that a whole series of church features at Zamora Cathedral, including the stalls, were done under Bishop Diego Melendez Valdes (1495–1506). Manuel Gomez Moreno's corroboration of this claim is based on his identification of this prelate's emblem on the upper section of the set. A more recent author, Ramon Luelmo Alonso, advances the date of the stalls by about twenty years on the ground that a number of foreign sculptors were cited at Zamora around 1514. But this 'proof' is hardly serious.

16 Ciudad Rodrigo's lower-stall frieze consists only of a repetitive foliar pattern and is therefore excluded from the features common to this group (See Table II). As will be seen when we study the creation of this assembly, there were particular reasons for the simplification of its carving.

17 The upper register at Toledo was redone in the mid-sixteenth century in plateresque (Renaissance) style.

18 The breakdown in Plasencia's illustrated vices is: Drunkards, 6.3 percent; Sex Occurrences, 4.0 percent; Other Vices, 7.6 percent. Total: 17.9 percent.

19 A good example of this accepted influence are the side-reliefs at Oviedo and Leon. These are a rare feature, not only among Spanish Gothic stalls but in similar stalls in other European countries.

CHAPTER XII ICONOGRAPHY OF THE 'SOCIETY AT WAR'

1 An ironical twist to this coincidence was that Columbus's first voyage was largely financed by two Aragonese *conversos*, Luis de Santangel and Gabriel Sanchez. Jews and *conversos* were also members of the crew, including the 'interpreter' (Henry Kamen, *The Spanish Inquisition*, 1965).

2 St Ferdinand, King of Castile (1230–52), had referred to himself as the 'king of the three religions' (*Ibid.*, p. 3). Americo Castro has written brilliantly on the subject of the contributions of the Moslems and Jews (as well as Christians) to the Spanish nation. See especially his *The Structure of Spanish History* (Princeton University Press, 1954).

3 Miguel Angel Ladero Queseda, in *La Ciudad Medieval (1248–1492): Historia de Sevilla*, n.d., declares that the Inquisition was established by Rome at the request of Ferdinand and Isabel while they were present in Sevilla during 1477–78. Henry Kamen (*op. cit.*, p. 46) tells of the revolt of a group of rich Sevillian *conversos* in 1481; they were seized and the first Spanish *auto da fe* followed. Expulsion of the Jews began in 1483 (Leon Poliakov, *The History of Anti-Semitism*, 1955, p. 186).

4 Angus McKay, in 'Popular Movements and Pogroms in Fifteenth-Century Castile,' *Past and Present* (May 1972), No. 55, pp. 33–67.

5 Isabel Mateo Gomez, *Temas profanos, etc.*, 1979, pp. 198–202. The Arabist scholar was Pedro Martinez Montavez, of the Universidad Autonoma de Madrid. The book, *El libro llamado el Alboraique*, was written *c.* 1498 and was published in modern times in the work of N. Lopez Martinez, *Los judaizantes castellanos y la Inquisicion en tiempos de Isabel la Catolica* (Burgos, 1954), Apendice IV.

6 The Hercules carvings have been studied by Isabel Mateo Gomez in *op. cit.*, pp. 115–24.

7 Angus McKay, in *Spain in the Middle Ages* (London: Macmillan, 1977), p. 55, tells of a famous popular caballero hero of the period, Corraquin Sancho, who coming upon a large troop of Moorish soldiers who were taking some shepherds prisoner, singlehandedly killed or dispersed the band and saved the herd. A song of the time vaunted Corraquin's exploits over those of Roland and Oliver. Pelayo Quintero Atauri states that the attack by a dragon on a shepherd with intervention of a caballero was a frequent subject of medieval 'romances' and signified a combat between Good and Evil.

8 Santiago Sobreques Vidal, et al., in *Patriciado Urbano* (pp. 118ff), assert that Sevilla's great prosperity in the fifteenth century was based on international wool commerce. A majority of the leading Castilian families owned great flocks or enormous pastures that they rented out to graziers.

9 Three main routes were used by the flocks, Santiago Sobreques reports (pp. 278ff). They passed through a number of the cities that possess Gothic stalls. One of them for example went through Zamora on the way to the Extremadura.

10 Marie-Claude Gerbet, in *La noblesse dans le royaume de Castille ... structures sociales en Estremadure ... 1454–1516* (Paris: Sorbonne, 1979), describes the non-noble 'caballeros villanos' as serving as municipal troops. Besides the defense of a city, their task was to protect the citizens' herds on the range outside the walls (pp. 75–76). – Sobreques reports that the big landowners encouraged *hermandades* (fraternities) for mutual protection of flocks. These fused by the fourteenth century under royal inspiration into the gigantic

Mesta, the great sheep-herders' national organization.

11 Miguel Angel Ladero Queseda (*op. cit.*, p. 135) declares that the caballeros held all the posts of Sevilla's municipal government, constituting a kind of oligarchy.

12 Claudio Sanchez-Albornoz, in *España, un enigma historico*, II (Buenos Aires, 1956), pp. 42ff., has made cogent observations about the 'openness' of Spanish medieval society in contrast to those under feudalistic regimes. The chief reasons he offers for the distinction were the long war of reconquest and the repopulation of the absorbed territories.

13 Miguel A.L. Queseda, in *op. cit.*, p. 144, says that three times a year war games were conducted at Sevilla in which thousands of armed men participated. Many other authors describe the jousts and tournaments that took place in Spanish towns. See especially Manuel Criado del Val, *Historia de Hita y su arcipreste* (Madrid, 1976); Martin de Riquier, *Vida caballeresca de la España del siglo XV* (Madrid, 1965); and J.N. Hillgarth, *Los reinos hispanicos, 1250–1516* (Barcelona, 1979).

14 Pelayo Quintero Atauri, in 'Silleria de coro de la Catedral de Sevilla,' *Boletin . . . Excursiones* (1901), pp. 122–6, suggests that it may be a 'Judgement of God' duel in which the offended woman wins justice by her own hand. However, it is known that women did on occasion fight in jousts.

15 Pelayo Quintero Atauri (in *op. cit.*) reported this '*lucha entre un caballero armado con espada y revestido con su armadura, y otro a cuerpo descubierto y solamente la espada por defensa, a pesar de lo cual lleva la mejor parte en el combate. . . .*' It is possible, however, that this might have represented another handicap fight involving an attempt to wipe out a mortal sin.

16 Nicolas Fernandez Moratin, in *Sobre origen y progresos de las fiestas de toros* (1776; Barcelona, 1929), held that the Moors originated bull-fighting, which was adopted by Spanish nobility in the mid-thirteenth century. However, Gaspar Melchor de Jovellanos, in *Espectaculos y diversiones publicas* (reprinted by Ediciones Catedra, Madrid, 1982), 94, refers to a law in *Las Partidas*, which '*puede hacer creer que ya entonces se ejercitaba este arte por personas viles . . . por dinero,*' indicating that bull-fighting was early engaged in for pay by commoners.

17 Jovellanos also cites the prohibition by *Las Partidas* of attendance by churchmen at bull-fights (p. 94). Isabel Mateo Gomez, in *Temas profanos, etc.*, p. 337, quotes the wording of this ban, in *Partida* LXXIX.

18 J.N. Hillgarth, in *op. cit.*, Vol. I, 1250–1410: '*Un equilibrio precario,*' p. 229, declares that practically all parish churches of Andalucia have *mudejar* elements.

19 The fingers of the female dancer's hand are gone but it does look as though they may have been making that typical clicking movement.

20 Isabel Mateo Gomez, for example, in *op. cit.*, p. 335, states: 'The female entertainer must have been, in the thirteenth and fourteenth centuries, the type of itinerant who earned her living from the contributions of the public . . . a woman who sold to the public not only her songs, dances, etc., but her body as well.'

21 Pelayo Quintero Atauri in his piece on the Sevilla stalls, identifies the woman riding the monster as wearing a nun's raiment.

22 The two hundred or so religious figurettes framing the upper panels were probably considered too tiny to deliver a vigorous pious message.

23 Nufro Sanchez, who is widely accepted as having been of Spanish origin, nevertheless did undoubtedly experience influences from various other sources. One of these was the French artist, Lorenzo Mercadante de Bertaña, who was active at Sevilla from the mid-fifteenth century, Maria Elena Gomez-Moreno has suggested (*Breve historia de la escultura española*, Madrid, 1951, p. 62).

24 Pelayo Quintero Atauri (*op. cit.*, 1901) reports that Nufro Sanchez, in 1461, lived in the chapter's house on the Plaza de Torneros (turners). His father, Bartolome Sanchez, was '*maestro mayor de carpinteria de la catedral.*'

25 This is Isabel Mateo Gomez' suggestion (p. 237), with which we do not agree, as we

shall explain later.

26 These documents were published by Pelayo Quintero Atauri in his article on Sevilla's stalls, in the *Boletín . . . de Excursiones*, Marzo 1901, pp. 122–6.

27 The entry in the Actas Capitulares for November 10, 1478, declares that 'it was agreed to give Dancart for the big stall [the archbishop's] twice as much as was given him for two of the other stalls, which were priced at 18,000 mrs. . . .' This, based on the original pay set at 16,000 mrs, meant an increase of 2,000 maravedis.

28 Pelayo Quintero Atauri, *op. cit.*, pp. 125–6.

29 *Ibid.*, pp. 124–5.

30 Augustin Duran Sanpere and Juan Ainaud de Lasarte, in *Ars Hispaniae*, Vol. 8: *Escultura Gotica* (Madrid, 1956). They add that Dancart also worked on the reredos sculpture, starting in 1482, which was completed years later by his disciple, Jorge Fernandez. Nevertheless a close study of the *Flagellation* and *Last Supper* carvings in the Sevilla reredos and choir-stalls (both of which *could* have been done by Dancart) showed little similarity in style.

CHAPTER XIII IMAGES OF SPAIN'S 'FAR WEST'

1 Hector Luis Arena, who has made a thorough study of Rodrigo Aleman's work (see especially his *Die Chorgestühle des Meisters Rodrigo Aleman*, a doctoral thesis presented at Heidelberg and published in Buenos Aires in 1965), postulated a life story for the artist: born in the Lower Rhine in the mid-fifteenth century, working there until the 1470s, when he came to Spain, etc. Arena claims to find a strong similarity in Aleman's Spanish work with the style of the stall-work at 'Kleve, Boppard, Emmerich, Kalken, usw.'

2 Vicente Paredes, 'Silleria del coro de la Catedral de Plasencia,' *Revista de Extremadura*, Vol. XII (1910), pp. 305–11.

3 J. Dominguez Bordona, *Proceso inquisitorial contra el escultor Esteban Jameta* (Madrid, 1933).

4 This theory was in recent years developed at length by Canon Manuel Lopez Sanchez-Mora, of Plasencia Cathedral. See Note 6, following, for details.

5 Vicente Paredes.

6 M.L. Sanchez-Mora, *Las catedrales de Plasencia y tallistas del coro* (2nd edition: Plasencia, 1976). In a special Appendix to his book, titled 'Tallistas Judios?,' the author seeks to build up evidence regarding supposedly virulent interpretations by Jewish or *converso* artists and manages to bring Rodrigo Aleman into the plot by a kind of logical legerdemain based on conjecture, oblique argument and unsupported gossip. Toward that end he tells of the prominence of the Jewish community at Plasencia and names several Jewish artisans and sculptors who had worked for the cathedral, though all except one had done so before Rodrigo's time. That one, Maistre Moises, has left no evidence of having worked on the stalls, but Sanchez-Mora for obscure reasons names him as one of those Jews who in 1492 'approved' of the sale of their cemetery to the dean of the cathedral when the Jews were expelled. From this and other 'evidence,' he concludes that it is '*muy probable*' that Jews had infiltrated among the carvers of the stalls. He still is not certain, however, about the proof that Rodrigo Aleman was Jewish but concludes that it is in his sculpture that one can find the truth: in the 'vile events' narrated, in the 'obscene suggestions,' and 'above all in the blasphemous irreverences that are steadily carved there. . . .'

7 Maria Luz Rokiski Lazaro, 'Proceso del tribunal de la Inquisicion de Cuenca contra el entallador Rodrigo Enrique,' *Archivo Español de Arte* (1979), No. 207, 358. She gives her source as A.D.C. Inquisicion. Delitos. Leg. 84, No. 1211.

8 Tomas Villacorte Rodriguez, in *El cabildo de Leon . . . siglo XII–XIX* (Leon, 1974), points out that in the sixteenth century candidates for various offices in the cathedral chapter had to prove that they were not descendants of Jews, Moslems, heretics, etc., in order

to assure their *'limpieza de sangre'* ('purity of blood').

9 The 'Chronology' has been derived chiefly from documents that were published early in the century. The most important printed sources of these archives were: *Datos documentales para la historia del arte español*, II: *Documentos de la catedral de Toledo, coleccion formada en los años 1869–74 y donada al Centro en 1914*, por D. Manuel R. Zarco del Valle. Barcelona: Biblioteca de Catalunya (Madrid, 1916); and Jose Ramon Melida, *Catalogo Monumental de España: Provincia de Caceres, 1914–1916* (Madrid, 1924), Vol. II, Texto.

10 Hector Luis Arena cites, from Zarco del Valle's documents, wings for eight angels done by Rodrigo for the Corpus Christi procession, for which he received 1,000 maravedis (*Libro de gastos del año 1496*, fol. 95).

11 There is a mysterious reference to a *'muestra'* (model) for the *'retablo de San Ildefonso'* that Rodrigo was supposed to have made, in 1498 or 1499, which is listed by Francisco Perez Sedano, in his *Datos documentales ineditos para la historia del arte español*, I (Madrid, 1914), a reprint of a work of the eighteenth century. Two other artists also seem to have made *'muestras'* for this reredos: Peti Juan, the well-known sculptor, and Maestre Alberto, *'entallador.'*

12 Hugo Kehrer, *Deutschland in Spanien* (München, 1953), p. 104.

13 Hector L. Arena, 1965, citing documents from Manuel R. Zarco del Valle. The change of fee to 10,380 mrs appears in an undated document, probably 1494, declaring that Rodrigo's stalls *'fueron tasadas [judged] por maestros a diez mill e trezientos e ochento mrs. cada silla. . . .'* This was based on the work already done of 38 stalls, hence may have been retroactive. The raise amounted to about 4 percent.

14 See for example the work of Santiago Sobreques Vidal et al., *Patriciado Urbano, etc.* (p. 308). The authors point out that a peon with hoe and sickle earned 16–18 pepiones a day, without food, in Toledo, whereas in other parts of Spain a reaper earned 36 *pepiones*. The variation for a *'tapiador'* (wall builder) was even greater – 12 to 42 *pepiones* – though the first sum may have included food. A carpenter earned fully 48 *pepiones* in Andalucia (Sevilla). Craftsmen in Toledo got much less. Asturian prices, by the way, were among the lowest in Spain.

15 There are actually fifty-four of the Granada scenes, two more having been added at a later date.

16 We have no record of the exact date in 1489 when Rodrigo began working on the Toledo stalls but there is a document citing payments to him for that year of 61,365 maravedis (Hugo Kehrer, *op. cit.*). Since he earned 10,000 mrs per stall, that sum would have carried him well back into 1489. A number of authors have written about this assignment. A meticulous study of the Granada series was done by J. de M. Carriazo: 'Los relieves de la guerra de Granada en el coro de Toledo,' *Archivo Español de Arte y Arqueologia* (1927), No. 7, pp. 19–70.

17 Hugo Kehrer, pp. 101–3.

18 Hector Luis Arena (1965), p. 19.

19 This stairway, as well as other terminal work done by Rodrigo Aleman, is listed in the documents published by Zarco del Valle, in particular that of January 10, 1495. It should be added that the central stone enclosure, which would not have been built unless there were stalls to 'enclose,' is mid-fifteenth century, or earlier, judging from the external sculpture. Finally, we should refer to the evidence that there were stalls of some kind at Toledo early in the thirteenth century, as we have already mentioned in reference to the exchange brotherhood established between Oviedo and Toledo Cathedrals, in 1234 (See Chapter I and Note 17).

20 Vigarny was a Burgundian, according to August L. Mayer, writing in *Toledo* (Leipzig, 1910), p. 91.

21 Jose Ramon Melida, in the *Catalogo Monumental . . . de Caceres*, 1914–16, quotes in full

the document of June 7, 1497, where all details of the contract are given. Melida also suggests that Rodrigo Aleman may have started on the Plasencia stalls during 1496 or even earlier, when there is a gap in the sculptor's known activity. He also argues that it would have been unlikely to start the set with the two major stalls or to have given Aleman the most important assignment before he had been tried out on minor pieces, a curious argument regarding an artist who had already done the magnificent stalls at Toledo.

22 This could not possibly have been the Hanequin (Egas) de Bruselas, brother of Egas Cueman, who was the Toledo Cathedral architect at least forty years before 1497. Actually, Enrique Egas had acceded to his post as architect in 1496, taking the place of Juan Guas, according to Hector Luis Arena, who also claims that Rodrigo Aleman's close relations with Enrique Egas brought him the important assignment, in 1498, of participating on the Toledo reredos.

23 Jose Ramon Melida gives this detail about the delayed construction of the church and its repercussions on the stalls.

24 Earl J. Hamilton, *American Treasure and the Price Revolution in Spain, 1501–1650* (Cambridge, Mass., 1934), pp. 101–5. Aside from the riches in precious metals that arrived in galleons, the *conquistadores* brought great personal fortunes home, a large number of them to the Plasencia diocese; they included some famous names like Hernando Cortes, Pizarro and Orellano. As we look at the 'old' church today, at its handsome late Romanesque-early Gothic form, we can hardly avoid being delighted that the project of completing the new church (which would have required demolishing the old one) was not pursued to the end. Can it be that recognition by the church authorities of the elegant beauty that they were planning to destroy contributed to the abandonment of the rebuilding plan, even if it meant leaving an unwhole church, divided into two unadaptable parts?

25 See Hector Luis Arena, under *Documents*: July 10, 1498.

26 The original contract required '*que llega cada una [silla] hasta diez mill. mrs. e si mas valiere que no le daran mas . . . e que antes las (h)aga de menos valor que no de major. E sy las hiciere de mas valor, que no son tenudos de dar por cada una mas de los dichos X. M. mrs.*'

27 The documents show that Rodrigo Aleman still kept a house in Toledo during 1498 and 1499, which indicates that his Plasencia and Ciudad Rodrigo assignments were not yet firm enough to bring a permanent break in his living arrangements (see *Documents* in H.L. Arena, p. 121, where he is said to receive 4,000 mrs '*para ayuda del alquiler de su casa*', to help pay the rent on his house).

28 Each of three masters, including Rodrigo, was to make a model that would presumably fit into the final assembly, every man receiving 4,500 mrs for his work, which inferred a job lasting several months. These details are given by Hugo Kehrer. The 4,500 mrs fee is cited by Francisco P. Sedano. We make the calculation that this sum, at 37 mrs per day, would give about 120 workdays or the equivalent of $5\frac{1}{2}$ months.

29 Rodrigo Aleman was supposed to be in Plasencia anyway that year making the drawings for the new bridge and presumably getting the work started on it. He could easily have continued to supervise this job while concentrating on the cathedral's stalls.

30 J. de M. Carriazo, in *Los relieves de la guerra de Granada, etc.*, asserts that Rodrigo contracted in 1497 not only to do the seats of the '*reyes catolicos*' at Plasencia but also twelve other stalls. But he gives no source for this information.

31 See Hector L. Arena under *Documents*: March 27, 1503.

32 The complete iconography of Yuste's stalls can be found in the work by Jose Ramon and Fernando Oxea, 'Reliquias de Yuste,' *Archivo Español de Arte*, Vol. XX (1947), 26–59, who also record the various shifts and changes of these stalls prior to their recent transfer back to the monastery. Hector L. Arena suggests that these stalls were done under Gutierre Alvarez de Toledo, who was bishop of Plasencia in 1498–1506 and whose blazon is on

the central seat ('Las sillerias de coro de Maestro Rodrigo Aleman,' *Boletin del Seminario de Estudios de Arte y Arqueologia de Valladolid*, Vol. XXXII (1966), pp. 89–123).

33 A remarkable anticipation of this subject could be seen at a recent exhibition of Tunisian art at the Petit Palais in Paris. Titled 'drunken woman,' the small work of the third century presented a seated female figure with bulging eyes and a big wine-jug between her legs. Its origin was Hadrumetum (Sousse).

34 The question of clerics appearing before the Inquisition for various sex transgressions is treated by a number of authors, including especially Bartolome Bennassar et al. (*L'Inquisition espagnole, XVe–XIXe siècle*, Paris, Hachette, 1979), and Henry Charles Lea (*A History of the Inquisition of Spain*, new edition, New York, 1966). The Bennassar group point out that ablation of the sinning member had been the punishment in medieval Spain for 'sins against nature,' but that Ferdinand and Isabel reinstated death by burning in 1497 for the 'abominable sins.' The present authors followed up several of the cases brought before the Holy Office, at the Archivo Historico Nacional in Madrid. The earliest of such cases were listed only starting in the 1530s. Prior to that, judaism made up the totality of cases, as Bennassar and colleagues had reported. However the prevalence of serious sex offenses in clerics during the earlier period is not denied by any authorities nor the fact that they assumed the same patterns as depicted in later cases such as those of Alonso de Valdelomar, 1535 (Legajo 235), and Antonio de Pareja, 1530/32 (Legajo 231), for example (A.H.N.: *Solicitantes en la Confesion*). The Church often was reluctant to report such cases to the inquisitors, fearing the scandal that resulted from their being made public, at a time moreover when the Reformation was already presenting it with enormous problems.

35 Marie-Claude Gerbet, *La noblesse dans le royaume de Castille . . . structures sociales en Estremadure . . . 1454–1516* (Paris: Sorbonne, 1979); and various others.

36 *Ibid.*, p. 99. The author cites a number of cities in the Extremadura where Jews and *conversos* were 'numerous': Caceres, Plasencia, Trujillo, Badajos, Merida. In the last, *conversos* represented a fourth of the population, she reports.

37 Angus McKay, 'Popular Movements and Pogroms in Fifteenth-Century Castile,' *Past and Present* (May 1972), p. 61.

38 M.L. Sanchez-Mora, *Las catedrales de Plasencia, etc.*, p. 75: 'Figura de judio tratada con especial respeto.' By this favorable treatment, he says, '*se vengaron asi algunos tallistas, judios falsemente conversos, contra la Iglesia. . . .*' ('thus some sculptors who were falsely converted Jews avenged themselves against the Church.')

39 As shown in Georg Liebe, *Das Judentum* (Leipzig: Eugen Diederichs, 1903): Abbildung 11, 'Anonymes Holzschnitt, ca. 1470. München, Kupferstichkabinet, Schr. 1961.' The Jew's attachment to the pig reaches a high point of symbolic irony in a carving of the cathedral stalls at Erfurt (East Germany), of the first half of the fourteenth century. It represents a joust, the author (Hannelore Sachs, *Mittelalterliches Chorgestühl*, Heidelberg, 1964) explains, fought between Church and Synagogue. The iconography, which she terms 'unique,' shows a Christian knight on horseback and a Jew mounted on a sow. Curiously the Jewish 'knight' is unarmed but seems unperturbed as he faces the oncoming point of the Christian's lance.

40 The great Flemish painter, Hieronymus Bosch, a contemporary of Rodrigo Aleman, has furnished a famous example of the sophisticated (non-Jewish) pig. In his Hell panel of the '*Garden of Delights*' triptych, he depicts a sow in the garb of an abbess who is insidiously coaxing a sinner to alter his will or to testify to a false relic (the latter interpretation being that of Isabel Mateo Gomez, in 'El Bosco en España,' 1965). Bosch was fond of these anomalous, even friendly roles for the pig, another one being that of the faithful companion of St Anthony.

41 The position of the Jews in medieval Spain is developed by a number of authors, including

Henry Kamen (*The Spanish Inquisition*, 1965); Jose Amador de los Rios (*Historia social, politica y religiosa de los judios de España y Portugal*, 1876); and others.

42 We have listed at Ciudad Rodrigo's stalls eleven pig subjects, seven of them what we call 'educated' pigs. In contrast, G.L. Remnant, in the Index to his *Catalogue of Misericords in Great Britain*, had recorded twenty pig subjects, the big majority (fourteen) being presented in ordinary, natural activities.

43 An anthology of selections from such works was recently published in Carlo Bascetta's *Sport e Guochi: Trattati e Scritti del XV al XVIII Secolo* (1978). The author includes references to Alfonso Martinez of Toledo's *Arcipreste de Talavera* (fifteenth century), as well as Fabian von Auerswald's *Ringer Kunst* (1539).

44 Marie-Claude Gerbet, *op. cit.*, p. 462.

45 Quoted by Manuel Criado del Val in his *Historia de Hita y su arcipreste* (Madrid, 1976), p. 134.

46 Already often quoted authors that raise this point include Marie-Claude Gerbet, Angus McKay, and especially Santiago Sobreques Vidal.

47 Angus McKay, *Spain in the Middle Ages* (London: Macmillan, 1977), pp. 170ff.

48 Among the tasks undertaken by the caballeros in towns, aside from their major military duties, was their required participation in the *fiestas publicas*. See on this especially Carmela Pescador, 'La caballeria popular en Leon y Castilla,' *Cuadernos de Historia de España* (Buenos Aires, 1964), 233ff.

CHAPTER XIV SPAIN'S DWINDLING PATRIMONY OF CHOIRSTALLS

1 The letter has been reproduced in the *Boletin de la Real Academia de Bellas Artes de San Fernando* (1898), 167–8. It was sent on August 29, 1560, and was directed to the bishop, dean and chapter of Leon Cathedral.

2 Mariano Dominguez Berrueta, *La Catedral de Leon* (Madrid, 1951), p. 64.

3 See this communication in the Archivo de la Catedral de Leon, No. 8786 (Cajon Roma Choro, letra C, legajo no. 37, a 1584). The letter is dated May 13, 1584, and is addressed to Pope Gregory XIII by Bishop Francisco and is titled on the obverse, in Latin: 'Copy of the plea by the bishop of Leon for the concession by his holiness regarding [the subject] of the transfer of the choir.'

4 *Ibid.* It is surprising to find the prelate ending his arguments with a battery of implied warnings to his canons, including a tax on their daily 'distributions,' 'sequestration' of the cathedral's fabric funds and, ultimately, excommunication, if they refused to pay the expense for the transfer of the choir.

5 Archivo de la Catedral de Leon, No. 8786, 1584, which consists of three documents giving the chapter's reasons why the bishop's request should be turned down. Also, one document, No. 8785, 1584, the reply from Laurentius Blanchettus, JUR. BTR. DOCTOR, a long and repetitious summary of the case in legalistic language.

6 Archivo de la Catedral de Leon, Actas Capitulares, Documento No. 10037, August 13, 1746.

7 Archivo de la Catedral de Leon, No. 8786, May 6, 1891.

8 A curious twist in this position taken by Leon's churchmen is the fact that they won the support for it by the renowned Real Academia de Bellas Artes de San Fernando, which was, and still is, a highly respected authority in Spain on such matters. The canons vaunted the idea that this lofty body declared forthrightly that it was advisable that Spanish choirs should remain in the center of their churches (Archivo de la Catedral de Leon, No. 8786, May 6, 1891). We wish to refer back here to the Oviedo controversy on this issue, in which it will be recalled that the chapter had asked Bishop Martinez Vigil to allow the

San Fernando Academy to enter the situation as arbitrator, a suggestion that the prelate persistently chose to ignore. He was doubtless aware of the Academy's viewpoint as expressed at Leon.

9 Archivo de la Catedral de Leon, *op. cit.*

10 Archivo de la Catedral de Leon, Actas Capitulares, April 19, 1913: The offer was 'gratefully' accepted by the chapter. The donor had asked for anonymity, with merely a 'parchment' acknowledging the canons' approval, according to the cathedral archivist, Don Agapito Fernandez Alonso. But this request must have been forgotten since the count is named on a plaque that is attached to the roodscreen.

11 Manuel Gomez Moreno, in *Catalogo Monumental . . . de Leon*, 1926: *Catedral de Astorga*, has collated most of the information regarding its stalls. His evidence on the artists that were presumably involved is very uncertain, however, the attribution for the earlier period to Juan de Colonia (Cologne) being based merely on the fact that he was living in Astorga in 1523. The new work done in 1547 is more securely ascribed but it is no longer Gothic, of course.

12 The travels of the Yuste stalls are described by Jose Ramon Melida (*Catalogo Monumental . . . de Caceres*, 1914/16) and Jose Ramon y Fernandez Oxea, 'Reliquas de Yuste,' *Archivo Español de Arte*, Vol. XX (1947), 26–59. The latter work in particular is fully detailed.

13 Pelayo Quintero Atauri, in *Sillerias de Coro . . .*, 1928, reports that the stalls of Najera were long 'abandoned,' which left them in a sad state: important statues lost, large parts of the structure destroyed.

14 Pelayo Quintero Atauri has written copiously about Sevilla's stalls. This has been annotated here in Chapter XII especially. He reports, for example, that when the stalls were taken out of the choir after the accident of 1888 and thrown into a chapel used as a warehouse, this was done 'sin proposito de armarla otro vez' ('without intention of reinstalling them').

15 Ildefonso Fernandez y Sanchez, in *Historia de . . . Talavera de Reina*, 1896, writes a short section about the collegiate church and its artistic furnishings but says nothing about the granting of the early stalls to the nunnery. In any case this must have happened when the new stalls were made for the Collegiate (1750/52), which coincides with the date when the nunnery was founded (1733), as can be read on the decorated tiles that are incrusted in a wall. The date of '1461' for the creation of the stalls is our guess, based on their style and the fact that the Collegiate's organs were done in that year. The latter were destroyed by fire in 1846, together with the 'new' stalls that had replaced the original ones, which were spared by having passed on to the nunnery.

16 Most of the Gothic stalls *without figures* went through the same kind of alterations and transfers as did those with figured carving. Examples are the cathedrals of Segovia and Mondoñado; the churches of Avalos and Carrion; the Monastery of Guadalupe. They will not be discussed in detail in this book, however.

17 Manuel Trens, the animator of the archbishop's campaign to shift the Barcelona Cathedral's stalls, published a long study in *La Vanguardia Español*, of June 19, 1958, in defense of the move. One of his major arguments was that such changes had been common for centuries everywhere in Spain. He listed some of the most prominent recent cases, including Oviedo, Valladolid, Mallorca, Urgel, Granada, Santiago de Compostela and Valencia while imminent transfers had been announced for Salamanca and Astorga. The request for the shift of the Salamanca stalls was brought before the Real Academia de San Fernando and was turned down. (See Jose Yarnoz, 'Traslado del coro . . . de Salamanca . . .,' in *Boletin de la Real Academia de Bellas Artes de San Fernando*, Segundo Semestre de 1958, No. 7).

18 See 'Sobre el coro de la catedral de Barcelona,' *Boletin de la Real Academia de Bellas Artes de San Fernando*, III Epoca, Vol. I, No. 1, 65–73.

19 *Ibid.*: 'Informe de la Comision Provincial de Monumentos Historicos y Artisticos de Barcelona' (pp. 65–69). A quick response and the agitation fell flat: '*Cuando en 1943 reaparecio el proposito, bastaron algunos articulos periodisticos para que se desistiese del mismo.*'

20 *Ibid.*, pp. 67–8.

21 Miguel Autisent, delegado diocesano of the *Scholae Cantoram*, 'El problema del traslado del coro de la catedral basilica: "La liturgia no es espectaculo,"' *El Correo Catalan* (June 1958), 4.

22 The big controversy that was carried on in newspapers and journals during 1958 can be studied at the Archivo de la Ciudad, in the Biblioteca Massana, Barcelona, which has an excellent card index on the subject. The articles cover the period of March 27 to July 19 and include all shades of opinion, official and private.

23 We have in recent years attended important ceremonies at Barcelona Cathedral when the choir was opened to the public, who were allowed to take places in the stalls.

24 *Nueva España*, 20 Marzo 1982: '*España es una sobrecogedora herida por la que se derrama sus tesores.*' The quotation about the desecration of Oviedo's cathedral square was adapted by Avello from Ramon Perez de Ayala, who wrote the text of the handful of protesters against this desecration: '*En lo alto de las colinas donde el viejo Oviedo reposa, la flecha gentil de la catedral se yergue desde una plazoleta tacita, devota, de porches humildes y fachadas multi-colores. . . . Ricon bellisimo y patetico, recatado seno maternal. . . .*'

Photographic Credits

The authors and publishers wish to thank the following for permission to reproduce the photographs used in this book.

Pascal Corbierre, of Caen (France), did 76 of the 104 illustrations, which are not individually numbered here. All others are listed as follows: Dorothy Kraus, 1, 9, 13, 15, 25, 30; Guzman, Oviedo, 3, 29; Isabel Mateo Gomez (Instituto Diego Velazquez, Madrid), 40, 49, 50; Museo Arqueologico Nacional, Madrid, 32, 34; Royal Commission on the Historical Monuments of England (London), 41, 45; German Ramallo Asensio, Oviedo, 20; Joaquin Pueche, Madrid, 36; Alfredo de la Roza, Oviedo, 28; Cachero, Oviedo, 104; Photographs and Photocopies, taken from books, manuscripts: 6 (Archivos de la Catedral de Oviedo, Actas Capitulares – 1492); 7 (Jose Maria Quadrado, *Recuerdos y Bellezas . . . –*1855/1977); 8 (J. Alvarez Amandi, *La Catedral de Oviedo* – 1929); 10 (Aurelio de Llano Roza de Ampudia, *Pequeños Anales . . . –* 1935/1977); 11 (P. Quintero Atauri, *Bol. Esp. de Excursiones*, XV – June 1907); 12 (Enrique Rodriquez Bustelo, *Arquitectura de Renacimiento en Asturias –* 1951); 39 (Burgos postcard); 96 (Georg Liebe, *Das Judentum* – Leipzig, 1903); 99 (N. Giganti, *Scola overo teatro . . . di parare e di ferire di spada*, in Carlo Bascetta, *Sport e Guochi* – Anthology, 1978).

Index

Index